GARCILASO DE LA VEGA AND THE MATERIAL CULTURE OF RENAISSANCE EUROPE

Garcilaso de la Vega and the Material Culture of Renaissance Europe

MARY E. BARNARD

UNIVERSITY OF TORONTO PRESS
Toronto Buffalo London

© University of Toronto Press 2014
Toronto Buffalo London
www.utppublishing.com
Printed in the U.S.A.

ISBN 978-1-4426-4755-8

Printed on acid-free, 100% post-consumer recycled paper with vegetable-based inks.

Library and Archives Canada Cataloguing in Publication

Barnard, Mary E., 1944–, author
Garcilaso de la Vega and the material culture of Renaissance Europe/
Mary E. Barnard.

(Toronto Iberic)
Includes bibliographical references and index.
ISBN 978-1-4426-4755-8 (bound)

1. Vega, Garcilaso de la, 1503-1536 – Criticism and interpretation. 2. Material
culture in literature. 3. Material culture – Europe – History – 16th century.
I. Title. II. Series: Toronto Iberic

PQ6392.B37 2014 861'.3 C2014-903116-5

University of Toronto Press acknowledges the financial assistance to its
publishing program of the Canada Council for the Arts and the Ontario Arts
Council, an agency of the Government of Ontario.

 Canada Council Conseil des Arts
for the Arts du Canada

University of Toronto Press acknowledges the financial support of the
Government of Canada through the Canada Book Fund for its publishing
activities.

For my mother, in loving memory

Contents

Acknowledgments

In writing this book, I incurred a number of debts, which I gratefully acknowledge. Research was aided by a grant from the National Humanities Center, Research Triangle Park, where a lively group of scholars provided the intellectual stimulation that led to new ways of reading Garcilaso de la Vega's poems. David Konstan, in particular, read portions of the book and offered invaluable comments. The Institute for the Arts and Humanistic Studies (now the Institute for the Arts and Humanities), a University Endowed Fellowship in the Humanities, and a Faculty Grant from the Research Office at Penn State provided time and financial support for research and writing at critical stages of the project. For their generous and encouraging readings, and for sharing their expertise in Golden Age literature and material culture, I thank Laura Bass, Frederick de Armas, Frank Domínguez, and María Cristina Quintero. I have also benefitted greatly from the two anonymous readers, whose suggestions enhanced the framing of the book and strengthened its arguments.

I am grateful to collections and museums which provided illustrations for the volume: the Palacio Real in Madrid, the Rijksmuseum in Amsterdam, the Special Collections Research Center at the University of Chicago, and the Rare Books and Manuscripts, Special Collections Library at Penn State University. I am most appreciative for the kindness extended by Concha Herrero Carretero, Curator of Tapestries at the Patrimonio Nacional, and Sandra Stelts, Curator of Rare Books and Manuscripts at Penn State.

Note on Editions and Translations

Garcilaso's poetry is cited from *Garcilaso de la Vega: Obra poética y textos en prosa*. Edited by Bienvenido Morros. Barcelona: Crítica, 1995. Translations are from John Dent-Young, *Selected Poems of Garcilaso de la Vega: A Bilingual Edition*. Chicago: University of Chicago Press, 2009. Translations of the "Ode to Ginés de Sepúlveda" (Ode ad Genesium Sepulvedam) and Sonnet 33 ("Boscán desde La Goleta") come from Richard Helgerson, *A Sonnet from Carthage: Garcilaso de la Vega and the New Poetry of Sixteenth-Century Europe*. Philadelphia: University of Pennsylvania Press, 2007. I have made silent emendations to these translations. I provide my own prose translations of the Second Eclogue (vv. 744–52, 1032–1885), the Fourth *Canción*, and the "Ode to Antonio Tilesio" (*Ode ad Antonium Thylesium*). All other translations are mine unless otherwise indicated.

Illustrations

xiv Illustrations

GARCILASO DE LA VEGA AND THE MATERIAL
CULTURE OF RENAISSANCE EUROPE

Introduction
Engaging the Material

Rome and Naples

When Garcilaso de la Vega (1501?– 36), courtier and soldier in the army of Emperor Charles V, arrived in Rome in August 1532, he could not have imagined that he was embarking on the most creative and productive phase of his short career as poet. En route to Naples with his patron and friend Pedro de Toledo, marquis of Villafranca and newly appointed viceroy, Garcilaso spent ten days in Rome, where ancient public monuments, like Trajan's Column and the Equestrian Statue of Marcus Aurelius, still stood, and where antiquities were all the rage.[1] If his was an age of warfare and religious upheaval, it also was an age of consumers and collectors, and Italy, the centre of classical art and learning, was unrivalled for its commerce in "worldly goods" of both ancient and modern provenance. Five years earlier, imperial troops had sacked Rome (1527), looting palaces and churches, and dispersing libraries and collections of antiquities (Christian 2010, 215). But collecting soon resumed on an even more extravagant scale, fuelled by acquisitive nobles and well-financed cardinals. By 1532 the city boasted many splendid collections of paintings, artefacts, and especially sculptures displayed in elaborately furnished courtyards as enlightened acts of cultural recovery and preservation, but also to celebrate the good taste of their owners. The Dutch artist Maarten van Heemskerck, who sketched Rome's monuments and antiquities in the 1530s, captured that quest for the antique.[2]

Garcilaso was already familiar with the culture of worldly goods when he arrived in Italy. As a member of the Habsburg court since 1520, he had witnessed the collection and circulation of luxury objects

intended for social and political transactions.[3] Charles V (1500–58; r. 1519–56), following the example of his grandfather Maximilian, used his remarkable collection to enhance his image for political and diplomatic ends. His most valuable and impressive objects were his Flemish tapestries, which travelled with him for public display. Among his other items were paintings and portraits, books, medals and coins, arms and trophies, clothing and gems, and relics, as well as exotica from the Indies, the most spectacular being the feather headgear belonging to the "treasure of Montezuma" presented by Hernán Cortés (Morán and Checa 1985, 47–61; Checa Cremades 2010, 1:29–35, 57–74; inventories, 1:75–834).[4] Charles had an exemplary mentor in his aunt Margaret of Austria (1480–1530), regent of the Netherlands, who raised him and who, as a savvy patron of the arts at her court in Mechelen, gathered one of the finest collections of cultural objects in northern Europe.[5] Garcilaso had seen similar but less extravagant collections belonging to Spanish aristocrats, who had become assiduous collectors of luxury objects.[6] Fadrique de Toledo, second duke of Alba, was known for the exquisite Flemish tapestries in his palace at Alba de Tormes, which Garcilaso visited frequently as a close friend of the duke's grandson Fernando. Thus when Garcilaso travelled to Italy, first to Bologna in 1529–30 as a member of the imperial entourage for Charles's coronation by Pope Clement VII, and then in 1532 for his extended sojourn, he arrived as an informed observer fully prepared to absorb the material culture of contemporary Italy and of ancient Rome.[7]

Visually striking for Garcilaso in Rome must have been the artefacts recently excavated from the ancient city. Most statues came up from the ground in fragments – torsos and detached heads, arms and legs – but a few had survived virtually intact, like the *Laocoön*, which was put on display in the papal courtyard of the Belvedere at the Vatican palace. In *Unearthing the Past*, Leonard Barkan describes its recovery in a vineyard near S. Maria Maggiore in Rome's Esquiline Hill, where several beautiful statues had been discovered. Francesco da Sangallo, son of the noted architect Giuliano, recalls that winter day in 1506, when he witnessed the excavation in the company of his father and Michelangelo:

> I climbed down to where the statues were when immediately my father said: "That is the *Laocoön*, which Pliny mentions." Then they dug the hole wider so that they could pull the statue out. As soon as it was visible everyone started to draw, all the while discoursing on ancient things, chatting as well about the ones in Florence. (cited in Barkan 1999, 3)

These early "archaeologists" look, draw, and talk. The elder Sangallo recalls the *Laocoön* "canonized" by Pliny in his *Natural History*, a work widely read by artists and poets. Others will later remember the Trojan martyr of Virgil's *Aeneid*, who prophetically admonished, "Beware of Greeks bearing gifts." This recovered antique statuary becomes a "place of exchange not only between words and pictures but also between antiquity and modern times and between an artist and another. A piece of marble is being rediscovered, but at the same time a fabric of texts about art is being restitched" (Barkan 1999, 4). The artefact not only carries a textual reminiscence, it also assumes a new role within the sixteenth century as a site of cultural discourse, a point where the present intersects with the past, and where the object inspires new texts.

Garcilaso understood the significance of the nexus between object, text, and memory in viewing Italy's monuments and retrieved artefacts. Enacting his own retrieval and his own re-stitching, he writes about objects that were for him sites of discourse and cultural exchange. If Garcilaso stayed with Pedro at the Villa Medici-Madama, the lodging designed by Raphael and used by distinguished visitors entering Rome from the north, he acquired first-hand knowledge of the courtyard's seemingly random collection of antiquities, which Heemskerck sketched (figure I.1). Those recovered artefacts invited examination and delighted viewers just as much as the prized frescoes, tapestries, paintings, and other objects found in the villas and palaces of the Italian nobility.

Two hundred years earlier, Petrarch, a poet who would exercise a decisive influence on Garcilaso, had his own encounter with material Italy as he wandered through Rome's ancient monuments with his friend Giovanni Colonna. In a letter recalling their visit, Petrarch describes what he saw through an ancient cityscape borrowed from Livy, in effect imposing on the city's ruins an imperial Rome evoked by his historical imagination (Greene 1982, 88–9; Christian 2010, 13–15).[8] Garcilaso saw a different Rome, a city that for a century had been unearthing ancient artefacts and was experiencing an urban and cultural rebirth under the Renaissance popes. This was a new cultural scene, where the eye was trained to see anew and where, as Kathleen Wren Christian writes, "Changes in the status of the visual arts, in particular, a new appreciation for the creativity and *ingenium* of artists, helped foster the idea that antique objects preserved the precious, unique inventions of gifted artists ... [Artefacts] began to live an independent life as images, valued not only for their beauty and rarity but also for their

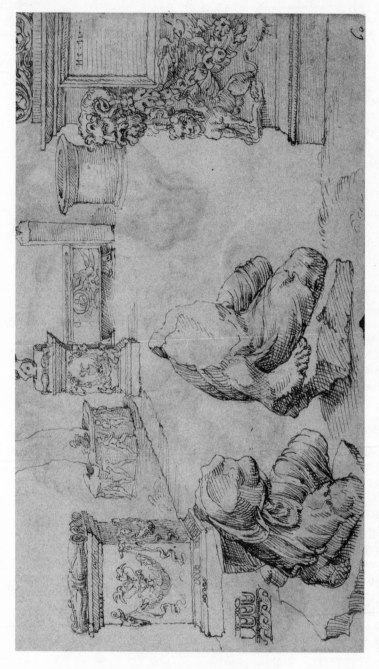

Figure I.1: *The Garden of the Palazzo Medici/Madama.* Drawing by Maarten van Heemskerck, 1532–6. Berlin, Kupferstichkabinett, Staatliche Museen. Volker H. Schneider / Art Resource, NY.

ability to inspire complex and varied interpretations" (2010, 5–6). If Garcilaso imagines objects, ancient and modern, in a way akin to Petrarch's reading of ruins in his letter to Colonna, correlating those objects with written accounts, he also is highly attuned to their material presence.[9] What Garcilaso encountered in Italy was the invitation to admire and dialogue directly with its material culture.

If Rome and the other cities he visited, like Bologna, Mantua, and Ferrara, exposed Garcilaso to storehouses of antiquities and contemporary works of art, it was Naples, above all, that nourished his intellectual life and provided him with a wealth of imagined objects from the textual sources that he and his scholar friends read and discussed. He had arrived in Italy as an exile, fresh from an island in the Danube, where he had been sent by the emperor for having served as official witness to his nephew's marriage to Isabel de la Cueva, heiress of the Duchy of Alburquerque, against the wishes of some members of her family.[10] Thanks to the intercession of Pedro de Toledo and his nephew Fernando, third duke of Alba, Garcilaso was allowed to spend his exile in Naples in service to the new viceroy. We hear the nostalgic voice of exile in the poet's first Latin ode, written in Naples and dedicated to his Neapolitan friend Antonio Tilesio: "through cold regions, student of the Muses, I learned to bear the pride and fierce costumes of the barbarians" (vv. 1–5), echoing Ovid who, banished by Augustus to the shores of the Black Sea at Tomis, complains in his *Tristia* of the "barbarians" who spoke no Latin (1996, 3.1.5–10, 5.1.5–6).

Garcilaso was luckier than Ovid, who was not allowed to return to Rome. In Naples he participated in the rich court life of the viceroy and vicereine, moved easily in aristocratic and intellectual circles, and made friends with the likes of Bernardo Tasso and Luigi Tansillo. He frequented the exclusive Accademia Pontaniana, which met after Sannazaro's death in 1530 at the villa of Scipione Capece, professor of law at the University of Naples, who dedicated his edition of Donato's commentary on the *Aeneid* to Garcilaso (1535). At the Pontaniana, Garcilaso befriended leading humanists, including Antonio Epicuro, author of *Dialogo di tre ciechi*; Bernardino Maritano, imperial secretary in Naples; the poet and critic Antonio Minturno; and Cardinal Girolamo Seripando, archbishop of Salerno. In 1535, Garcilaso would send several Latin odes with Seripando to Pietro Bembo, who wrote the poet a glowing letter praising them.[11] The poetic practices of his Italian colleagues, particularly the rewriting of classical texts, and their delicacy of style and *sprezzatura*, left their imprint on Garcilaso (Navarrete 1994,

117). The poet, who with his friend Juan Boscán had staged a revolution in Spanish letters by establishing Italianate poetics in the Peninsula, was inspired by these writers to reread the ancients as well as recent vernacular "classics," Sannazaro, Castiglione, Ariosto, Poliziano.[12] Of the ancient writers, Ovid and Virgil in particular cast a long shadow over Garcilaso. With Ovid he shared the rigours of exile, and with Virgil the pleasures of Naples, where the Mantuan poet composed the *Georgics*, began the *Aeneid*, and was buried.

Writing the Material

In this study I examine the use of objects in Garcilaso's Neapolitan poems, his most complex and sophisticated. From the abundance of objects he encountered at the imperial court and in his travels across Europe and to North Africa, he appropriated a number of iconic items (tapestries, paintings, urns, statues, musical instruments, weapons) as active participants in lyric acts of discovery and self-revelation. In her study of the material in Shakespeare, Catherine Richardson observes how in early modern England "things were seen to be useful, thought-provoking, marvellous, entertaining, capable of being surprising," good for performing emotions and, above all, "good for thinking with" (2011, 3). Early modern Spain shared in this fascination with the capacity of objects to perform, as Garcilaso's lyric production attests. The chapters that follow show how objects were powerful carriers of culture, especially those inscribed with words and images, be it a shiny crystal urn, a sumptuous tapestry, or a "tablet" within the soul. Objects, words, and images animate one another. Garcilaso uses objects for social networking, for examining the psychology of the self, for engaging cultural memory, and for exploring the interplay between orality and writing. It is at those material sites where orality is revealed as contingent and inherently unstable, where knowledge of the self is exposed as deceptive, and where, in an archive woven in cloth or carved on an urn, history intersects with the ideology of empire. The body, too, is a material site of inquiry: as a space for the investigation of melancholia, for imagining phantasmatic visions, and for celebrating corporeal beauty as a collection of fetishized body parts. This book argues that a key to understanding Garcilaso's Neapolitan poems lies precisely in his response to the material culture of the Renaissance. The dynamic introduced by objects makes Garcilaso's poems powerful exemplars of the "new poetry" of sixteenth-century Europe.[13]

Garcilaso's gathering of lyric objects finds its analogue in the Italian *studiolo*, the private chamber of wealthy aristocrats designed for reading and meditation, and a venue for displaying the taste and culture of its owner through books and artefacts (Campbell 2004, 1). Among the most lavish were the *studioli* constructed by the soldier and scholar Duke Federico da Montefeltro in his palaces between 1474 and 1483. The Urbino *studiolo* features *trompe-l'oeil* marquetry panels filled with images of objects: mirrors, lenses, an hourglass, musical instruments, armour, and heraldic devices, along with emblems, poems, and paintings – including one of Petrarch – lining the upper walls (figure I.2). Imagined objects served as cultural markers to stimulate thought and memory within the theatrical and rhetorical space of the *studiolo* (Kirkbride 2008, 5).[14] Garcilaso's discursive *studiolo* creates a similar realm of memory and the imagination where, for his cultured readers, objects like an urn-archive, a commemorative tapestry, a mythological painting, a voice-embedded lyre, or a Janus-like mirror occasion a fruitful cultural discourse. Like an actual *studiolo*, the poet's collection of imagined objects comprised a *lieu de savoir*, a place of discovery and knowledge.

Garcilaso may have seen Isabella d'Este's *studiolo* in the ducal palace in Mantua on a visit in April 1530, while travelling with the imperial court for Charles V's coronation in Bologna. The *studiolo*'s most notable collection was a group of seven paintings, anchored by Mantegna's *Mars and Venus* (1497) and *Pallas and the Vices* (1502), which were representative of an emerging genre, the mythological painting. They were "paradigmatic of *studiolo* culture around 1500," writes Stephen Campbell, "and [of] its most central and vital concerns" (2004, 121). Mantegna's paintings answered to the needs of patron and painter in re-inventing and re-imagining the classical past in new ways. In these works the painter not only reveals his "passion for ancient statuary" but connects to court literary culture and its humanist ideals by using images and themes from which the ancients themselves crafted their own poetic fables (Campbell 2004, 118, 252–3). Garcilaso shared Mantegna's and Isabella's taste for the antique and the mythological. Orpheus, Narcissus, Echo, Venus, Mars, Daphne and Apollo, Polyphemus and Galatea, Anaxarete, and river nymphs figure prominently in his poems. Reworked from the ancients and Italian humanists, and placed in material settings, myths were convenient vehicles for exploring social and rhetorical issues, the relation between the body and the psyche, and the psychic states evinced by melancholia.

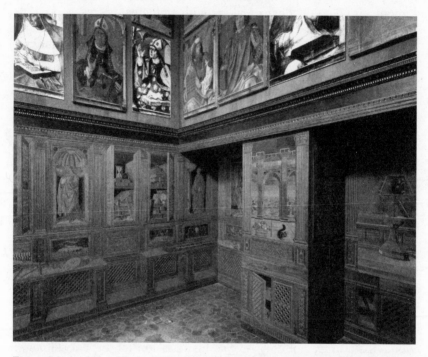

Figure I.2: *Studiolo* of Duke Federico da Montefeltro. Urbino, Palazzo Ducale. Scala/Art Resource, NY.

I have chosen the Neapolitan poems that best illustrate how the material works in Garcilaso. The chapters are arranged, not by genre or according to the conventionally accepted chronology, but as discrete studies, each engaging a set of objects cast in unique roles. I begin with tapestries, which even more than paintings were exclusive markers of refined taste and grandeur in sixteenth-century Europe. Chapter 1 examines how in the Third Eclogue, traditionally regarded as his last and most polished, the poet relates the craft of writing, remembering, and memorializing to the production and circulation of tapestries. He describes river nymphs weaving tapestries while he "weaves" his poem from earlier textual strands, in an interplay of text and textile that constructs an elaborate, self-referential stage for gift-giving and networking with the vicereine of Naples, to whom the poem is dedicated. The materiality of writing, of the written word inscribed on cloth and paper, offers a means of preserving memory and escaping the oblivion inherent in orality.

Chapter 2 examines how the battlefield of Tunis (1535) is a site of discourse for the retrieval of memory for Garcilaso and the Flemish painter Jan Cornelisz Vermeyen, who were both serving in Charles V's campaign. Vermeyen's sketches of the battle scenes became visual cues for the production of twelve tapestries, the *Conquest of Tunis*, commissioned as an official history to commemorate Charles's victory. Like Vermeyen, Garcilaso in his Sonnet 33 ("A Boscán desde La Goleta") [To Boscán from Goleta] celebrates the emperor, but through a recollection of Roman imperial victory, as he surveys the bloody fields of Tunis from the Goleta fortress. Another memory, however, the destruction of ancient Carthage, still visible in ruins near Tunis, evokes Virgilian Dido, whose fate the poet appropriates to voice his own erotic undoing. The Latin "Ode to Ginés de Sepúlveda" goes further in tempering the celebration of imperial might with the lament of Moorish women wailing from their towers, balancing in the process Sepúlveda's triumphalist reading of the campaign. And, ultimately, if placed side by side, Garcilaso's personal memories confront Vermeyen's woven memories, which were displayed as emblems of imperial power.

In a lighter vein the *Ode ad florem Gnidi* (chapter 3) recounts a rhetor's manipulation of a series of artefacts – a lyre, a viol, a shell boat, a painting, a fresco, and a marble statue – to construct an ironic discourse of persuasion. Addressed to an unyielding Neapolitan noblewoman, it encourages her to submit to her suitor, in effect to abandon the model of conduct for court ladies encoded in popular manuals like Cas-

tiglione's *Il Cortegiano*. The chapter examines how objects play pivotal roles to enchant, to mock, and finally to threaten the lady with public dissection in an anatomy theatre, the ultimate transgressive spectacle of the sixteenth century. If the *Ode ad florem Gnidi* is structured through a succession of objects, the Second Eclogue revolves around two dominant sites, a mirror and an urn (chapter 4). The mirror reflects the fractured interior world of the melancholy Albanio, while the urn's carved images celebrate the House of Alba, in particular its third duke, Fernando Álvarez de Toledo, who lives large in the public sphere of arms and imperial doings. But the poet makes those sites complicit in another project, to reveal how self-knowledge and history are mediated and contingent. The mirror fails the new Narcissus as a site of epistemological discovery, and the urn, an archive of past deeds modelled after Trajan's Column, mixes history and fiction to expose the conflicting political and ideological motives driving the emperor and the Castilian warrior Fernando. The urn's layered narrative, which migrates through different media as its carved images are interpreted, recorded, and then reported orally, ultimately reveals the instability and unreliability of the spoken word. The artifice of the performances of the mirror and the urn lies in the fact that neither yields certain knowledge, either of the self or of the past.

Chapter 5 addresses one of Garcilaso's abiding interests, the relation between the material world and the inner self, specifically under the effects of melancholia. In two sonnets the psychic dislocation caused by eros is projected onto material sites. The subject of Sonnet 11, a prisoner of debilitating melancholia, seeks solace from river nymphs living in *otium* in crystal palaces, while the pictorial imagist of Sonnet 13, who is not a melancholic, portrays the transformation of Daphne's body, and then is pulled by the force of Apollos's grief into the spectacle itself, a phenomenon I explain through Albertian perspectivism and modern film theory. In *Canción* 4 the subject materializes his disordered mental state in accordance with humoral theory and the phantasmic imagination current in the period. The subject of Sonnet 5 similarly materializes his melancholia, imagining his soul as a writing tablet on which his beloved – a scribe and a painter – "writes" herself; in a sexually charged scene, the soul dresses itself with the woman as a garment, a habit, standing for both costume and custom.

I conclude the book with Eclogue I, which stages objects for lament and mourning (chapter 6). For the abandoned Salicio, a failed Pygmalion, his beloved Galatea is harder than marble, and his voice,

though Orphic, cannot work its magic on such an unyielding substance. His companion Nemoroso imagines his dead Elisa as a set of objects that define both her and their relationship: a delicate cloth rent by death, strands of her hair bound in a white cloth, evoking a relic, and a graceful Ionic column, standing for her lovely white neck. These material reminders of the beloved anchor memory, making the absent present, no matter how illusory the act.[15]

The chapters of *Garcilaso de la Vega and the Material Culture of Renaissance Europe* move from objects in the public sphere, for social networking and for the celebration and critique of empire, to objects in the private and intimate realm of self-reflexivity of melancholy lovers and mourners. They proceed from issues relating to the project of empire, to the conduct of an aristocratic woman and the ideology of a Castilian warrior, to internalized imaginings of the self. Taken together, the Neapolitan poems analysed here represent a kind of anthology of a sixteenth-century poetic imaginary, one that absorbs and repurposes the material culture of its time within a textual inheritance so essential to Renaissance humanists.

1 Weaving, Writing, and the Art of Gift-Giving

In sixteenth-century Europe, gift-giving ranked among the most significant social practices within an aristocratic culture of consumption. Garcilaso certainly witnessed the ritual exchange of needlework, medals, and precious items like gems and jewellery at the Habsburg court, and especially of tapestries, markers of wealth, status, power, and cultivated taste. Whether they hung in the chambers of kings and nobles or in public arenas, these "woven frescoes," which were more expensive to produce and more prestigious than paintings, played a prominent role in the art, propaganda, and ceremonies of church and court.[1] In this chapter I examine the tapestries woven by nymphs in Garcilaso's Third Eclogue as lyric versions of the figurative tapestries of the period and as objects that, like many actual tapestries, served as gifts for social and political networking with patrons and powerful others, in this case María Osorio Pimentel, vicereine of Naples, to whom the poem is dedicated.[2] What makes these lyric weavings so striking is that they appear *en abîme* within a poem itself conceived doubly as a fabric: as an interweaving of textual fragments from ancient and contemporary Italian works, and as a text written on paper [carta], a sheet of matted fibre on which the poet's quill [pluma] inscribes and thus preserves the memory of María.

In an age thoroughly imbued with the dynamics of networking, making and maintaining social connections "became something of an art" that deeply implicated the self (McLean 2007, 4). Perhaps no one understood that better than Baldassare Castiglione, papal nuncio to the Spanish court (1524–9), whose book on manners, *Il Cortegiano* (1528), was translated into Spanish by Juan Boscán with Garcilaso's polishing

touches and prologue (1534). Castiglione reveals elegantly the interplay between the art of networking and the construction of the self. His courtier, far from being autonomous, shapes an identity through masks donned in staged public performances while interacting with those in high positions (1959, Book 2). Garcilaso, an equally keen observer of social manoeuvrings and gift-giving in his own circles, figures himself in the eclogue as grateful friend and flattering courtier, but also as a skilled verbal craftsman of four sumptuous tapestries for the vicereine, whose court at Naples had sheltered him during his exile from the imperial court (1532–6).[3] The poet's luxurious gifts in turn figure María as a discerning member of a literate culture.

Tapestry Culture

In the heartland of tapestry production in the Low Countries and Northern France skilled artisans crafted the most expensive and highly sought weavings in silk, and silver and gold thread that circulated throughout France, England, Italy, and Spain.[4] Tapestries were an ideal medium of ostentation to parade monumental images of ancestors, military campaigns, and historical or mythological figures with which a patron wished to be associated (Campbell 2002, 15). The most affluent patrons commissioned sets of related tapestries, called "chambers," which typically covered a room's interior walls from floor to ceiling. An engraving by Frans Hogenberg, c. 1558, *The Abdication of Charles V* (figure 1.1) shows how a chamber of tapestries set the stage for that historic event: Charles is surrounded by his heraldic devices – most prominently the stag – and behind him hangs his coat of arms, below which is inscribed "Carolus Caesar." Marketing visual imagery for propaganda, just as his grandfather Maximilian had done so successfully in his own time, Charles exploited the symbols embedded in the tapestries to enhance imperial authority on behalf of his son Philip and his brother Ferdinand, who would carry Habsburg rule forward.[5]

As a member of Charles's court, Garcilaso would have been familiar with these imperial trappings, especially when displayed conspicuously on festive occasions at home and abroad, notably during the emperor's coronation by Pope Clement VII in Bologna in 1530, which the poet witnessed. At a time when royal households itinerated seasonally and for political reasons, tapestries became the ultimate transportable emblem of wealth and power, as essential to a Christian prince as his

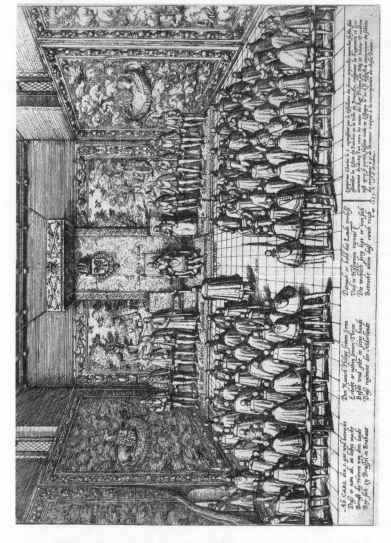

Figure 1.1: *The Abdication of Charles V* from *Events in the History of the Netherlands, France, Germany and England between 1535 and 1608*. Engraving by Frans Hogenberg, c. 1558. The Elisha Whittelsey Collection. The Metropolitan Museum of Art, NY. © The Metropolitan Museum of Art / Art Resource, NY.

portable altars. An inventory taken in 1544 of Charles's Removing Wardrobe, as portable tapestry collections were called, listed fifteen sets comprising ninety-six tapestries, the most prized being the spectacular nine-piece chamber *Los Honores* (1520s), an allegorical celebration of Habsburg values and a kind of "mirror for princes" because of its moral content (Delmarcel 2000). The seven-set *Battle of Pavia*, commemorating Charles's victory over Francis I (1525), was one of the most important chambers in the imperial collection. For the wedding of Prince Philip to Mary Tudor (1554), Charles sent his twelve-piece *Conquest of Tunis* tapestries to hang in Winchester Cathedral. That formidable set, a visual tour de force, celebrated Habsburg prestige and magnificence (see chapter 2). But if the display of tapestries indexed a ruler's status and authority, the lack of tapestries reflected just the opposite. When in 1527 Stephen Gardiner, bishop of Winchester, visited Pope Clement VII, then in exile in Orvieto following the sack of Rome, it was the absence of tapestries that first drew his attention. "Before reaching [the pope's] privy chamber," he reported, "we passed three chambers all naked and unhanged" (cited in Campbell 2002, 4). Living within bare walls, the pope was as undressed of authority as his chambers were of tapestries.

Nymphs' Weavings

The Third Eclogue's four discursive tapestries, like a chamber of actual hangings, are linked by style, iconography, and subject matter: the violent loss of a loved one and an abandoned, grieving lover in the mythological tales of Apollo and Daphne, Orpheus and Eurydice, Venus and Adonis, and the pastoral story of Elisa and Nemoroso. They recall the decorative hangings known at the time as verdures and now often called millefleurs. Characterized by foliage arranged in "repeating patterns of flowers and plants, enlivened with animals and figures in more elaborate pieces," they made up the majority of tapestries in quotidian use, particularly in private, intimate settings (Campbell 2002, 24). The *Diccionario de Autoridades* offers the plural "verduras" for these designs: "Llaman en los paises, y tapicerías el follage, y plantage, que se pinta en ellos" [Called in paintings (of villas, country houses, or countryside) and tapestries the foliage and plants that are painted in them]. Garcilaso plays with the technical term in the singular "verdura" to describe the stylized, bucolic setting of the banks of the Tagus, where the nymphs execute their craft:

Cerca del Tajo, en soledad amena,
de verdes sauces hay una espesura
toda de hiedra revestida y llena,
que por el tronco va hasta el altura
y así la *teje* arriba y encadena,
que'l sol no halla paso a la *verdura*.

[Close by the Tagus, in pleasing solitude,
there is a stand of willows, a dense grove
all dressed and draped with ivy, whose multitude
of stems goes climbing to the top and *weaves*
a canopy thick enough to exclude the sun,
denying it access to *green leaves* below.] (vv. 57–62, my emphasis)

"Verdura" is joined by the metatextual "teje," by means of which nature weaves its own thick, complex patterns, in effect crafting for itself the shade requisite for the *locus amoenus*, that intimate, private space of *otium* and creativity. The ground is covered with flowers: "el suave olor d'aquel *florido suelo*" [the subtle scents arising from the *flowery field*] (v. 74; my emphasis). "Verdura," "teje," and "florido suelo" announce a kinship between the textual setting and actual millefleurs tapestries, presaging the plant and floral weavings fictionally destined for María's quarters: the snake, which bites and kills Eurydice, lies hidden in the grass and flowers [entre la hierba y flores escondida] (v. 132); the blood oozing out of Adonis's chest, torn open by the boar's tusk, turns red "the white roses growing on the site" [las rosas blancas por alli sembradas] (v. 183); and the decapitated Elisa, metaphorically echoing the floral setting, "cuya vida mostraba que habia sido/antes de tiempo y casi en flor cortada" [whose life has clearly been cut short before its day,/ just as the bud was coming into flower] (vv. 227–8), appears in a flowery spot (v. 229), lying among the blades of green grass (vv. 231–2).

Millefleurs were eminently suited for a vicereine in accordance with contemporary tastes in weavings, their placement in private vs. public spaces, and in certain cases gender-based themes as the following anecdote suggests. When Philip the Fair and Juana of Castile visited the Château de Blois in 1501, they found it filled with tapestries and cloths of all types. Louis XII had hung his *grande salle* with *The Destruction of Troy* and his dining room with *The Battle of Formigny*, scenes celebrating military events, much like Charles V, who displayed tapestries to

reflect his imperial status and magnificence for political purposes. By contrast, the queen, Anne of Brittany, had her private quarters at Blois hung with tapestries akin to millefleurs, depicting "beasts and birds with people from distant lands," while her daughter Claude had her room hung with "a very beautiful bucolic tapestry filled with inscriptions and very small figures" (Guiffrey 1878, 67). In Naples, according to an inventory taken in 1553, the palaces of the vicereine and her husband were richly decorated with hangings, including millefleurs.[6] When the ambassador from Mantua, Nicola Maffei, visited the capital in 1536, he found the walls of Castel Nuovo covered with tapestries: "tapezarie fine et bellisime et vanno attacate fin alla volta delle camere" [elegant and most beautiful tapestries were hung up to the vaulted ceilings of the rooms] (cited in Hernando Sánchez 1993, 51). Most likely the vicereine did needlework – a sister art to weaving – much like her contemporaries Catherine de Medici in France and Mary Queen of Scots, who typically went about their stitching while engaged in conversation (Jones and Stallybrass 2000, 153). Empress Isabella of Portugal was also known for her needlework.[7] There is as well a bond between the vicereine and Garcilaso's nymphs, who appear in Sonnet 11, "labrando embebescidas/o tejendo las telas delicadas" [bowed over your embroidery,/or toiling at the weaver's delicate art], taking pleasure in one another's company, "unas con otras apartadas/contándoos los amores y las vidas" [sitting in little groups apart/making your loves and lives into a story]. A millefleurs tapestry dated circa 1520, now in the Musée de Cluny (figure 1.2), offers a splendid pictorial play *en abîme* illustrating how aristocratic ladies pursued their pastime: one embroiders a millefleurs scene, while another carries skeins of yarn and a convex mirror, which reflects the very setting that is the subject of the embroidery.

Garcilaso knew that for tapestry making, only the highest level of craftsmanship and the finest materials, gold being the most luxurious and expensive of threads, were worthy of a vicereine. His nymphs fabricate their tapestries from the riches of the Tagus River, transforming nature into culture by turning its grains of gold and aquatic plants into thread, and by dying their yarn with the purple of its shellfish:

> Las telas eran hechas y tejidas
> del oro que'l felice Tajo envía ...
> y de las verdes ovas, reducidas

en estambre sotil, cual convenía,
para seguir el delicado estilo
del oro, ya tirado en rico hilo.
 La delicada estambre era distinta
de las colores que antes le habían dado
con la fineza de la varia tinta ·
que se halla en las conchas del pescado.

 [The fabric of the cloth that they were weaving
was made from gold the happy Tagus gives ...
and also made from the strands of green waterweed,
converted into a fine yarn, which serves
to complement the delicate style that's bred
from gold spun out into a precious thread.
 The threads they worked were delicate and fine,
subtly colored with many tinctures,
using the various shades one can obtain
from their origin in shells of the sea's creatures.] (vv. 105–6, 109–16)

The gold of the Tagus was legendary – it is mentioned in Pliny's *Natural History* and cited by Ovid and Martial, among others (Morros 1995, notes to vv. 105–8, pp. 229, 518) – but purple dye (the most desirable being from Tyre) was no doubt added by Garcilaso to glorify the fertile river. The poet likens the artistry of the weaver nymphs to that of the ancient Greek artists Apelles and Timanthes (vv. 117–20), a comparison justified by the coupling of painting and weaving: "lo que pinta/y texe cada ninfa" [what each nymph paints and weaves] (vv. 117–18).[8] The term "pintar" [to paint] appears here as a Latinism, according to Leo Spitzer, since "*pingere* was used in Latin also of embroidery" (1952, 246). Erwin Panofsky notes that in sixteenth-century Latin the terms *pingere, pingi,* and *pictus* refer "to a graphic representation, drawing or print, in contradistinction to a sculpture or metal" (1951, 34, note 1). If we follow Panofsky's lead, "pintar" (placed alongside "texer") draws our attention to the cartoon, a drawing used in the weaving process. Thomas Campbell alerts us to its meaning: "Full-scale colored version of the intended designs that weavers copy during weaving. Generally painted on linen until the late fifteenth century. From the early sixteenth century on, cartoons were painted mostly in body color on paper" (2007, 397). Garcilaso does not mention a weaving technique, but we

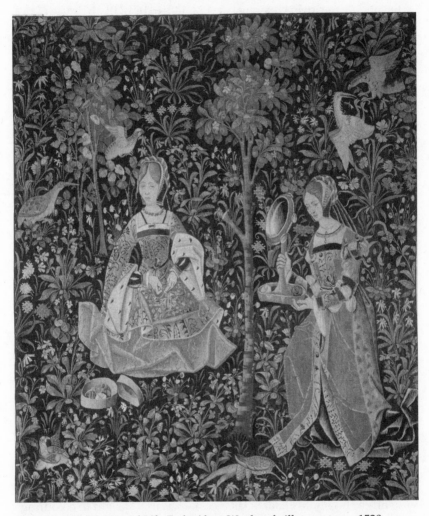

Figure 1.2: *The Seignorial Life: Embroidery*. Wool and silk tapestry, c. 1520. Southern Netherlands. Paris, Musée national du Moyen Age-Thermes de Cluny. © RMN-Grand Palais/Art Resource, NY.

may suppose that, given their mythological origin, his nymphs did not use cartoons as guides to weave their pieces.

Beyond dexterity in weaving (vv. 122, 145–6, 169–70), their use of perspectivism serves as a touchstone of the skill of these artisan-weavers, who are well-versed in Renaissance artistic codes:

> Destas historias tales varïadas
> eran las telas de las cuatro hermanas,
> las cuales con colores matizadas,
> claras las luces, de las sombras vanas
> mostraban a los ojos relevadas
> las cosas y figuras que eran llanas,
> tanto, que al parecer el cuerpo vano
> pudiera ser tomado con la mano.

> [Such are the varied stories that were told
> in the fine tapestries of these four sisters,
> who joined their colors in an artful blend,
> with highlights that from the empty shadows
> brought forward, as if standing in the round,
> objects and figures that were flat and so
> you'd think that empty forms were solid and
> could actually be taken in the hand.] (vv. 265–72)

Perspectival depth, achieved through *chiaroscuro* to produce a sense of three-dimensionality, was a valued technique for oil paintings and tapestries alike. Giorgio Vasari, writing from his experience as a tapestry designer, has this in mind when he describes what was required: "[F]or pictures that are to be woven ... there must be [a] ... variety of composition in the figures, and these must stand out one from another, so that they may have strong relief, and they must come out bright in colouring and rich in the costumes and vestments" (1996, 2:571). In the eclogue's tapestries, shaded colours [con colores matizadas] converge with bright highlights [claras las luces] – Vasari's "bright in colouring" – to provide an arresting visual display for the vicereine.

Tapestries as Gifts

By virtue of their portability and splendour, tapestries made for convenient, lavish gifts. When Don Juan, heir apparent to the Spanish throne,

died in 1499, his widow, Margaret of Austria, left Spain with her collection of tapestries and a parting gift of twenty-two others from Juan's mother, Isabel of Castile (Sánchez Cantón 1950, 91, 108–9). That gift, we may suppose, had a diplomatic as well as personal value. Isabel had arranged the marriage of Juan to Margaret and of her daughter Juana to Maximilian's son and heir, Philip the Fair, for a double wedding celebrated in 1496. Aware of the need to reaffirm her political alliance with Margaret's father, she found the ideal objects for gift-giving in her large collection of tapestries, acquired through inheritance, purchase, commission, and as gifts (Sánchez Cantón 1950, 89–150; Junquera 1985, 22–5; and Junquera de Vega 1970, 16–22).

If a soldier and courtier like Garcilaso could not have afforded such an expensive material gift, an inspired poet could "weave" a set of tapestries worthy of the wife of his patron and protector, Pedro de Toledo, viceroy of Naples. Fernando Bouza documents the early modern practice of gift-giving as a way of keeping friendships and as a sign of deference, a social custom that was defined as "service": "Generosity was a virtue to be displayed at all times by the [courtier], who, devoid of self-interest ... generously *served* those whom he regarded as his equals or friends or those to whom he was indebted: his superiors or others who had rendered him service with the same generosity" (2007, 153; emphasis in the original). Located at the intersection of history and fiction, art and court society, Garcilaso's cloth gifts were tokens of friendship and gratitude for the vicereine and her husband, who (with his nephew Fernando Álvarez de Toledo, third duke of Alba) had successfully convinced the emperor to trade the poet's exile on an island in the Danube for exile in Naples; there, Garcilaso made friends with aristocrats and leading humanists, like Bernardo Tasso and Luigi Tansillo, and attended the exclusive Accademia Pontaniana. Pedro also recommended Garcilaso for the post of chatelain of Reggio, which Charles readily granted.[9] But, as Sharon Kettering points out, the notion of "service" in the giving of a gift, seemingly a "courtesy" freely offered by the donor, was a "polite fiction" (1988, 135). Something of what Marcel Mauss observed about gifts in archaic societies – items of exchange requiring reciprocity – applies here, for Garcilaso's tapestry gifts were not totally disinterested. In theory, according to Mauss, gifts are "voluntary, [but] in reality they are given and reciprocated obligatorily." Apparently gratuitous, they call for a return (1990, 3).[10] Garcilaso's verbal weavings are as much exquisite gifts for past hospitality and protection as tokens for the future, a gesture from the nimble-minded

courtier to noble friends to keep him in their thoughts for when he might need them again.[11] And of course these magnificent presents would enhance his status and prestige at the Neapolitan court.

Gift-giving functions as a highly personal transaction in that it creates an intimacy, ingratiating one person to another. Mauss writes that a gift bears the "soul" or "spirit" of the giver, the *hau* in Maori gift rituals – "to make a gift of something to someone is to make a present of some part of oneself … In this system of ideas one clearly and logically realizes that one must give back to another person what is really part and parcel of his nature and substance, because to accept something from somebody is to accept some part of his spiritual essence, of his soul" (1990, 12). If we demystify the magical quality of Mauss's gift exchange, we might say that Garcilaso's "hand made" gift did indeed embody him, for his tribute to María bears the craftsman's artifice as a seal, an "imprint" of his identity. The symbolic link between the giver and his gift creates in turn an intimate bond between the courtly giver and his aristocratic recipient.[12] Garcilaso's gifts to María, probably sent from Provence, where he wrote the eclogue while "maestre de campo" [aide de camp] of the emperor's troops facing the army of Francis I, recall the "portrait letters" of the period. In his study of letter-writing customs of the European nobility, Bouza notes that for those separated by long distances, a handwritten letter was "a second-best substitute for private conversation," and that customarily a portrait accompanying the letter as a gift served as a "personal contact" to reaffirm a relationship (2007, 154). Bouza cites the letter and self-portrait that Philip II sent to Francisco Barreto in thanks for his support in capturing the rock of Vélez de Gomera in 1564. "I did not know how to pay and thank you," writes the king, "but by sending you a portrait of myself on a chain in order that I be bound to you every day of your life, for whatever you wish" (2007, 151). The gesture of sending a letter and "himself" in a portrait makes the king's presence "doubly felt" (2007, 154). Garcilaso's poem sent from a great distance is a kind of letter, containing his personal imprint within verbal tapestries so that he will "be bound" to the vicereine.

Inscribed within the fourth tapestry woven by the nymph Nise is a snapshot of special significance: the topography and cityscape of Toledo, "la más felice tierra de la España" [the happiest region of the whole of Spain] (v. 200), where Garcilaso was born. The famous Tagus [el claro Tajo] (v. 197), reified through ekphrasis, is pictured bathing the land, circling the mountain on which the old buildings of the imperial city stand majestically:

Pintado el caudaloso rio se vía,
que, en áspera estrecheza reducido,
un monte casi alrededor ceñía ...
Estaba puesta en la sublime cumbre
del monte, y desd'allí por él sembrada,
aquella ilustre y clara pesadumbre
d'antiguos edificios adornada.

[The mighty river in her picture's seen
reduced at this point to a rocky narrows,
surrounding almost on all sides a mountain ...
Perched on the lofty brow of the great hill
and scattered down its slopes on every side,
was that incomparable and weighty pile,
with many an ancient edifice supplied.] (vv. 201–3, 209–12)

The celebrated river irrigates the countryside "con artificio de las altas ruedas" [with the ingenious aid of water-wheels] (v. 216). If not a self-portrait, Garcilaso sends the next best thing, a poignant material recollection of a place of origin. And more poignant still, now that both he and María are in foreign lands fulfilling Charles's calling, the poet in the emperor's army on the field of battle in Provence, the vicereine at the Neapolitan court in service to the imperial administration. That bit of nostalgia is announced in the eclogue's dedicatory stanzas, where Garcilaso tells María about his longing for the homeland and for all that he holds dear, revealing early in the poem, albeit obliquely, his desire to connect with her at an intimate level: "la fortuna .../ya de la patria, ya del bien me aparta" [fortune ... now separates me from my country, now from all that is good and safe] (vv. 17–19) Within the context of Italian-Spanish rivalries, the bringing of Spain's illustrious city to Neapolitan soil represents a triumphant gesture of imposing the Spanish presence in Italy, reinforcing the textual competition implicit in Garcilaso's imposing a "weft" of Castilian words on Italian antecedents, as noted below.

The Poem as Fabric: Weavers and Writers

Roland Barthes's well-known observation that "etymologically the text is a cloth; *textus*, from which text derives, means 'woven'" (1979, 76), resonates in the eclogue with an almost literal sense: the nymphs are weavers, as is the poet, who "weaves" with words. This comple-

mentarity, anchored in the poem on the word "texer" [to weave], echoes an ancient link between text and textile. "By the first century BCE *texere* no longer meant simply to weave or braid but could also mean to compose a work. From the first century CE on, the word *textus* took on its modern sense of 'written text,' yet it remained common in the lexicon of weaving: *textor* (weaver) ... *textum* or *textura* (fabric or textile)" (Chartier 2007, 86). In the eclogue, "texer" appears both materially in the making of each tapestry ("lo que pinta/y *texe* cada ninfa" [what each nymph paints and weaves]) (vv. 117–18) and metaphorically in the speaker's scriptural weaving, which combines pieces from ancient texts with fragments from contemporary Italian works to compose stories in the vernacular.[13] A dramatic example is Eurydice's death, where Garcilaso transforms and expands in implicit competition clipped renditions of scenes from Ovid and Virgil with rewritings of images from Ariosto's *Orlando furioso* and Sannazaro's *Arcadia* (Barnard 1987a, 318–19).

John Schied and Jesper Svenbro write about this cross-cultural appropriation in Roman literature in terms of a textual "weaving" applicable to the eclogue:

> When Catullus writes his poem on the wedding of Peleus and Thetis, his "weaving" has meaning connected to the occasion of the poem and the symbolism of the nuptial fabric, of course, but inevitably the poem-fabric also becomes a fabric on an "intercultural" level. It is a place where two cultures meet. And here, it is as if Catullus were using a Greek warp – the traditional basis for his poem – into which he introduces his own Latin woof, as if the best text were made of a Greek warp and a woof of Latin words. (1996, 145)

The nuptial fabric, a coverlet placed on the marriage bed of Peleus and Thetis, is inscribed with the story of Theseus and Ariadne (Catullus 1988, 64.50–264). Like the coverlet, the nymphs' tapestries serve as a thematic occasion and symbol of the eclogue's own textual fabric, the point at which cultures meet, a warp of Greco-Roman mythology and Italian subtexts intersecting with a weft of Castilian words. Texts and textiles naturally call forth the instruments and the "authors" who produce them: the poet "weaving" his intercultural discursive cloth with a pen parallels the nymphs' "writing" stories with a shuttle as pen.

If in the sixteenth century, the needle was primarily a woman's tool for composing narratives in fabrics, needlework being a sign of

aesthetic virtuosity and even a way of making political statements, the shuttle belonged to the male world of industrial production in tapestry workshops (Jones and Stallybrass 2000, 148–71, 94). Yet the eclogue's weaver nymphs, who "write" their stories with shuttles, belong to a literary tradition, a product of an ancient textual memory. They find precedents in the lovely Virgilian naiads of *Georgics* 4, who appear "spinning fleeces of Miletus, dyed with rich glassy hue" (1999, 1:4. 334–5). Filódoce [Phyllodoce] and Climene [Clymene] are cited here by name (1:4. 336, 345).[14] Ovid's *Metamorphoses*, a popular exemplar for literature and textiles in the sixteenth century, offers even closer antecedents, Philomela and Arachne, who "write" their stories with the shuttle as pen. The Ovidian tales, like those told by the eclogue's nymphs, are violent narratives, and distinctive in that the mythological weavers, like the naiads, are eminently skilled. Philomela is raped by her brother-in-law, the Thracian king Tereus, who cuts off her tongue with his sword to silence her. Her tongue "faintly murmuring" on the dark earth (1984, 6.558) signals her alienation from speech. Weaving a tapestry for her sister Procne to "read," a victim becoming a master in her telling, she chooses materials that represent the brutality of her rapist and her bloody mutilation: "She hangs a Thracian web [*barbarica tela*] on her loom, and skillfully weaving *purple* marks [*purpureas* notas] on a white background, she thus tells the story of her wrongs" (1984, 6.576–8; my emphasis).[15] Lydian Arachne, for her part, after challenging Pallas Athena to a contest, weaves tales of deceit and seduction committed by the gods against mortals. Like the goddess, she works warp and weft with "well-trained hands" (6.60), deftly blending threads of gold (6.68) and Tyrian purple with lighter colours (6.61–2), details that resonate in the fabrics of the eclogue's nymphs. Arachne's tapestry is "flawless," but she is punished for her presumption. Pallas strikes her with a shuttle and then, in pity, transforms her into a spider, the very emblem of her delicate art (6.129–45). Like Ovid's *ekphrases* of Philomela and Arachne's tapestries, Garcilaso's verbal representations of his nymphs' tapestries are not "finished products" but "*ekphrases* in the making." In contrast to Sannazaro's Eurydice tapestry in the *Arcadia* 12 (1966, 135–6) or the tapestry celebrating Hippolytus d'Este's deeds in Ariosto's *Orlando furioso* (2008, Book 46), Garcilaso presents the nymphs in the very act of weaving their cloths, bringing the stories alive for his spectator, the vicereine of Naples.

Garcilaso's mingling of ancient and contemporary cultures, connecting as he does the world of luxurious textiles with classical myth

reimagined within a court setting, finds a suggestive pictorial ana-
logue a century later in Diego Velázquez's recreation of the myth of
Arachne in *Las hilanderas* (*The Spinners*, c. 1655–60) (figure 1.3). In the
painting's foreground appear humble spinners working their wool.[16]
But what interests me here is the courtly scene in the brightly lit back-
ground, where Arachne and a helmeted Pallas Athena, similarly
dressed, stand centre stage in front of a tapestry and, anachronisti-
cally, in the presence of three seventeenth-century aristocratic women
in elegant clothing. The tapestry, which portrays the rape of Europa
(one of the "celestial crimes" woven by Ovidian Arachne in her own
tapestry), is a copy of Titian's painting of the same subject, housed at
the time in the royal collection at the Alcázar (Brown 1986, 252).
Jonathan Brown notes that the tapestry is a tribute to Titian, the favou-
rite painter of Charles V and Philip II. By "quoting" Titian, Velázquez
celebrates painting as the noblest and most transcendent art: "Titian is
equated with Arachne, and Arachne could 'paint' like a god" (Brown
1986, 253). Arachne, however, does not "paint," she "weaves" like a
god. If the tapestry is an homage to Titian the painter, as Brown sug-
gests, it is a more distinctive homage to Arachne the weaver, who
within Velázquez's painterly fiction weaves her loom like Titian paints
his canvas, implicitly with equal skill, reminiscent of Garcilaso's weav-
er nymphs whose own artistry [artificio], as noted above, is celebrat-
ed by its identification with that of the Greek painters Apelles and
Timanthes. Velázquez stages "[Titian's] design into the more luxurious
and costly world of textiles. Velázquez himself was keenly aware of
the significance of textiles and of other costly goods in the production
of the court and the courtier" (Jones and Stallybrass 2000, 102). The
painter captures a social scene that could well have been the vicere-
ine's own at her Neapolitan court. A chamber of tapestries covers the
walls (only the Europa and a strip of another hanging are visible) and
the three finely dressed noblewomen admire the display, two of them
chatting as in a typical court event. The vicereine, an admirer of tapes-
tries and a collector in her own right, belonged to this world of luxury
and magnificence, and by extension to the practice of the shuttle as a
metaphorical pen.

Javier Portús reads Velázquez's painting as a reflection on the na-
ture of artistic imitation and competition that suggestively connects
with Garcilaso's lyric "weavings." Portús comments on how Rubens,
one of Philip IV's favourite painters, imitates and "corrects" Titian's
Rape of Europa by using colour for narrative purposes (2005, 78;

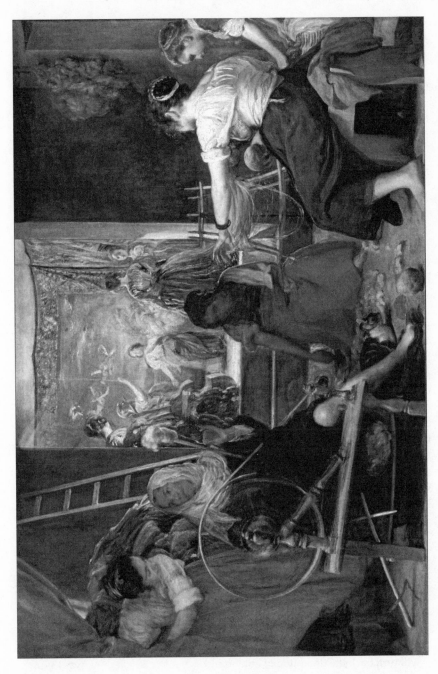

Figure 1.3: Diego Velázquez, *Las hilanderas*, c. 1655–60. Madrid, Museo del Prado. Erich Lessing / Art Resource, NY.

Rubens's painting on 75). Velázquez likewise supersedes his sources through his own use of colour and a complex spatial and narrative structure (along with iconographic details such as the spinning wheel in the foreground, representing the illusion of movement) (79–80). In this context, we may ask: Is Garcilaso, in his own way, trying to compete with and outdo the tapestry makers of his time by "weaving" for the vicereine his own artistic creations as inspired gifts from a humble poet/soldier? If the world of tapestries was María's domain, she belonged as well to the world of the actual pen and its special fabric, paper.

Pen on Paper

The eclogue's dedication is a rich discursive space containing another type of fabric and another occasion for praise and networking. Despite the poet's Orphic voice celebrating the vicereine in two lines inspired by Virgil – "mas con la lengua muerta y fria en la boca/pienso mover la voz a ti debida" [for with the tongue cold and dead in my mouth/I aim to raise the voice I owe to you] (vv. 11–12) – it is the poet's pen and its fabric, paper, that will record both voice and María's fame. In the Virgilian source, *Georgics* 4 (1965, 1:523–7), Orpheus's head, torn from his body by the Maenads, floats down the Hebrus River, "its voice and death-cold tongue" singing the name of Eurydice, who was lost to the underworld. Recast in Garcilaso's vernacular, the Latin fragment is animated for the self-representation of the lyric voice as an Orpheus figure and for a celebration that calls into action a magical act of memory. The tongue that gives birth to song belongs to the son of Calliope, the muse who possesses the gift of song, and the daughter of Mnemosyne, goddess of Memory. The new Orpheus in his own katabasis will use his voice to still the waters of oblivion, the river Lethe, in order to keep María's presence alive in historical memory:

libre mi alma de su estrecha roca,
por el Estigio lago conducida,
celebrando t'irá, y aquel sonido
hará parar las aguas del olvido.

[my soul, when freed from its narrow prison
and ferried over the waters of the Styx,
will sing of you, and the sound it gives out then
will turn back the flood tide of oblivion.] (vv. 13–16)

The poet further promises María that Apollo and the muses will bestow on him "ocio y lengua" [leisure (*otium*) and a tongue] to praise her (vv. 29–31). María's memory, however, will be preserved not by the tongue, the instrument for composing song, but by pen and paper, the authorial tools for textual production. Garcilaso mentions in a typical *recusatio* how the duties of the soldier take him away from celebration through pen and paper: "y lo que siento más es que *la carta*/donde *mi pluma* en tu alabanza mueva,/poniendo en su lugar cuidados vanos,/ [fortuna] me quita y m'arrebata de las manos" [and what troubles me most is that *the page* (paper)/*my pen* ought to be filling with your praise/ (fortune) snatches from my hand …/replacing it with unprofitable cares] (vv. 21–4; my emphasis). But *carta* and *pluma* already appeared implicitly at the beginning of the dedication, where the poet turns to epideictic, the rhetoric of praise, for an encomiastic "ilustre y hermosísima María" [illustrious and most beautiful María] (v. 2). María, the wife of an eminent imperial official, was important in her own right in carrying the lineage of the marquisate of the Osorio Pimentel. Her official title was Marquise of Villafranca del Bierzo, which she brought to the viceroy by marriage. The pen is mentioned once again in the memorable "tomando ora la espada, ora *la pluma*" [taking up now the sword and now *the pen*] (v. 40, my emphasis) in the field of battle, where Garcilaso writes his textual gift to María. The self-conscious staging of pen and paper ("carta" meaning paper, according to its Latin etymology [Morros 1995, 225]) against song and voice illustrates what Roger Chartier sees as a major concern of the period, the desire to record what was in danger of obliteration:

> [S]ocieties of early modern Europe … preserved in writing traces of the past, remembrances of the dead, the glory of the living, and texts of all kinds that were not supposed to disappear. Stone, wood, fabric, parchment, and paper all served as substrates on which the memory of events and men could be inscribed. In the open space of the city or the seclusion of the library, in majesty in books or in humility on more ordinary objects, the mission of the written was to dispel the obsession with loss. (2007, vii)

Understood in this context, Garcilaso's written word rescues the vicereine from the instability of commemoration through voice and song.[17] Her memory is materialized, inscribed by the author's quill on the surface of the paper – a kind of fabric made from linen and cotton rags – then printed in the ubiquitous chap-books [pliegos sueltos], and ultimately in a book.

The tension between oral and written discourses reminds us that the lyric speaker is the product of a written culture. And if *he* is a writer, the vicereine is above all a reader, and if *carta* is understood to mean letter as well as paper, the eclogue acts as an epistle, sophisticated and erudite in its classical import, read in the privacy of her chambers. Placed in the world of learning and the pen, where she is lauded for her beauty and high worth [valor], María is also praised for her "ingenio" [ingenium] (vv. 3–4), meaning here intelligence and excellence of mind, traits customarily reserved for men, as in "hombre doctor y de ingenio agudo" [a learned man of acute intellect] (*Diccionario de Autoridades*). This is not the first time that Garcilaso flatters a woman for her intellectual acumen. In his letter-prologue to Boscán's translation of Castiglione's *Il Cortegiano*, he similarly flatters Jerónima Palova de Almogávar, following the example of Giuliano de' Medici, who in his defence of the *donna di palazzo* [the court lady], calls on her to assume the virtues of the male courtier, among them wit and "knowledge of letters" (1959, 3.211). In praising Jerónima's courtly virtues, including her intellectual qualities, Garcilaso assures her that the book she convinced Boscán to translate is worthy of being in her hands [merece andar en vuestras manos] (Boscán 1994, 75), that is, worthy of being read by her, its success now guaranteed by virtue of her very reading.

Garcilaso's praise runs counter to the conduct manuals that advised women to shun learned texts and the pen in favour of religious books and the needle as signs of virtue. In his *Árbol de consideración y varia doctrina* [*Tree of Consultation and Varied Teaching*, 1548], the canon Pedro Sánchez writes about this feminine ideal of behaviour: "She should pray devotedly with a rosary and if she knows how to read, she should read devotional books and books of good doctrine, for writing must be left to men. She should know how to use a needle well and how to use a spindle and distaff, having no need for the use of a pen" (cited in Bouza 2004, 60). Garcilaso distances himself from this type of moral preaching as well as from counter-prescriptions of court poets like Ariosto who, seeking patronage from noblewomen, reversed the preference for textiles over writing in his *Orlando furioso*, praising instead "the women poets of Italy for leaving 'the needle and the cloth' for the fountain of Aganippe on Parnassus, proving that Italy could produce more poets like Vittoria Colonna" (Jones and Stallybrass, 2000, 142). Garcilaso does a double turn. While placing María as participant and spectator in the nymphs' world of the needle and the shuttle, the poet locates her as well in the erudite world of the pen, as a reader for a

distinctive act of networking. If we recall Barthes's observation, mentioned above, that "etymologically the text is a cloth" (1979, 76), and that networking in its own etymology points to the enterprise of fabric-making in cloth – "work in which threads ... or similar materials are arranged in the fashion of a net; especially a light fabric made of netted thread" (*OED*) – text, textile, and networking become fused for a celebratory inscription of the writer as a poet-craftsman. In his flattery and praise of the vicereine, he joins Castiglione's courtier as a skilled performer of court manoeuvres.

A Precarious Figuration

Garcilaso's reassuring identity crafted in artifice and networking within a tapestry culture is not the whole story, for the violent narratives complicate the configuration of an identity based squarely on these cloths as gifts. Another poetic self emerges: a vulnerable one centred on "lengua," Orpheus's tongue, the bodily organ that is the locus and emblem of voice and song. Speaking from a severed head swirling down the Hebrus, Orpheus's tongue stands for both the power of voice and its fragility. Thus its restaging in the eclogue, as the lyric I appropriates it to become an inspired verbal artist, involves a double movement: the tongue that sings María and the tapestries also conjures up an act of precarious voicing that culminates in the fourth tapestry, the scene of the decapitated Elisa and her epitaph, written by a mourning nymph on the bark of a poplar tree, whose letters speak on her behalf, "que hablaban ansí por parte della" (v. 240):

> "Elisa soy, en cuyo nombre suena
> y se lamenta el monte cavernoso,
> testigo del dolor y grave pena
> en que por mí se aflige Nemoroso
> y llama: 'Elisa,' 'Elisa'; a boca llena
> responde el Tajo, y lleva presuroso
> al mar de Lusitania el nombre mío,
> donde será escuchado, yo lo fío."

> ["I am Elisa, and to my unlucky name
> the cave-infested mountain echoes and moans,
> witness to the grief, the overwhelming pain
> Nemoroso must suffer on my account:

'Elisa,' he calls out, and 'Elisa' again
Tagus intones, as it rushes swiftly on,
bearing my name to the Lusitanian sea,
to where it will be heard, I can safely say."] (vv. 241–8)

The pastoral convention of carving letters on bark shares in the practice
of carving inscriptions on funerary monuments designed to preserve
the memory of the dead in stone.[18] The eclogue's epitaph, incised on
wood as if on a tombstone, preserves the memory of Elisa in a public
space. It is addressed to a literate pastoral community, the shepherds
being, as the genre dictated, courtiers in disguise. If the memory of the
vicereine is directly inscribed and preserved on paper [carta], that of
the dead Elisa is inscribed and preserved on multiple surfaces: the epi-
taph's words are carved on wood and recorded by Nise on cloth, in the
manner of a tapestry's cartouche, which the poet transcribes onto pa-
per. And yet, encased *en abîme* within these material objects, Elisa's
voice, which had been ventriloquized by the epitaph's "speaking" let-
ters, betrays a profound fragility as it recedes into a polyphony of voic-
es, with first the mountain, then Nemoroso, and finally the Tagus
echoing her name. Elisa's name becomes a disarticulated utterance mir-
roring her decapitation. Orpheus's decapitation by the Maenads and
bodily scattering, present subtextually, strengthens the sense of vio-
lence and vulnerability. Chartier argues that one of the missions of the
written is to preserve "remembrances of the dead" (2007, vii). Here
Nise inscribes Elisa's "lamentable cuento" [dreadful tale] (v. 257) in her
tapestry to make it known on land and beyond:

quiso que de su tela el argumento
la bella ninfa muerta señalase
y ansí se publicase de uno en uno
por el húmido reino de Neptuno.

[she wanted the story of her tapestry
to signal the beautiful dead nymph,
so that the news would spread from mouth to mouth
throughout Neptune's humid realm.] (vv. 261–4)

What is "published" in the tapestry – and recorded by the poet – is not
only the news of Elisa's death, but the loss of the beautiful nymph

through violent death: her delicate, decapitated body lying like a white swan among the grass and flowers (vv. 229–32).[19]

A fragile, personal lament is thus projected through the mediating screen of the tapestry, a space where figures take on bits of discourse, which stand for a disguised lyric self-reflection. In the eclogue, Garcilaso offers María another memorable gift, a vulnerable self, the voice of loss, now encased in a lovely weaving: an intimate gesture in networking from a soldier skilled with the sword that decapitates and a poet whose pen captures decapitation intrinsic to both war and eros.

2 Empire, Memory, and History

In June 1535 Emperor Charles V arrived with a grand armada at Tunis to engage the Berber pirate Kheir-ed-Din Barbarossa, admiral of Sultan Suleyman the Magnificent's fleet, who had been raiding the coasts and disrupting Christian shipping in the western Mediterranean.[1] Still visible near Tunis were the ruins of ancient Carthage, Rome's most powerful naval rival, which the Scipios had conquered (202 BCE) and destroyed (146 BCE). Expecting no less a victory, Charles brought with him a "cultural and commemorative entourage" of humanist scholars, historians, and artists to produce an official record of the event, in effect to treat the battlefield of Tunis as a site of discourse for celebrating his campaign in multiple media.[2]

The most impressive visual account of the campaign is a set of twelve tapestries, the *Conquest of Tunis*, designed by the Flemish artist Jan Cornelisz Vermeyen from drawings he made at the scene, recounting the main stages of the expedition. My analysis of those magnificent tapestries will establish the historical, political, and cultural backdrop to two poems written by Garcilaso, a soldier in the imperial army who was, like Vermeyen, an eyewitness to the campaign: Sonnet 33, "A Boscán desde La Goleta" [To Boscán from Goleta], written to his friend ostensibly from the captured fortress, which guarded the entrance to Tunis, and a Latin ode, composed later in Naples and addressed to the Spanish philosopher and historiographer Juan Ginés de Sepúlveda.

Tapestries and poems, originating from the same place, time, and event, provide a notable example of how different media process the intersection of history, memory, and the ideology of empire. Memory served as the primary means for crafting the visual and textual

representations of the Tunis campaign, with a visual image becoming a mnemonic device, a mental tool or a "machine for thinking" [machina memorialis] that stimulates and inspires recollection for invention and composition (Carruthers 1998, 16). Thus recollection through memory cues is critical to the creative process.[3] But "forgetting," too, is an integral part of recollection, a special type of forgetting that involves the retrieval of memory in a deliberate act of selection and omission (1998, 54–7). What is codified in the tapestries and in Garcilaso's poems are in fact selectively constructed representations. For Vermeyen, the creative process of recollection began a decade after Tunis in the Netherlands, where he turned his drawings into cartoons for the manufacture of the tapestries, which conveyed the official account of the campaign. For Garcilaso, the process began in Tunis at the Goleta, where ancient history and Virgilian legend combine to inspire meditations on empire and love, which continued in Sicily after the battle, and later in Naples. Vermeyen and Garcilaso drew on material cues for their recollections, the artist consulting his drawings sketched at various locations during the campaign, and the poet looking at the bloody battlefield of Tunis, the nearby ruins of Carthage, and the imagined ashes of Carthaginian Dido. Both artist and poet commemorate the emperor and his ideology, while at the same time resisting the grand imperial narrative of conquest.

An Archive in Cloth

All of Vermeyen's drawings from the Tunis campaign are lost (with one exception, as noted below), but ten of the twelve large-scale cartoons he made from them survive in the Kunsthistorisches Museum in Vienna, and ten of the twelve tapestries are preserved in the Royal Palace, Madrid. Together, the cartoons and tapestries make for a stunning visual record of the expedition. The tapestries were produced as part of a publicity campaign orchestrated in the late 1540s on the emperor's behalf by his sister Mary of Hungary, regent of the Netherlands (1505–58), and by the emperor's adviser, the Flemish cleric Antoine Perrenot de Granvelle (Kagan 2009, 67). Using visual media for propaganda was not new. Emperor Maximilian I (r. 1486–1519) had orchestrated an effective campaign to celebrate his political ideology and enhance his personal prestige through images. But the propaganda campaign undertaken for Charles was particularly ambitious. It included an equestrian portrait by Titian commemorating the victory at Mühlberg over

the Protestant League (1548), a bronze statue of Charles by Leone Leoni (c. 1555), and the publication of Luis de Ávila y Zúñiga's *Comentario de la guerra de Alemania hecha por Carlos V* (1548), which "represented Charles as a new and improved version" of Charlemagne (Kagan 2009, 68). The tapestries commemorating the Tunis expedition were the most costly and extravagant component of that campaign.

From Drawings to Tapestries

In June 1546 Mary of Hungary signed a contract with Vermeyen for the execution of the cartoons, which were sent to the workshop of Willem de Pannemaker, the leading weaver in Brussels. Between 1549 and 1554 Pannemaker produced a set of twelve tapestries made of wool, silk, gold, and silver. Two of the tapestries, the eighth and the eleventh, are lost but their content is known through extant cartoons. The twelve-set chamber recounts the entire Tunis campaign, from the emperor's sailing from Barcelona through the battles at the Goleta fortress and at the Wells, to the capture and sack of the city of Tunis, and ending with the departure of the imperial forces. The tapestries are "the most important expression in art of [Charles's] Idea of Empire," notes Hendrick Horn, who has made the most extensive study of them; they were "intended to rival the major monuments of Roman military art in [their] function as a visual archive" (1989, 1:xi).[4] As was customary for narrative tapestries and similar works in other media, the woven images are accompanied by inscriptions to guide the viewer in the proper understanding of the scenes.

The tapestry series begins with *The Map of the Mediterranean Basin* (figure 2.1), leaving no doubt as to the political and religious dimensions of the military undertaking. Encased within a cartouche and prominently displayed at the bottom of the tapestry is a Latin verse caption that reads:

> Wishing to overcome the infidel armies of the Turk and the warrior [Barbarossa] who, obeying the orders of Suleiman, raises cruel war against the realms of Spain, Caesar, Charles the fifth of that name, gathers together with the blessing of heaven the armies and fleets of Spain and Italy to threaten the African troops. Not brooking delay while time and the hour proceed, he energetically hastens to his ships and his loyal companions.[5]

Latin, the language of erudition and elegance – witness Lorenzo Valla's handbook of Latin language and style entitled *Elegantiae linguae Latinae*

Figure 2.1: *The Map of the Mediterranean Basin.* First tapestry of the *Conquest of Tunis* series. Designed by Jan Cornelisz Vermeyen. Woven in Brussels by Willem de Pannemaker (1549–54). Madrid, Palacio Real © Patrimonio Nacional.

(1441) – and the basis of the *studia humanitatis*, was for the early moderns also the traditional language of nobility and celebration, as here in praise of Charles, the new Caesar, and of empire. The message of imperial conquest is expanded in two longer captions written in the vernacular at the top of the tapestry and on the lectern, behind which Vermeyen stands, ostensibly as the cartographer who is explaining his map. The Castilian texts are no less noble and no less authoritative than the Latin, conforming as they do to Antonio de Nebrija's prescription in his *Gramática de la lengua castellana* (1492), "language has always been the companion of empire" (1992, 13). Nebrija takes a cue from Valla's influential *Elegantiae*, which linked language and empire, "wherever the Roman language is, there, too, is Roman power [imperium]" (I:2) (cited in Kagan 2009, 16). Nebrija counselled Queen Isabel of Castile: "After Your Highness takes under her yoke many barbarian towns and nations with strange tongues, and with the conquering of them, they will need to receive the laws that the conqueror puts on the conquered and with those, our language" (1992, 16). Imposing his "law" and the Castilian language on the "barbarians" was not Charles's purpose in Tunis, as it would be in the New World.[6] Yet through the tapestry inscriptions – which give the official history and explain the images of the defeated – Charles does impose the Castilian language, albeit symbolically, on the conquered at Tunis and, by extension, on his enemies elsewhere. The performative value of the tapestries was demonstrated in 1554, shortly after being woven, when they were sent to hang in Winchester Cathedral as backdrop for the wedding of Charles's son, Prince Philip, to Queen Mary Tudor, daughter of Henry VIII and Catherine of Aragon (the emperor's aunt). There, in their first public display, the tapestries served as political and religious propaganda, with the Castilian language prominently staged as a signature and stamp of imperial power and prestige, just as Nebrija had prescribed. Representing Catholic Charles, and so the royal couple, the tapestries must have been an affront to anti-Catholic factions at court, which were plotting against the queen, later dubbed Bloody Mary for her execution of many of her Protestant enemies. The tapestries' narrative of imperial conquest served as a forceful and unmistakable message to the English.

Vermeyen the Cosmographer and Visual Journalist

In the first tapestry Vermeyen presents himself as a cartographer (a cosmographer in the language of the day) with a compass held in his right

hand, as if lecturing on the map that appears to his right; his words are inscribed in a cartouche on the front of the lectern.[7] His left hand resting on the lectern points to the legend at the top, the miles and leagues. The map captures that momentous occasion when the emperor and his armada leave Spain for Tunis, and his allies depart from other ports. The point for viewing the spectacle is Barcelona, the port of departure for Charles and his entourage, including Vermeyen.[8] Every detail of the tapestry is selected to celebrate the campaign as an official history created through images. Particularly eye-catching are the armada's galleys and caravels, which are not merely decoration, as in period maps, but function here as carriers of culture and power, the very emblems of *translatio imperii* at the core of the campaign. They are transporting Charles and his troops to impose a Habsburg *pax Christiana* on North Africa. As if to reinforce that message, Charles's device, the columns of Hercules surrounded by a banderole with the motto *Plus Oultre* [Further Beyond], appears in the tapestry's borders, the French pointing to its origin in the Burgundian court in 1516. The emperor's device functions as a stamp in the image-making of official imperial history, reversing Hercules's own *Non plus ultra* and the meaning of his pillars, signifying boundary markers for sailors and a warning not to venture beyond the Straits of Gibraltar into dangerous ocean waters. Charles's device signals instead his mission to go beyond the columns, to expand his empire. As Earl Rosenthal points out, "Plus Oultre ... was charged with the sense of a Promethean daring for many contemporaries, and, obviously the Herculean motif of the Columns evoked the idea of the heroic or chivalric, but the religious and geopolitical implications were dominant" (1973, 230). Those implications resonated in the mid-century years, when the strong Protestant presence in the eastern part of the Habsburg Empire coincided with Turkish advances into the West.[9]

Having mapped the imperial project, Vermeyen presents himself in other tapestries as a visual "journalist" in the field, notably in the tenth tapestry, the *Sack of Tunis* (figure 2.2), where he appears prominently with notebook and pen in hand, the instruments of the skilled draughtsman, recording the scenes around him and listening intently to a friend, who according to Horn may be Felipe de Guevara, fellow artist and eventual author of a treatise on painting, *Comentarios de la pintura*, c. 1560 (1989, 215). Tiny portraits of Vermeyen appear in the third tapestry, *The Landing off the Cape of Carthage* (he is in a rowboat disembarking near the Goleta), the fourth, *Skirmishes on the Cape of Carthage* (he is seated drawing in front of the Water Tower between two imperial soldiers shooting their muskets), and the sixth, *The Quest for Fodder* (again

seated among the soldiers with notebook on his lap), suggesting that the artist observed events and drew scenes from different perspectives, which later in the Netherlands became the basis for his cartoons. Distance in time and space is a requisite for recollection, but distance also establishes what Carruthers posits as key for creation in memory: the field drawings become visual cues that evoke scenes for the composition of a pictorial narrative in the cartoons, then in the tapestries. The drawings, moreover, function as an "inventory," a "memory store" essential to creativity. "Having 'inventory' is a requirement for 'invention,'" writes Carruthers. "Not only does this statement assume that one cannot create ('invent') without a memory store ('inventory') to invent from and with, but it also assumes that one's memory-store is effectively 'inventoried,' that its matters are in readily recovered 'locations.' Some type of locational structure is a prerequisite for any inventive thinking at all" (1998, 12). Speaking of art images as a "chamber" for remembrance and invention, Lina Bolzoni arrives at a similar conclusion. She reminds us that memory "*becomes* the actual chamber of the treasure, the place where a unique collection has been deposited" (2001, xxiv; emphasis in the original). Bolzoni tells an evocative anecdote from Teresa of Ávila, who "wishing to find an image that will enable her to remember and articulate ... the condition of her soul in the moment of mystical union with God, will compare it to the small chamber where the duchess d'Alba kept her treasures" (2001, xxiv). Vermeyen's collection of drawings, conceived as memory stores or a chamber of "treasures," is the starting point for the translation of sketches into a set of cartoons, whose re-crafted images are the basis for an even more powerful representation, the woven images.

Vermeyen is evidently the primary author of this pictorial enterprise. His self-portrait in the tenth tapestry presents him as such, an imposing figure of noble bearing and high stature, carrying the tools of his trade and dressed in splendid clothing: elegant cape, stockings, feathered cap, and sword, as if he were a gentleman in the European court fashion of the late 1540s (figure 2.3). This self-portrait (along with the tiny others mentioned above) is his stamp of authorship, a visual inscription and signature by which he takes possession of his work as author and authority.[10] His anachronistic costume, quite out of place on the field of a battle that took place a decade earlier, serves as a material marker for the very distance requisite for the author's creative act of memory.

Yet Vermeyen was not the sole "author." If cartoons and tapestries were produced by a layering of images and memory, authorship, too, is

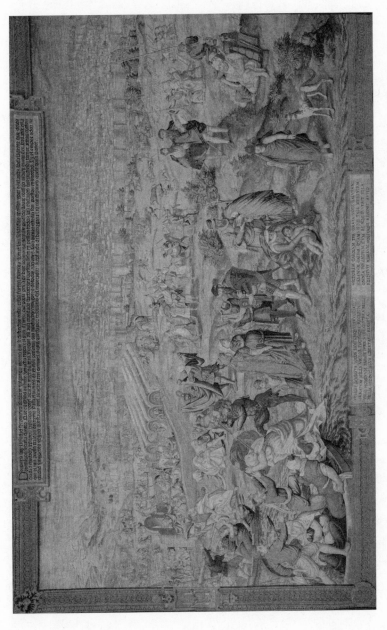

Figure 2.2: *The Sack of Tunis*. Tenth tapestry of the *Conquest of Tunis* series. Designed by Jan Cornelisz Vermeyen. Woven in Brussels by Willem de Pannemaker (1549–54). Madrid, Palacio Real © Patrimonio Nacional.

Figure 2.3: *The Sack of Tunis*, detail of Vermeyen in the battlefield with Felipe de Guevara.

a layered affair. Documentary and stylistic evidence point to Pieter Coecke van Aelst (1502–50), one of Charles's court artists and a skilled tapestry designer, as having helped Vermeyen execute some of the cartoons. Correspondence between Mary of Hungary and Charles offers strong evidence to that effect.[11] Aside from the shared composition of the images, the tapestries' inscriptions were added by a still different hand. Horn suggests that the explanatory captions were written by Alonso de Santa Cruz (1989, 1:178), cosmographer and professional historian who wrote a lengthy chronicle of the emperor's life and deeds, *Crónica del Emperador Carlos V* (1550–2). There is another "author" of the tapestries, none other than the emperor himself, who approved the preliminary sketches (the *modelli*) from which the cartoons were made. And finally, de Pannemaker and his master weavers, as is well known, made changes to the cartoons as they wove the tapestries. The tapestries were thus products of a complex process, with multiple "voices" sharing in the creation: the artist's direct observation (the drawings), his later selections (preliminary drawings and cartoons), contributions by the cartoonist, Pieter Coecke, inscriptions added by the court historian, and technical modifications introduced by the master weavers.

If the production of Vermeyen's tapestries translated the artist's sketches into official political memory, it also resulted in the "loss" of memory through an authorized act of forgetting. The seventh tapestry, the *Fall of Goleta* (figure 2.4), which depicts the emperor's superior naval power at the taking of the Goleta fortress, relates official imperial history at its most glorious. But Vermeyen had prepared other, less celebratory scenes in preliminary drawings not approved for the tapestries. The one surviving drawing, perhaps intended for the cartoon of the tenth tapestry, the *Sack of Tunis*, is now in the Rijksmuseum in Amsterdam. It opens a window into the personal voice of the artist, a private moment in which he comments on the atrocities of war committed during the massacre at Tunis (figure 2.5). Karel Boon describes it: "In the foreground a Tunesian [sic] man and woman who have been robbed and massacred: beyond women being assaulted and captured by soldiers. In the background the walled city of Tunis" (cited in Horn 1989, 1:17). Although Vermeyen in his capacity as court artist represented the official machinery of empire, here, as a private witness, he draws the scene of massacre, in effect a "counter memory" to the officially sanctioned version of events embodied in the final cartoons and tapestries. But that personal visual record becomes a "forgotten memory," marginalized by the imperial enterprise and Charles's personal

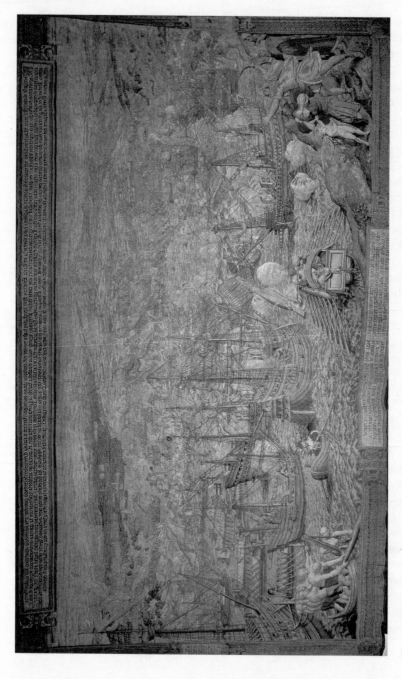

Figure 2.4: *The Fall of Goleta*. Seventh tapestry of the *Conquest of Tunis* series. Designed by Jan Cornelisz Vermeyen. Woven in Brussels by Willem de Pannemaker (1549–54). Madrid, Palacio Real © Patrimonio Nacional.

Figure 2.5: Preliminary drawing intended for the ninth or tenth tapestry of the *Conquest of Tunis*. Pen and brown ink with grey wash, c. 1545. Amsterdam, Rijksmuseum, Prentenkabinet.

victory. Could Felipe de Guevara, if he is indeed the figure gesturing in the tenth tapestry as Horn suggests, be telling Vermeyen about the massacre, perhaps registered in the artist's quizzical look, his frowning eyebrows subtly capturing an event of such enormity for the Tunisians and his own private concern?[12]

The tapestries, with their visual history of the Tunis campaign, resemble the urn of the Second Eclogue, with its inscribed friezes memorializing the deeds of the dukes of Alba (see chapter 4). The urn's friezes, carved in private by the River Tormes, were rendered public through a process of reading and deciphering, writing, and oral retelling. The tapestries likewise were crafted in private through the selection, omission, and layering of memories before assuming their public form as weavings. Once completed, the tapestries served as a monument to Charles, as a site of official memory in which the captions – as in any public monument – inscribed an authorized history.

Unearthing Carthage

Garcilaso's Sonnet 33, "A Boscán desde La Goleta," also conceives the Tunis campaign in terms of empire, with Charles as a new Scipio Africanus. Like the tapestries, products of selected, retrieved memories, the sonnet is embedded with layers of cultural and historical memory extending back to the destruction of Carthage, Rome's commercial and naval rival, and to the legendary self-immolation of Dido, the Virgilian queen abandoned at Carthage by Aeneas in his pursuit of empire. But unlike Vermeyen, who created his drawings and later cartoons as an official record of the Tunis expedition, ultimately for a public display of imperial might, Garcilaso penned his sonnet to his friend as a personal testament.

Garcilaso may have taken part in the capture of the Goleta, which guarded the channel to the city of Tunis. As recorded in his memorable Sonnet 35, "A Mario" [To Mario], Garcilaso was wounded on his right arm and tongue in a skirmish with the enemy, shortly before the taking of the fortress.[13] Writing from the Goleta, as announced in the title, he is a spectator like Vermeyen, recording his own version of events, with the weapons, blood, and fire of the battlefield serving as memory cues for a layered meditation on the binaries Tunis/Carthage, Charles/Scipio, Dido/Aeneas:

> Boscán, las armas y el furor de Marte,
> que, con su propia fuerza el africano

suelo regando, hacen que el romano
imperio reverdezca en esta parte,
 han reducido a la memoria el arte
y el antiguo valor italïano,
por cuya fuerza y valerosa mano
África se aterró de parte a parte.
 Aquí donde el romano encendimiento,
donde el fuego y la llama licenciosa
solo el nombre dejaron a Cartago,
 vuelve y revuelve amor mi pensamiento,
hiere y enciende el alma temerosa,
y en llanto y en ceniza me deshago.

[Boscán, the arms and fury of Mars, which, watering the African soil with
 its own strength, make the Roman Empire flourish once again in this
 region,
have brought back to memory that art and ancient Italian valor by
 whose strength and valorous hand Africa was leveled from end
 to end.
Here, where the Roman torch, where fire and licentious flame left to
 Carthage nothing but a name,
love turns and turns again my thought, wounds and inflames my fearful
 soul, and in tears and in ashes I am undone.]

The sonnet engages cultural and historical memory primarily through
an imperial and textual *translatio*. In a layering of two material sites
drawn for Juan Boscán's "eyes," the bloody fields of modern Tunis are
superimposed on the ancient city of Carthage, its ruins within sight of
the Goleta, depicted in the sixth tapestry, *The Quest for Fodder* (fig-
ure 2.6). The weapons of Mars, animated in service to empire – like the
Third Eclogue's "entre las armas del sangriento Marte" [amidst the
weapons of bloodthirsty Mars] (v. 37) – bathe the African soil with
blood, and awaken a memory of ancient Roman victories: "han redu-
cido a la memoria el arte/y el antiguo valor intalïano." In a memory
within a memory, "valor italïano" sparks a recollection not only of a
transference of Roman imperial might to North Africa but of an impe-
rial celebratory tradition built upon history, mythology, and legend,
which makes Charles implicitly an early modern version of the Scipios:
Scipio Africanus (the Elder), who conquered Carthage in the Second
Punic War (202 BCE), and Scipio Aemilianus (Scipio Africanus the
Younger), who destroyed it (146 BCE), bringing to fruition Cato the

Figure 2.6: *The Quest for Fodder*. Sixth tapestry of the *Conquest of Tunis* series. Designed by Jan Cornelisz Vermeyen. Woven in Brussels by Willem de Pannemaker (1549–54). Madrid, Palacio Real © Patrimonio Nacional.

Elder's famous declaration "Cartago delenda est" [Carthage must be destroyed]. The exaltation of Charles is anchored in a spurious genealogy invented to root the Habsburg dynasty in the Roman past, in its emperors and heroes, including Trojan Aeneas (Tanner 1993, 109–30). This official image-making aligns Garcilaso's text with Vermeyen's artistic production, as in the first tapestry's identification of Charles with Caesar. The iconography of the Titian painting and the Leoni sculpture, which belong to Mary of Hungary's propaganda campaign, is particularly relevant here. In Titian's equestrian portrait, *Charles V at Mühlberg* (1548), Charles is identified with Emperor Marcus Aurelius (figures 2.7 and 2.8), and in Leoni's gigantic bronze statue, *Charles V Conquers Fury* (c.1555), with Aeneas (figures 2.9). We may recall that this false genealogy was exploited for political and personal gain. To flatter the emperor during his visit to Mantua (25 March–19 April 1530) following the coronation in Bologna, Federico Gonzaga had painter and architect Giulio Romano decorate the Sala del Imperator in the Palazzo del Té with frescoes of Charles's "ancestors," Scipio Africanus, Caesar, and Alexander (Mitchell 1986, 147, and Tanner 1993, 116), featuring a familiar rhetoric of conquest.[14] Garcilaso, travelling with the imperial court, surely must have seen those historical frescoes.

Evoked auspiciously at the sonnet's *volta* in a resounding "aquí" [here], is another layer of memory and a new allegiance, Virgilian legend, to bind the shared geography of contemporary Tunis and ancient Carthage: "vuelve y revuelve amor mi pensamiento" [love turns and turns again my thoughts]. Leaving behind celebratory genealogy by *not* invoking Aeneas, Garcilaso melds in pained recollection his erotic torching ("en llanto y en ceniza me deshago" [in tears and ashes I am undone]) with the wounded and burning body of Dido, who kills herself after being abandoned by the Trojan hero. As Aeneas sails to Italy in order to fulfil the prophecy of empire, she climbs in tears onto the "high pyre" and falls on his sword (Virgil, *Aeneid* 1999, 4.645–65). In an important essay, José María Rodríguez García examines at length the political significance of the sonnet and its Virgilian source. He argues that Garcilaso turns from epic to lyric: "the poetic voice begins by echoing the ideology of imperial Rome, and ends by paying homage to Dido's feelings and words when she kills herself in an orgy of ashes, tears, and blood"; at the end he "sings from where she sang and with words that *could be* hers" (1998, 154, 161; emphasis in the original). But Dido already appears implicitly in the "epic" section of the quatrains in the terms "regando" and "reverdezca." These ironic references to the

Figure 2.7: Titian, *Charles V at Mühlberg*, 1548. Madrid, Museo del Prado. Scala/Art Resource, NY.

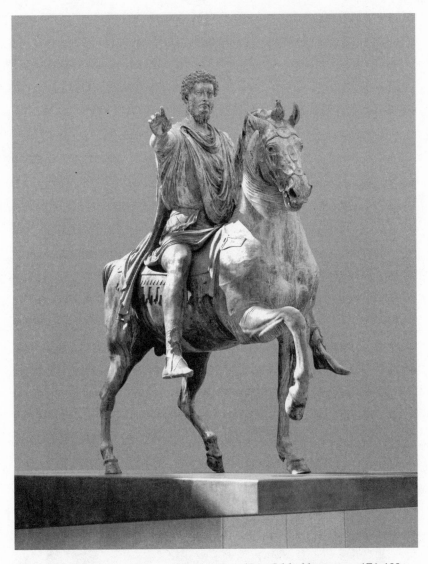

Figure 2.8: Equestrian Statue of Marcus Aurelius. Gilded bronze, c. 176–180 CE. Rome, Palazzo dei Conservatori, Musei Capitolini. © Vanni Archive/Art Resource, NY.

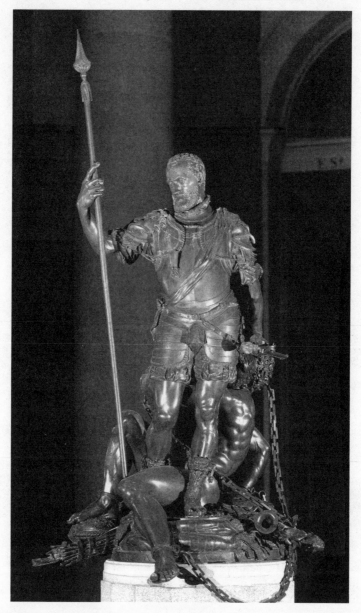

Figure 2.9: Leone Leoni. *Charles V and Fury Restrained*. Bronze
sculpture, c. 1555. Madrid, Museo del Prado. Album/Art Resource, NY.

blood bath, through which empire flourishes in North Africa, bring to mind the fallen Carthaginian queen, her undoing echoed and reinforced in the annihilating "romano encendimiento" [Roman conflagration] and "fuego y llama licenciosa" [fire and licentious flame] of the first tercet, which announce her subtextual presence in the final tears and ashes. Epic and lyric are conjoined at the very site of Roman, and now Habsburg, torching and bloodletting.[15]

If in the Goleta sonnet the subject speaks "with words that could be" Dido's, and takes on imagined ashes (the queen's material remains) for his self-representation, in Sonnet 10 the subject seems to appropriate Dido's voice once again to "sing" his erotic undoing:

¡Oh dulces prendas por mi mal halladas,
dulces y alegres cuando Dios quería,
juntas estáis en la memoria mía
y con ella en mi muerte conjuradas!

¿Quién me dijera, cuando las pasadas
horas que'n tanto bien por vos me vía,
que me habiades de ser en algún día
con tan grave dolor representadas?

Pues en una hora junto me llevastes
todo el bien que por términos me distes,
lleváme junto el mal que me dejastes;

si no, sospecharé que me pusistes
en tantos bienes porque deseastes
verme morir entre memorias tristes.

[O sweet mementoes, unfortunately found,
sweet and also, when God willed it, happy!
You live together in my memory
and, with memory conspiring, plot my end.

When in those times, now forever fled,
your presence was such happiness to me,
how could I imagine you would be
with such a pain as this revisited?

Since in one moment you took it all away,
the happiness you'd given over time,
take away too this pain that you have left me;

or else I shall suppose you only showed me
such happiness because it was your aim
among sad memories to see me die.]

Before her suicide, Dido addresses the garments Aeneas left behind: "O sweet relics [dulces exuviae] once dear, while God and Fate allowed, take my spirit, and release me from my woes!" (1999, 1:4.651–2). These objects are tangible reminders of the absent Aeneas, at once triggering and preserving memory, and like true relics, inspiring meditation and veneration. Garcilaso's subject selects Dido's "dulces exuviae" to recreate (as in Sonnet 33) a layered scenario of a memory within a memory, textual and historical, which in the poem's lack of referentiality we may construe as a lover's own history. The anonymous sweet mementoes [dulces prendas] are mnemonic devices that stimulate recollection, as in the *Aeneid*, while actively conspiring with memory – the very mechanism that brings them "to life" – to cause the subject's death. In a sense the "dulces prendas" are a site of memory or his undoing.

We might also think of Sonnet 10 as a re-imagination of Dido's final moments, as her voice is adopted by the lyric subject as his own. That is Richard Helgerson's insight, which prompts his question: "What does it mean for Garcilaso to take as his own Dido's dying words, as in the sonnet from Carthage he takes as his own her dying posture in tears and ashes?" (2007, 54). Echoing Andrew Lipking, Helgerson concedes that "inhabiting" the abandoned Dido, Garcilaso voices "the emptiness of empire," recognizing in the process that lyric is "an inevitable part of epic" and that "imperial self-making entails a *me deshago*, an undoing that speaks for the victims of empire." Yet even if Garcilaso "speaks for" these victims, he feels a deep ambivalence about war and Charles's imperial agenda. José Antonio Maravall insists on Garcilaso's dislike of a military profession that was his by lineage and whose practice legitimated his privileges (1986, 19). Garcilaso, writes Maravall, "muestra un despego indisimulado hacia la pretendida gloria de la guerra y honor … [D]etesta la guerra porque no le deja ser lo que es, alcanzar lo que anhela" [Garcilaso reveals an unveiled detachment towards the alleged glory and honour of war … [H]e dislikes war because it does not let him be what he is, to achieve what he longs for] (1986, 18). And yet in this detachment Garcilaso does not seem to be against Charles's imperial ideology as such – he does celebrate the emperor on several occasions – but against war's excesses and brutality, especially when committed against lovers.[16]

The Excesses of War

In two elegies that serve as a kind of preface to the "Ode to Ginés de Sepúlveda," and written in the aftermath of the Tunis campaign, with

the conquered city and legendary Carthage still fresh in his memory, Garcilaso addresses the issue of war's excesses and its cost to lovers. Composed in Trapani, the Sicilian port where the returning imperial army was resting, the Second Elegy recalls briefly for Boscán the recent victory, "debajo de la seña esclarecida/de César Africano" [under the illustrious banner of the present-day African Caesar] (vv. 4–5), and the greed and hypocrisy of many of the soldiers. Recognizing that he has transgressed, for his is not "satire" but an elegy, he continues writing, but now of love and, at length, of the possible loss of his Neapolitan beloved, perhaps the one who sparked the erotic flames in Sonnet 33. In words similar to the sonnet's last line, he writes that a long absence such as his can turn love into "dust and ashes" [en polvo y en ceniza] (v. 62). In an angry apostrophe to Mars, "endurecido siempre en toda parte" [always hardened in every part] (v. 96), and so dressed in his typical "diamond tunic" (v. 95), Garcilaso asks: "¿Qué tiene que hacer el tierno amante/con tu dureza y áspero ejercicio,/llevado siempre del furor delante?" [What has the tender lover to do with/your callousness and savage occupation,/unceasingly spurred on by a mad fury?] (vv. 97–9), knowing full well that war will bring the now familiar undoing: "reducido a términos que muerte/será mi postrimero beneficio" [I am reduced to such a state that death will/seem to me a final benediction] (vv. 101–2).[17]

He addresses explicitly war's excesses in his First Elegy, a funeral elegy dedicated to Fernando de Toledo on the death of his brother Bernaldino, in which he recalls the losses inflicted by war and the exile it imposes:

¿A quién ya de nosotros *el eceso*
de guerras, de peligros y destierro
no toca y no ha cansado el gran proceso? ...

¿De cuántos queda y quedará perdida
la casa, la mujer y la memoria,
y d'otros la hacienda despendida. (my emphasis)

[Which of us now's not hurt by *the excess*
of wars, of danger and of banishment?
Who is not weary of the endless process? ...

How many have lost, will lose, their wife, their home
and their good name and how many others
will see their estate plundered or dispersed?] (vv. 82–4, 88–90)

In his Latin "Ode to Ginés de Sepúlveda" written in Naples sometime between November 1535 and March 1536 (Rivers 1974, 479), Garcilaso again reveals the excesses of war, its victims represented by Tunisian women who warn their young husbands against Charles. Although the emperor is the protagonist, the poem conveys a searing, and sobering, message to Sepúlveda, an avowed apologist for Charles and his imperial agenda, whom Garcilaso had met in Bologna at the imperial coronation (1530), when the Spanish humanist and chronicler was a member of the papal court. The ode begins with praise of Sepúlveda's *Democrates primus* (1535), which reconciles war with Christian teaching, and then alludes to the chronicler's *De bello Africo* [On the African War], an account celebrating the victory at Tunis and Charles as the saviour of Christianity (Kagan 2009, 75).[18] Sepúlveda portrays Charles as soldier and as general, leading his troops with fearless courage [intrepido animo].[19] Garcilaso's text revisits that flattering treatise in an apostrophe ("to you alone, learned Sepúlveda, it befits you to tell of fearful Africa under an intrepid and pious king," vv. 5–6), and embellishing the account, with Horatian and Virgilian echoes offering an epic subtextual base (Lumsden 1947a, 340 and Morros 1995, 252), he sings of Charles in the "African trembling" (vv. 6–7), "mounted on his famous pied stallion" (v. 9) and "brandishing the deadly lance in his hand" (vv. 11–12). This is Charles displayed yet again as the exalted emperor warrior – like the new Scipio Africanus of the Goleta sonnet and the African Caesar [el César Africano] of the Second Elegy (v. 5) – an iconic image that anticipates the Caesar of the Tunis tapestries and Titian's equestrian painting of Charles with a lance at the battle of Mühlberg.

Evoking the killing fields at Tunis, Garcilaso locates imperial weapons centre stage once again, though not through allusion to the arms of a god of war standing in for Habsburg military might, but by placing them in Charles's grip in order to hone more urgently and concretely the move from celebration of empire to empathy for its African victims. The shift occurs when young Moorish wives scan the battleground from their high towers – much like Garcilaso's own scanning of the bloody fields of Tunis from the heights of Goleta – to warn their husbands against Charles's weapons: "Oh young men avoid with your unequal strength the arms of Caesar and their unholy encounters!" (vv. 25–7). Garcilaso does not mention the gratuitous massacre at the city of Tunis, but the image of Charles as a fierce lion stalking "peaceful beasts" (vv. 17–20) hints at the atrocities.[20]

Garcilaso's scene of the anguished Moorish wives yields a performance as heartfelt as Vermeyen's preliminary sketch of a massacred woman and man lying on the battlefield of Tunis. Here Tunis becomes a site of memory, not for a moment of self-reflection that determines a subjectivity in pained dissolution (as in the Goleta sonnet or Sonnet 10), but for a different kind of pain and a different kind of voice, the collective voices of Moorish women, who speak as if, through their words, they could re-appropriate their space to prevent further bloodshed. Their encounter with Charles stages a devastating portrait of the emperor within the tradition of genealogical myth-making. Having "read" their history, they recall the emperor's Roman lineage, his eponymous ancestor, the ancient Caesar, and his unnatural bloodsoaked birth:

> When to posterity his sacrificed mother gave his name, as they struggled to pull the weak infant from her womb, from this proceeds the Caesarean race, from this the delight in new slaughter: Do you think that he who from a funereal threshold thrust his savage foot into life would not derive from this and engender in others a native fury and a thirst for hot blood? (vv. 28–36)

Born of a violent birth that killed his mother, Caesar fates Charles to "new slaughter." Image-making according to Roman exemplars is turned on its head. We are left not with praise of imperial authority and a cult-like reverence for Charles, but the very opposite, a rejection of the images and messages sponsored by the imperial propaganda machine. Within the political discourse on Charles's wars against the Moors, of which Sepúlveda was an advocate, Garcilaso offers the historian an alternative way of looking at Charles the warrior emperor, at the imperial agenda, and at the "enemy."

Sepúlveda mentions the massacre in his *De bello Africo* but dismisses it. Only a few perished by the sword, he writes, and they themselves were to blame for following "stulto concilio" [stupid advice] by defending their homes, women, and children instead of the walls of their city (Sepúlveda 2005, 3.16, 80). The soldiers, especially the Germans, were angered by the Tunisians and, unlike the Spaniards and Italians who were interested in booty, committed much of the massacre. Charles is nowhere to be seen in Sepúlveda's account of the carnage. Garcilaso writes his ode to Sepúlveda as if he were advising the chronicler to consult the oral archive of the vanquished, of those without sanctioned voices like the victims depicted in Vermeyen's sketch, to remember in

his history those "forgotten" from the official narrative. Garcilaso writes in neo-Latin, the universal language of high culture and serious subjects, which he practised in Naples, by reading and interacting with the "refined circles of Italian Humanism"(Lumsden 1947a, 339), especially at the Accademia Pontaniana. Addressing "the learned Sepúlveda" in the very language the chronicler uses to write his treatises, in particular those justifying war on religious grounds, Garcilaso offers a revisionist interpretation of the Tunis war to recall the underside of empire, the "other" history.

The project of empire and history intersected with cultural memory in the *Conquest of Tunis* tapestries and Garcilaso's Sonnet 33 and the Latin "Ode to Ginés de Sepúlveda." Vermeyen's drawings of the expedition, a documentary reportage, became a visual archive of scenes for the composition of cartoons for the weaving of the tapestries. These weavings, the authorized account of the Tunis expedition and a public memorial to the emperor, took on a life of their own, with copies commissioned by Mary of Hungary, the pope, and even Suleyman the Magnificent. Garcilaso's own encounter with Tunis/Carthage prompted a cultural excavation of a site of remembrance, of history (Caesar, the Scipios, and the destruction of Carthage), and of legend (Dido and Aeneas). The poet and the artist celebrated empire, but they presented as well a counter-narrative, the excesses of war. Vermeyen's drawing of the massacre, however, was soon "forgotten" and excluded from the official history. Garcilaso's melding in erotic agony with Dido's self-immolation and his commiserating with the Tunisian women survive to balance Sepúlveda's triumphalist commemoration of empire.

3 Objects of Dubious Persuasion

In the *Ode ad florem Gnidi* the poet, assuming the role of a go-between, casts a series of objects – a lyre, Roman triumphal carts, a viol and a zither, a shell boat, a painting, and a marble statue – to structure an irreverent act of persuasion and to figure the players, a spurned lover and an unresponsive beauty, at the centre of his tongue-in-cheek performance. Written sometime between 1533 and 1536, after Garcilaso had established himself as a member of Pedro de Toledo's court in Naples, the *Ode* was supposedly inspired by the rejection of the poet's aristocratic friend, Mario Galeota, by a noblewoman from the Neapolitan quarter of Nido, Violante Sanseverino. In the guise of an amorous intrigue, the poet seeks to draw Violante out of the double bind in which court ladies were placed by conduct books inspired by Petrarchan models, like Baldassare Castiglione's *Il Cortegiano* (1528), which prescribed that a woman be both chaste and deeply sensual, her unassailable modesty matched only by the erotic titillation that her beauty and her "flirtatious volubility" produced in her suitors (Jones 1987, 44–8). The lyric voice, playfully transgressing cultural exemplars, constructs a counter-model for Violante, a wilful Venus figure, urging her to act on her sensuality to console her dispirited Mars.

Within the irreverence lies an act of self-figuration that constitutes the speaker as a rhetor modelled after Orpheus the *vates*, with touches of his magic, and Orpheus the early modern culture hero, whose voice is typically located within the formulaic space of the classical oration.[1] But the *Ode*'s persuasion is laden with irony. A call to civic duty was one of the main goals of oratory as practised by Renaissance humanists. In calling Violante to adhere to what might pass as her civic duty, the pander's rhetorical performance seems all the more sardonic and

entertaining. Material objects assume a critical role as active agents that reveal the rhetor's clever ruses and brilliance in the act of saving a friend in peril.

The Lyre and the Viol(a)

Among the cultural artefacts evoked to "coax" the woman, Orpheus's lyre is privileged as the locus of song and performance. For archaic Greece, Orpheus was the poet of incantation, whose song embodied the magical and mysterious power of poetry over the world.[2] For the early moderns, that power represented no less magically and mysteriously the power of the logos, the spoken word in action, since Orpheus occupied an iconic presence as the prototype of the gifted orator. "It is the humanists," writes Thomas Cain, "who make the formal oration the goal of education; who equate eloquence and civilization. And it is the humanists who quite naturally find in Orpheus a convenient culture-hero triumphantly symbolizing the goals of their rhetorical program" (1971, 25). But we must not forget that in calling forth the power of orality within a written culture, Garcilaso subtly alludes to a popular practice of the time, appropriate for a text that attempts to capture the performative force of a song "sung" to a woman from the Neapolitan nobility. "[R]eading aloud," Roger Chartier points out, "was very much a habit of literate and aristocratic sociability" (forward to Bouza 2004, xii). The lyric speaker's appropriation of Orpheus's lyre as the emblem of song and the spoken word is most expedient, given the task of charming and moving the modest flower of Gnido, who was accustomed to orality and the singing of courtiers and thus susceptible to the rhetor's persuasion. Sixteenth-century Spain was also "a culture of liturgical prayers, town criers, hymns, and formal hearings," as Fernando Bouza observes, where "the spoken word was considered the most authentic form of communication because of its immediacy, compared to images and writing, where deceit was easier since they are further removed from that which is natural" (2004, 17, 20). But the Ode's persuasion in song is an ambiguous enterprise, announced subtextually by the lyre itself, which typically stands for both the power of song and its failure. Orpheus charms the gods of the underworld to win Eurydice, only to lose her after disobeying their injunction not to look back as he leaves their realm. He goes on to move the world of the living with his song, enchanting even the spears and stones hurled by the Maenads angry at his scorn. Ultimately their shouts drown out his voice and the

sound of his lyre before they dismember him (Ovid 1984, 11.9–19). In the *Ode*, however, power and failure are mapped differently. The power to move is illustrated by the rhetorician's technical skill, most strikingly in his manipulation of discursive artefacts, which embody classical erudition, imperial conquest, and sardonic verve, whereas the failure of voice to persuade derives from a rigid erotic code, perhaps familiar to Violante from a book of manners read to her. Fictionalized as the Petrarchan *donna pretosa*, she cannot transgress the conventional erotic boundaries.

The lyric speaker begins his persuasion with a conditional statement stretching through six stanzas, telling the unavailable Violante that if he had Orphic powers he would not sing of epic matters but of her beauty and her unhappy lover. He starts slowly, elegantly and modestly, centring on the lyre:

> Si de mi baja lira
> tanto pudiese el son, que en un momento
> aplacase la ira
> del animoso viento
> y la furia del mar y el movimiento,
> y en ásperas montañas
> con el süave canto enterneciese
> las fieras alimañas,
> los árboles moviese
> y al son confusamente los trujiese.
>
> [If the sound of my simple
> lyre had such power that in one moment
> it could calm the anger
> of the violent wind and
> the fury of the sea, the sea's turbulence,
> and if in the wilderness
> with sweet singing I could melt the savage hearts
> of the fiercest animals,
> and so move the trees that
> they approach, stirred and bewildered by the sound.] (vv. 1–10)

The speaker's lowly lyre, "baja lira," coupled with the hypothetical "pudiese," proclaims the insufficiency of his song. Unlike Orpheus, who calmed wind and wave, and in the high peaks of the Rhodope

tamed beasts and enchanted trees with his lyre, the speaker professes the incapacity of his own lyre to charm and move.[3] But he implicitly affirms what in false modesty he explicitly denies, his "baja lira" celebrating what it belittles: the power of the spoken word embedded in song. Representing himself as a new Orpheus, the speaker privileges the lyre as the carrier of truth, spirit, and presence, thus affirming the authority of his voice and message.

As the speaker continues his apostrophe to Violante, he sings of epic, though he denies it, introducing an imperial discourse into which he deviously inscribes the female in an ironic inversion by which military weapons and the viol, a wailing instrument of erotic melancholia, embed an improper conduct within an ostensibly celebratory gesture:

> no pienses que cantado,
> seria de mí, hermosa flor de Gnido,
> el fiero Marte airado,
> a muerte convertido,
> de polvo y sangre y de sudor teñido,
> ni aquellos capitanes
> en las sublimes ruedas colocados,
> por quien los alemanes,
> el fiero cuello atados,
> y los franceses van domesticados;
> mas solamente aquella
> *fuerza de tu beldad* sería cantada,
> y alguna vez con ella
> también seria notada
> *el aspereza de que estás armada,*
> y cómo por ti sola
> y por tu gran valor y hermosura,
> *convertido en vïola,*
> llora su desventura
> el miserable amante *en su figura.*

> [do not suppose, beautiful
> flower of Knidos, that I would sing of
> the deeds of angry Mars,
> dedicated to death,
> his countenance stained with powder, blood and sweat,
> nor of the captains would I
> sing, who ride in state, seated in high chariots,

by whom the German princes,
their proud necks tied to the yoke,
and French ones too, are tamed and put on show.
No, for I would sing of
nothing but *the power of your beauty,*
though occasionally too
I might put on record
the harshness with which you are armed,
and tell how only because of you,
because of your worth and your beauty,
the wretched lover *is turned*
into a pale violet
and weeps his ill fortune *in its figure.*] (vv.11–30; my emphasis)

The orator sings powerfully of epic with the figure of Mars – his body covered with dust, blood, and sweat – and an iconic material marker, "sublimes ruedas" [high chariots], the carts that carried victorious emperors and generals, as well as chained prisoners, in triumphal imperial processions. The "sublimes ruedas," identified with Roman triumphs by Fernando de Herrera (Gallego Morell 1972, 411), are read by Hayward Keniston as the spiral bands [ruedas] of the narrative columns that celebrate in relief Rome's imperial victories, notably of Emperors Marcus Aurelius and Trajan (1922).[4] Historicized through a *translatio imperii,* the transfer of imperial power from Rome to sixteenth-century Europe, these Roman victories are staged here implicitly in the figure of Emperor Charles V, the new Caesar (Dunn 1965, 290). He is an angry Mars, having triumphed over the French forces of Francis I at Pavia (1525), over the Berber pirates at Tunis (1535), and in a not-so-distant future will triumph over the German princes at Mühlberg (1547). Witness the sonnet "A Boscán desde La Goleta" [To Boscán from Goleta], written by Garcilaso as both observer and participant of the Tunis campaign, where the theme of *translatio imperii* reinforces the image of Charles as a new Scipio, but also as Mars, who brings his weapons [armas] and fury [furor] for imperial conquest to Africa (see chapter 2). Among Charles's imperial entries, typically staged with Roman imagery and triumphal arches, two of the most grandiose, into Naples in 1535 and into Rome in 1536, celebrated his conquest of Tunis.[5]

The *Ode*'s poetic voice not only sings of epic, it frames Violante, the ruling figure of lyric in her role as distant object of desire, as a quasi-epic figure: a *Venus armata,* called forth in "el aspereza de que estás armada" [the harshness with which you are armed]. As defined by

Edgard Wind, this armed Venus is "bellicose," having "donned the weapons that normally belong to her opponent – either Diana, Minerva, or Mars" (1968, 92).[6] But this early modern martial Venus is more like Mars, the god of war, than her ancient counterpart, who "may stand for the strength that comes from love, from the fortitude that is inspired by charity, or – in the reverse – for sweetness derived from strength" (1968, 92). Violante is neither sweet nor loving, her harshness a quality typically identified by Garcilaso with female bellicosity as in so many of his poems, including *Canción* 4 (Avilés 2005). "Dressed" like an angry Mars, Violante rehearses an imperial conquest over Mario. Playing with the porous boundaries of gender and genre, the poet places political agendas in imperial wars in Europe and Africa as a backdrop to set off, ironically, a moment of social entanglement, of erotic undoing in Neapolitan court circles. As epic enters the lyric, lyric in the figure of the irascible female enters epic to make Violante aware of the inappropriateness of her behaviour, and subtle mockery splashes on both woman and suitor. It is impossible to separate love and war, as ancient Roman elegy made abundantly clear, followed closely by courtly love poetry and Petrarch's *Canzoniere*, where Laura is the fierce "nemica" of the lover. Violante inherits this tradition; martial conflict suits her.[7]

And what of Mario the courtier, skilled soldier, and musician, robbed by this armed and harsh Venus of the objects that once gave him life in the jousting arena and at court? Deprived of the bit and spurs for taming his horse, of the sword, and of the zither (vv. 36–52), the emasculated, melancholy lover has been transformed by Violante into an object of weakness and derision, and in a clever pun on her name, into a "viola" (pale violet).[8] It is precisely Violante's physical beauty, weaponized into a powerful instrument, that carries out the conversion: "fuerza de tu beldad" [the power of your beauty] (v. 22) and "por tu gran valor y hermosura" [because of your worth and your beauty] (v. 27). Like Petrarch's Laura, like Circe, and above all like Medusa, this Venus is an enchantress whose beauty emasculates her suitor. "From the ancient *Physiologus* through the mythographers to Boccaccio," writes John Freccero, "the Medusa represented a sensual fascination, a *pulchritudo* so excessive that it turned men to stone" (1972, 7–8). The potent "female horror" of the *Ode* turns her man, wounded in his will, not into stone (that may be her own fate) but into a pale violet, one of Venus's flowers and, by extension, into the flower of Gnido herself.

Mario's psychological and physical undoing is best understood if we follow el Brocense's reading "en su figura" [in its figure], also proposed by Fernando de Herrera and Tamayo de Vargas, rather than the now

widely accepted "en tu figura" (Whitby 1986, 134).[9] The "viola" may also stand for a viol, a plaintive musical instrument into which the lover is metaphorically transformed as he laments his misery, "llora su desventura" (Whitby 1986, 136). And if we stretch the semantic associations of *figura* to signify a musical note, indicating the length of a sound (*Diccionario de Autoridades*), the viol assumes a musical register of lament. Sad and ultimately mocking, it establishes a counterpoint to the vibrant zither, which the lover has left behind. In the sixteenth century, its golden age, the zither accompanied not only lyric but epic songs and heroic tales and was, like the rhetorician's Orphic lyre, elegant and vigorous. Whether "viola" means pale violet or viol – or both – it denotes the melancholy Mario, who is carried by the new Venus in her own prisoner cart, a shell boat.

The Shell Boat

In a justly famous stanza, the *Ode*'s speaker places the weak, longing Mario in a shell boat, the space where he is constituted and exhibited as a galley-slave suffering a "living death":

> Hablo d'aquel cativo,
> de quien tener se debe más cuidado,
> que 'stá muriendo vivo,
> al remo condenado,
> en la concha de Venus amarrado.

> [It is of that captive
> I speak who deserves more consideration,
> for his is a living death,
> sentenced and chained to the oar,
> a slave caught and bound to the shell of Venus.] (vv. 31–5)

Violante is implicitly identified with Venus, whose shell, her emblem, plays up the malice in the speaker's rhetorical exercise. The shell in which Mario is "enconched" [enconchado] (Lázaro Carreter 1986, 121) relies on a well-known iconography that inspired both art and literature. The best known is Botticelli's *The Birth of Venus* (c. 1486, figure 3.1), now at the Uffizi in Florence, where a young, gentle Venus stands on her scalloped shell among the waves, about to reach the shore of Paphos in Cyprus. More to the point is Francesco del Cossa's fresco *The Triumph of Venus* (c. 1470, figure 3.2) at the Palazzo Schifanoia in Ferrara, which

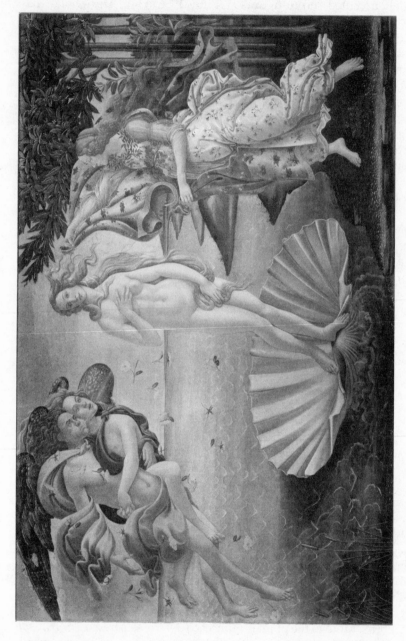

Figure 3.1: Botticelli, *The Birth of Venus*, c. 1486. Florence, Uffizi. Scala/Art Resource, NY.

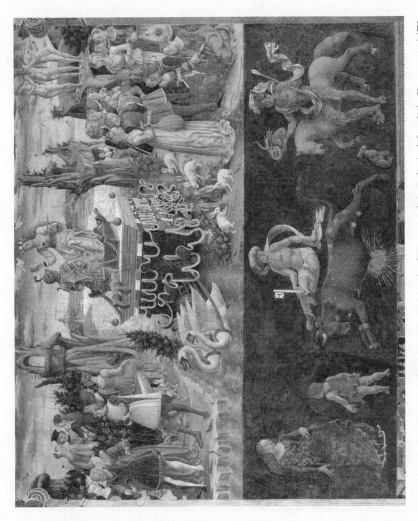

Figure 3.2: Francesco del Cossa, *The Triumph of Venus and Astrological Symbols*. Fresco, c. 1470. Ferrara, Palazzo Schifanoia. Scala / Art Resource, NY.

reinforces the social implications of the stanza in the salacious public life of courtiers and their ladies, which could very well have mirrored the Neapolitan aristocratic society of Violante and Mario.[10] Cossa's fresco, part of an astrological cycle, portrays Mars dominated by a Venus dressed in Renaissance clothing, wearing a crown of white and red roses and sitting on a throne placed on a barge – distinctly her shell – drawn by two swans. A vanquished, helmeted Mars, chained to her throne, kneels before her. Unlike the many pictorial images of the bondage of Mars by Venus, notably in the famous idylls by Botticelli and by Piero di Cosimo, Cossa's fresco offers a visual representation of the *discordia concors* popular among Neoplatonists: Venus, the goddess of love, tames Mars, the god of war, and from their union Harmony is born.[11] Garcilaso's image keeps the prisoner motif, which recurs later in the poem in explicit dialogue with an Ovidian fragment, but stands far from the fresco's astrological lore and Neoplatonic mystery. The *Ode's* stanza is written in the playful, lascivious spirit of the scenes surrounding Venus's barge, suggesting a rampant sensuality, with rabbits freely cavorting at the foot of the barge and ladies and courtiers engaged in erotic dalliance (figure 3.3). Witness the couple sitting and kissing on the grass, the hand of the courtier slipping into the front of the lady's garment, perhaps searching for her not so elusive "concha," while a quietly consenting group looks on. The fleshy, curvaceous Graces – the servants of Venus – stand high on a promontory, a distant but special stage of their own. Unlike Cossa's presentation of Venus's shell peeking coyly from the corners of her throne, Garcilaso's text "exposes" the shell and, playing along with the barge motif, transforms it into a galley.

The shell as a galley is a variant of the pictorial tradition that inspired Botticelli's *Birth of Venus*, where Venus's seashell is conceived as a kind of boat blown by the wind towards the shore. Raphael in his *Triumph of Galatea* at the Villa Farnesina in Rome (c. 1513, figure 3.4) effectively converts the shell into a boat by attaching a paddle wheel to it, undoubtedly to "suggest propulsion" (Meiss 1974, 321).[12] While Cossa's Mars is a gallant knight in chains, kneeling before Venus and her shell, Garcilaso's bound Mario Galeota is but a lowly "galeote" [galley-slave] placed inside Violante's shell boat. El Brocense, who first drew the equation of Galeota with *galeote*, describes him as "el [cautivo] forzado a la galera de Venus" [the captive condemned to Venus's galley] (Gallego Morell 1972, 273).

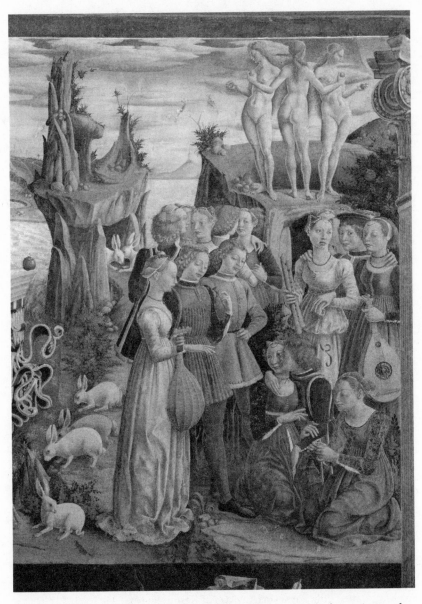

Figure 3.3: Francesco del Cossa, *The Triumph of Venus*, detail of courtiers and ladies with the Three Graces in the background

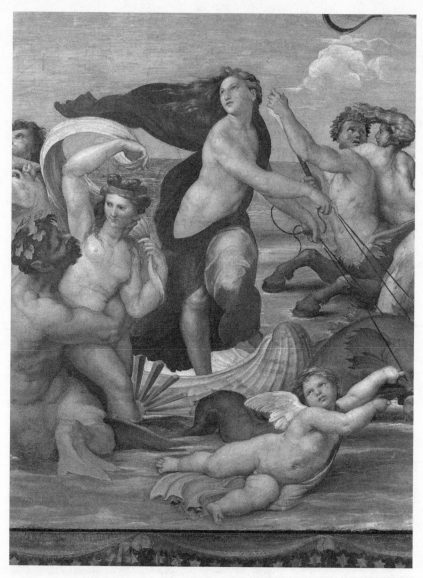

Figure 3.4: Raphael, *Triumph of Galatea,* central section. Fresco, c. 1513. Rome, Sala di Galatea, Villa Farnesina. Scala/Art Resource, NY.

Leonard Barkan calls attention to how, in the ancient oratorical tradition going back to Cicero and Quintilian, "rhetoric is taught by reference to well-known works of art or even to the theory of visual arts" (1999, 65). If this is a special case of "ut pictura poesis" [as in painting, so in poetry], the relation between words and images, it is something more as well, says Barkan, insisting on the importance of the visual in rhetoric, not only in Cicero and Quintilian, but significantly also in Leon Battista Alberti's *De pictura* (1435). This textual tradition "establishes the rhetoricity of images and instructs Renaissance viewers in a rhetorical mode of ekphrasis" (1999, 66). A sophisticated humanist, Garcilaso was well versed in art theory and practice as well as in classical oratory. He knew his Quintilian, his Cicero, and his Alberti. The rhetoricity of pictorial images informed his own brand of persuasion, as he qualifies his ekphrastic rendition of the shell with a scatological motif from popular lore, the "concha," to persuade Violante to be kinder to her longing lover.

In using the shell imagery to describe for Violante how she has sexually enslaved Mario Galeota, the *Ode*'s speaker ignores Neoplatonic concerns and the decorum dictated by the Petrarchan love lyric. Instead of the traditional collection of exquisite body parts (hair, neck, eyes, feet), the speaker zeros in on the "concha," redirecting our attention to the site of eroticism. Lázaro Carreter suggests that Garcilaso "materializes" with malice what had conventionally been sublimated (1986, 125). Garcilaso does this and more. He breaks the fragile balance advocated by the Petrachan love lyric between physical beauty and chastity – joined by praise in equal measure – to stress the power of Violante's sensual allure in order to coax her to cure her lover's condition. Petrarchan quest has been reduced to simple erotic persuasion and conquest.

A Marble Statue

The rhetor shifts to a darker form of malice as he improvises on the tale of Vertumnus and Pomona from Ovid's *Metamorphoses* 14 (1984, 69–764) to warn Violante that a "stony" woman may be punished by being converted into real stone. In Ovid's cautionary tale Vertumnus, disguised as an old woman, tries to woo Pomona, a woodland nymph who tends her orchard and shuns all men, by telling the story of Anaxarete, who was turned into a marble statue after her rejected lover, Iphis, hanged himself at her door. Vertumnus, like other fictive authors

in the *Metamorphoses* – witty verbal artists like the daughters of Minyas in Book 4 or Orpheus in Book 10 – delights in the pleasure of storytelling, and his persuasion is ultimately at the service of his art. In the *Ode*, Iphis and Anaxarete have no narrative life of their own, and much of Ovid's text is discarded: Iphis's desperation at the woman's rejection, his plaint, and his suicide with its touch of black humour, when the excluded lover hangs himself rather than his garland at Anaxarete's door, with the words, "Does this garland please you, cruel and wicked girl?" (1984, 14.736).[13] Ovid pays careful attention to the details of Anaxarete's eyes stiffening at the sight of Iphis's dead body, hinting at her transformation into a marble statue as the warm blood leaves her "pale body" (1984, 14.754–5). The *Ode*'s rhetor replays the image of Anaxarete's eyes fixed on the body of the dead Iphis (vv. 86–7) and builds on the Ovidian transformation by turning her bodily interior into an ominous spectacle, as she becomes a statue:

> los huesos se tornaron
> más duros y crecieron,
> y en sí toda la carne convertieron;
> las entrañas heladas
> tornaron poco a poco en piedra dura;
> por las venas cuitadas
> la sangre su figura
> iba desconociendo y su natura,
> hasta que, finalmente,
> en duro mármol [fue] vuelta y transformada ...

> [her bones still further hardened
> and grew, until they engrossed
> all the flesh, taking it into themselves,
> her frozen organs little
> by little converted into solid stone;
> in the anguished veins the blood
> was beginning to forget
> its proper form and function, its true nature;
> until at the end she was
> nothing but hard marble, metamorphosed.] (vv. 88–97)

The mapping of Anaxarete's veins, entrails, and bones turning to stone would be but a poetic conceit were it not for the interest in Garcilaso's own time in the human body's interior, a curiosity fed in part

by the spread of anatomy theatres, where a body's viscera were exposed to public view. Anatomy theatres were, as Jonathan Sawday calls them, "playhouses of organized violence," where anatomical dissections were performed in the presence of medical professionals and even "the fashionable, educated elite" (1995, 42). The earliest documented formal dissection for the teaching of human anatomy is thought to have originated in Bologna at the beginning of the fourteenth century, and by the end of the fifteenth it had become "a spectacle attracting a broad spectrum of scholars and artists" (Ferrari 1987, 53, 55). The anatomist Alessandro Benedetti in his *Anatomice* (1502) extended invitations to Emperor Maximilian I (to whom the treatise is dedicated), celebrated humanists, and cultured Venetian senators to observe parts of the body prepared for public dissection (Ferrari 1987, 57). By the time Garcilaso visited Bologna (November 1529 to April 1530) for the coronation of Charles V, the city was a highly respected centre for public anatomical dissections. These spectacles were conducted in January during carnival holidays, which coincided with Garcilaso's stay in the city. Given the importance of the imperial visitors from Spain, it is likely that the emperor and his entourage received invitations to attend one of those spectacles.[14]

In the *Ode* Anaxarete's visceral interior is exposed in a manner similar to that of figures whose flesh is set aside to reveal their internal organs in illustrations of anatomy treatises of the period, notably Berengario da Carpi's *Commentaria* (1521) and *Isagogae breves* (1522), and Andreas Vesalius's splendidly illustrated *De humani corporis fabrica* (*On the Fabric of the Human Body*) of 1543.[15] Vesalius's *Fabrica* was particularly famous for its integration of text and image, with illustrations executed by skilled artists and woodblock cutters (Cook 2006, 414). "The body dictated the text," writes Andrea Carlino, "with an emphasis on the decisive contribution of the visual to both anatomical teaching and research. With this aim in mind, and following the dictates of Greek and medieval biologists and physicians who sought to chart and reproduce the human body in images, Vesalius provided the *Fabrica* with a series of magnificent illustrations that make the book one of the masterpieces of sixteenth-century printing" (1999, 1). Vesalius's illustrations, comments Harcourt, "exist for the eye not as actual bodies dissected but as fragments of sculpture somehow miraculously able to sustain the act of real anatomical demonstration" (1987, 30). One notable illustration is a torso with insides spilling out, based on a famous antique fragment, the so-called Belvedere Torso, in the collection of Cardinal Prospero Colonna from the early 1430s (Harcourt 1987, 30) (figure 3.5). The rhetor ingeniously combines his own sense of statuary

Figure 3.5: Torso, Andreas Vesalius, *De humani corporis fabrica,* 1543.
Reproduced by permission of Rare Books and Manuscripts, Special Collections
Library, Pennsylvania State University Libraries.

– the image of a marble statue-in-the-making – with a dissection as an
epistemological site, unveiling what is concealed by flesh, as a warning
to Violante of what might be her own fate.

 Garcilaso's discursive vivisection, like the actual dissection in anato-
my theatres, trod on forbidden ground. A cultural taboo regarded the
cutting up of cadavers for scientific (thus profane) purposes, with the
inevitable delay in burial, as a religiously and anthropologically danger-
ous act (Carlino 1999, 3).[16] The transgression of the body in the *Ode*

trades the black humour of the Ovidian text – where Iphis hangs himself at Anaxarete's door, turning his body into a gift, a human garland to be "admired" by the stony Anaxarete – for an equally gruesome sight, a punishment that carries intimations of a fiery afterlife:

> Hágate temorosa
> el caso de Anajárete, y cobarde,
> que de ser desdeñosa
> se arrepintió muy tarde,
> y así su alma con su mármol arde.

> [It were better you should fear
> Anaxarete's outcome and avoid it,
> who of her disdainfulness
> too late repented and whose
> soul therefore is burning with her marble flesh.] (vv. 66–70)

Though malicious, the *Ode*'s "dissection" scene is also a moment for the poet's self-promotion, where the eloquent, informed rhetor enacts a self-congratulatory performance for the aristocratic Neapolitan woman, much like the anatomist Benedetti, who sends self-promotional invitations to the political and intellectual elite to view his public dissection, if for different ends.

Of Language and Things

The *Ode*'s depiction of a statue-in-the making, with its "ability to excite wonder," owes as much to Renaissance conceptions of amplification (Tuve 1972, 90) as to Ovidian transformation recast anew. The process of amplifying a passage belongs to the Erasmian technique for achieving *enargeia*, the rhetoric of presence, a powerful device for moving the affections. In his *De copia*, Erasmus stresses the materializing dimension of the technique:

> Instead of setting out the subject in bare simplicity, we fill in the colours and set it up like a picture to look at, so that we seem to have painted the scene rather than described it, and the reader seems to have seen rather than read. (1978, 24: 577)

For Erasmus, true linguistic plenitude occurs when words are properly and richly "filled with" things (Cave 1976, 7), calling forth a visible

presence to "the eyes of the mind" and achieving a fusion of *res* and *verba*. Erasmus cites copiously from Quintilian's *Institutio oratoria*, which discusses *enargeia* (using its Latin equivalent *evidentia*) under *ornatus*, the embellishment of language aimed to delight and persuade an audience (1961, 3.61). One way of effecting *enargeia* was for the orator to render a detail-by-detail "word picture" to evoke its corresponding "mental picture," empowering language by creating a verbal excess or supplement in order to make the audience "see" vividly what was being described.

 In the Renaissance, *enargeia* also rested on a magical or natural conception of language whereby things were believed to inhabit words in such a fashion that verbal signs were, in a sense, things as well as signs. Foucault has given lively circulation to this materializing of the sign, naturally empowered, as the sixteenth-century episteme. "[Language]," he writes, "has been set down in the world and forms a part of it, both because things themselves hide and manifest their own enigma like a language and because words offer themselves to men as things to be deciphered." (1973, 35).[17] Commenting on Foucault, Bouza stresses the connection between the material aspects of language and acts of sorcery, where the sign becomes "magically" present. "The idea that saying something was not far removed from invoking whatever was being named," writes Bouza, "is reflected in the power that people attributed, for example, to curses, blessings, prayers, and incantations" (2004, 21). This is the language that the Orphic rhetor tries to enact in the *Ode*: in describing Anaxarete's viscera, in representing the powers of the *baja lira*, and in using the incantatory formula of the anaphoric *por ti*'s, where the speaker blames Violante for her suitor's debilitated state in order to awaken her pity:

> *Por ti*, como solía,
> del áspero caballo no corrige
> la furia y gallardía,
> ni con freno la rige,
> ni con vivas espuelas ya l'aflige.
> *Por ti* con diestra mano
> no revuelve la espada presurosa,
> y en el dudoso llano
> huye la polovorosa
> palestra como sierpe ponzoñosa.
> *Por ti* su blanda musa,
> en lugar de la cíthera sonante,
> tristes querellas usa,

que con llanto abundante
hacen bañar el rostro del amante.
Por ti el mayor amigo
l'es importuno, grave y enojoso ...

[*because of you*, no longer
does he correct the fierce rebellion
of the restless stallion
or control him with the rein
or harry him with sharply pricking spurs;
because of you, he does not
brandish with expert skill the hasty sword, ·
and on the training ground
he flees the dusty lists
as if anxious to avoid a poisonous snake;
because of you, his gentle
muse abandons her sonorous zither
for melancholy complaints,
which cause the lover's face
to be inundated with copious tears;
because of you he finds
his best friend importunate, a bore, a burden ...]
(vv. 36–52; my emphasis)

The repetition of *por ti*'s (aided by alliteration and rhyme scheme) gives the stanzas a litany-like cadence, revealing the power of eloquence, formulaic and formalized, to move the emotions.

The persuasive force of rhetoric resides chiefly in elocution, its tropes and figures. Gorgias, the sophist who helped establish rhetoric as a systematic discipline (c. 480–375 BCE), recognized the power that rhyming words and the figures of symmetry and repetition – such as antithesis, isocolon, and parison – gave his orations. The Gorgianic figures, originally derived in all probability from magic songs and liturgical style, may have had the value of incantations, employed as a kind of spell to evoke a particular feeling in the audience (Romilly 1973, 18–19). Poetry, rhetoric, and magic were closely linked. Charles Segal writes of the spell-binding, energizing function of language in early Greek poetry, which was ascribed primarily to Orpheus and his lyre:

In archaic poetry, song, *aoidē*, is closely akin to *ep-aoidē*, enchantment. The chant like effects of repetition, alliteration, assonance or the like reproduce

some of the power of this song-as-magic even in highly sophisticated po-
ets like Sappho and the authors of the Homeric Hymns. Sappho's *Ode to
Aphrodite* ... uses this incantatory aura to compel the presence of Aphrodite,
but also to imitate, in its own word-magic, the quasi-hypnotic power of
love's sorcery. (1989, 11–12)

This confidence in word-magic is transmitted in varying degrees to
later poets and rhetoricians. In his *Institutio oratoria*, widely read in
Garcilaso's times, Quintilian ascribes an irrational power to the skilled
use of ornaments (tropes and figures) that he calls "flashing weapons"
(1961, 8.3.3). It is what Garcilaso attributes to his speaker's lyre, a ma-
terial site of rhetorical and magical performance. Through Orphic
song, the speaker/orator creates his own "incantatory aura" to compel
Violante to take pity on Mario and to revel in his skill in creating such
aura, along with the ironic twist that accompanies it in a play with
Horace's *Ode* 1.8 in the *por ti* sequence cited above.[18]

In Anaxarete's transformation the speaker tries to capture this aura
in potent word-things, offering her body as a violent spectacle for
Violante's eyes. The emphasis on the gaze – "mirando" [looking] (73);
"vido" [saw] (74); "los ojos s'enclavaron" [her eyes became fixed] (86);
"vieron" [they saw] (87) – serves as an imperative, urging Violante to
open her visual imagination to the horrific scene. The rendering visible
of Anaxarete's internal transformation, as through a vision secretly wit-
nessed and now revealed, finds parallels with the visual aspect of the
public anatomy sessions, a highly theatrical and public event, as men-
tioned above.

In keeping with Ovid's ambiguous endings, the *Metamorphoses* pres-
ents Anaxarete's transformation as both punishment and reward.
Worshipped at Salamis in Cyprus as *Venus Prospiciens* (Gazing Venus),
her statue is proof of her redemption in art and belief. Garcilaso focuses
on punishment only. He offers his text to Venus/Violante for her reflec-
tion: a Venus of flesh and blood can easily become a marble Venus. And
more so since, as Peter Dunn has commented, Violante may be identi-
fied with Praxiteles's *Venus of Knidos* (Cnidus), a statue well known to
early modern artists and writers. Venus had her temple at Cnidus/
Gnidus, Violante had hers at Gnido/Nido, the quarter in Naples where
she lives, in effect the "temple" where she is "worshipped" by Mario
(1965, 301–2). The fact that the *Venus of Knidos* is nude in contrast to the
draped *Venus of Kos* reinforces the lascivious associations connected
with the shell, Violante's newly acquired emblem.

4 The Mirror and the Urn

The bipartite, polymetric Second Eclogue privileges two iconic cultural artefacts, a mirror and an urn, for the construction of two figures, a melancholic and a warrior, who engage radically different worlds. The shepherd Albanio inhabits an interior world of introspection, while Fernando, third duke of Alba, lives large in the public sphere of arms, imperial doings, and panegyric. Two parts, two figures, two realities difficult to reconcile and, to critics, most confounding. Rafael Lapesa, in a widely accepted interpretation, finds a coherent structure in this unwieldy poem, seeing it as a diptych with a moral: a heroic Fernando serves as a corrective to a mad Albanio: "El desvarío del enamorado no deja de aparecer como un mal que necesita enmienda. Frente a él se yergue, con evidente ejemplaridad, la figura del héroe que en el momento decisivo obedeció a la llamada de la virtud y sometió el deseo a la razón" [The waywardness of the lover appears as an error that needs to be corrected. Before him rises, with evident exemplarity, the figure of the hero who at the decisive moment obeyed the call of virtue and subjected his desire to reason] (1985, 116). The coherence of the eclogue, I argue, lies not in a moral solution anchored in the disparity of the protagonists, but rather in their commonalities, each embodying a disorder of his own. They share something else: their acts of figuration, though at times profoundly different, occur at material sites, which function in liminal spaces between reality and fantasy for Albanio, between history and fiction for Fernando. The mirror and the urn are far from mute witnesses. They are active participants in journeys of discovery.

At the Fountain of Narcissus

Within the highly charged visual culture of the early modern period, the newly invented flat mirror became an ideal instrument – and metaphor – for self-imaging. Developed in Venice at the beginning of the sixteenth century, the flat-surface tin-amalgam mirror gradually superseded the medieval mirror, convex and circular in shape.[1] This novel cultural artefact at once abetted and encouraged a fascination with specular images and, by extension, with introspection and the construction of an interiorized model of selfhood. For Leonardo da Vinci, the flat mirror was "the master of painters," "the secret accomplice" that no self-portraitist could do without (Woods-Marsden, 1998, 31).[2] Leonardo also understood, as did Leon Battista Alberti, that the mirror was the site where reality and illusion, truth and appearance, are most intricately intertwined, which made for ingenious experiments in self-portraiture by painters and poets alike. For the poet, moreover, the text as mirror was a powerful discursive device, a master model to be copied, alternately appropriated and modified for acts of figuration.

One especially fruitful exercise involving the mirror was the reexamination of the Ovidian myth of Narcissus, the beautiful young man, beloved of Echo, who looks into the waters of a pool only to fall in love with his own reflection (1984, 1:3.344–510).[3] Narcissus's encounter with the pool offered early modern poets an intriguing exemplar of mirror recognition: What did it mean to look at one's reflection in a mirror and to locate the self within? What type of knowledge was received and what type of image was constructed? Garcilaso engages these questions in his Second Eclogue, where he recasts the myth of Narcissus to map the complex workings of the psyche, in the process constructing internal landscapes like those Petrarch had rehearsed so influentially in his *Canzoniere*.[4] For Garcilaso the mirroring pool is a dynamic site where illusion and reality, self-knowledge and self-deception, image and simulacrum actively converge.[5] In this chapter I examine how the solitary shepherd Albanio figures himself in his sense of loss and melancholia as a new Narcissus, who shares the reflecting waters with his companion, the huntress Camila, whom he invites to look into his mirror. By introducing a female counterpart Garcilaso considerably enlarges the role of the mirror as mediator of self-revelation and self-definition. Yet the mirror as the site of epistemological discovery and the locus of a gendered look ultimately calls into question the act of self-knowledge, challenging and complicating the very act of defining the self. I

consider the mapping of the self, male and female, against the back-
ground of the trope of self-portraiture in contemporary paintings of
women looking at themselves in mirrors and in Parmigianino's auda-
cious *Self-Portrait in a Convex Mirror*.

The poem opens with Albanio's apostrophe to the clear spring acting
as mirror at the centre of the pastoral enclosure. The waters serve as a
specular screen, where Albanio's visual memory of losing Camila for
the first time is projected onto its reflecting surface:

> ¡Oh claras ondas, cómo veo presente,
> en viéndoos, la memoria d'aquel día
> de que el alma temblar y arder se siente!
> En vuestra claridad vi mi alegría
> escurecerse toda y enturbiarse;
> cuando os cobré, perdí mi compañía.

> [O limpid stream, how clearly when I look in
> your water I see in memory the day
> that has my soul still shivering and burning!
> In your transparency I saw my joy
> become all muddied and confused; when I
> next saw you I lost my true companion. (vv. 4–9)

What Albanio sees in his vulnerable introspection are traces of a wound-
ing recollection, where happiness is transformed into something dark
and blurry. The shepherd obliquely imports Ovidian Narcissus into his
text, engaging fragments of a troubled mythic fiction to construct his
melancholy identity. In Ovid's story the blind seer Tiresias, when asked
if the beautiful Narcissus would live to a ripe old age, replied "If he
never knows himself" [si se non noverit] (1984, 1:3.348). Tiresias's pro-
phetic vision comes true, and Narcissus's crisis of self-knowledge is
revealed in the realization that he and his beloved, the reflected image
in the mirror, are one and the same, "I am he ... I know now my own
image" [iste ego sum ... nec me mea fallit imago] (1984,1:3.463), and
that he can love only himself. As Narcissus laments his fate, Ovid's
narrator meditates on the watery image both obscured and magnified
by the ripples made by fallen tears: "et lacrimis turbavit aquas, ob-
scuraque moto/reddita forma lacu est" [His tears ruffled the water, and
dimly the image came back from the troubled pool] (1984, 1:3.475–6).
Even though Albanio's own lament is not a comparable moment of

self-knowledge and certainly not of self-love, the water's reflecting surface is the locus of grief, dislocation, and irreparable sorrow for him as it is for Narcissus: "turbavit" and "obscura" become Albanio's "enturbiarse" and "escurecerse." In a discursive reversal, however, the shepherd interiorizes Narcissus's reflection ("obscura forma") as an image of bleakness within, a melancholy mood that overpowers the self and its fiction.

Albanio shares with other melancholy lovers in Garcilaso's poetry an impoverishment of the self coupled with exceptional linguistic powers (see chapter 5). Marsilio Ficino in his *De amore* (1459) conceives melancholia as a psychological affliction, which is accompanied by inspiration and creativity. Ficino's definition accords with Sigmund Freud's in his *Mourning and Melancholia*. "The melancholic," writes Freud, "displays an extraordinary diminution in his self-regard, an impoverishment of his ego on a grand scale" (1978, 14:246), yet manifests an obsessive need to speak his loss in exhibitionistic performances.[6] As his soliloquy unfolds by the fountain, the lovesick Albanio – somber and brooding in his pain but eloquently meticulous in depicting it – once again adapts Narcissus's language to his private personal history. Narcissus reveals his impoverishment while lamenting unexpected erotic riches, his "beloved" being so strangely an intimate part of him. But that abundance ironically makes him poor [inopem me copia fecit] (1984, 1:3.466) and grief saps his strength [dolor vires adimit] (1984, 1:3.469). The diminishment of Narcissus is emblematic of Albanio's inner poverty after the loss of his own riches:

> ¿Cómo puede ora ser que'n triste lloro
> se convertiese tan alegre vida
> y en tal *pobreza* todo mi *tesoro*?
> Quiero mudar lugar y a la partida
> quizá me dejará parte del daño
> que tiene el *alma* casi *consumida* ...
> ¡Ay miembros fatigados, y cuán firme
> es el *dolor* que os *cansa* y *enflaquece*. (my emphasis)

> [How can it be such happiness now turns
> into such sadness and such bitter tears
> and all my *treasure* into *worthless dust*?
> I want to go away, perhaps my cares
> may be avoided by a change of scene,

before they've finally *consumed my soul* ...
 O tired limbs, how immovable and deep
the *grief* that *wearies and enfeebles* you. (vv. 22–7, 31–2)

Narcissus's text serves as Albanio's linguistic mirror into which the shepherd "looks" to construct a self profoundly different from that of the Ovidian youth. The scene of loss, which is fashioned as a scene of discovery, reveals the distance between the early modern figure and his ancient counterpart. Consumed by desire, Narcissus's body dissolves, the Ovidian text offering gentle images of the fragile boy melting like yellow wax near a flame or like frost before the morning sun (1984, 1:3.487–90). While in the world of the dead he still gazes at his image in the Stygian pool, his body, conforming to Ovid's typically ambiguous endings, finds a new, albeit tenuous, life in the form of a delicate flower, the narcissus (1984, 1:3.509–10). Albanio dissolves in quite a different way, unravelling into madness. The blurring of boundaries between body and image, so central to the Narcissus myth, induces ontological catastrophe in a different mode, for Albanio descends into schizophrenia, blankly unaware of his own self. This troubled act of figuration logically occurs at the mirror, Albanio's "secret accomplice," where he paints his own self-portrait. But before discussing the shepherd's figuration, I turn to chaste Camila, who constructs her own self-portrait, both in relation to Albanio and, most significantly, in relation to the reflecting surface of the fountain.

Mirroring Camila

Transforming bits of a self-obsessed Narcissus into a self-destructive Albanio consumed with melancholia is only part of Garcilaso's reworking of the Ovidian myth. Equally innovative is the introduction of Virgilian Camila, an active female counterpart to the new Narcissus. As Albanio explains to his interlocutor Salicio, a former unhappy lover-turned-*magister* in the art of love – "de bien acuchillado a ser maestro" [from deeply slashed to teacher] (v. 355) – the origin of his affliction is the body of unavailable Camila, who is unaware of the pleasurable look he fixes upon her: "El placer de miralla con terrible/y fiero desear sentí mesclarse" [the pleasure of looking at her mingled with a fierce desire] (vv. 320–1). "Lust of the eyes" in contemplating corporeal beauty is well documented in Plato's *Phaedrus*, where sight is the active agent of *eros* (1972, 251 A). In Marsilio Ficino's *De amore* (1469), it appears as visual

pleasure tinged with lycanthropic feelings, a kind of bestial love that carries a measure of insanity [amor ferino] (1987, 7.3), which here fuels Albanio's desire. Innocently detecting the shepherd's erotic feelings in his blushing face [rostro y color] (v. 427), Camila asks the cause. Albanio urges her to peer into the clear fountain, to see fully the beautiful face of the one he loves: "le dije que en aquella fuente clara/veria d'aquella que yo tanto amaba/abiertamente la hermosa cara" (vv. 470–2):

> a la pura fontana fue corriendo,
> y en viendo el agua, toda fue alterada,
> en ella su figura sola viendo.
> Y no de otra manera, arrebatada,
> del agua rehuyó que si estuviera
> de la rabiosa enfermedad tocada,
> y sin mirarme, desdeñosa y fiera,
> no sé qué allá entre dientes murmurando,
> me dejó aquí, y aquí quiere que muera.

> [She rushed to the pure spring and looked
> in its clear water. And as she looked, her face
> changed, for her face, her own face, was all she saw;
> and from the water she recoiled and fled
> as hurriedly as if she were infected
> with the mad rage of hydrophobia;
> affording me no look, indignant, proud,
> and muttering who knows what between her teeth,
> she left me here. And here she would have me die.] (vv. 476–84)

Having stepped into Albanio's mirror world, chaste Camila sees her reflected self as the lovely object of the shepherd's misplaced desire. Her implicit "I am she," a recognition that she and the water's "figura" are one and the same, parallels Narcissus's moment of discovery. But whereas Narcissus's eyes offer him the unintended knowledge that he is his own beloved, Camila acquires a different kind of knowledge, an awareness of herself as Albanio's beloved. This recognition pushes the text into a politics of gender that is intimately connected with the dynamics of vision, for Camila rebels against the visual entrapment implicit in the sexual allure of her mirrored image. Repelled at seeing herself through Albanio's projection – and the role he has prescribed for her – she angrily averts her eyes from the reflecting waters and from the shepherd. Camila's rejection reminds us of the disdain of unruly Laura,

the "aspra fera" of the *Canzoniere* that both fascinates and dislocates her male creator. Yet Camila is as distant from the self-reflexive world of idolatrous obsession of Petrarch's subject, which famously prefigures early modern lovers like Albanio, as from the world of Ovid's Narcissus. Her true model lies in the non-introspective realm of Virgilian epic, in the Volscian warrior-maiden of the *Aeneid*, a follower of Diana who joins with Turnus against the Trojan intruder, Aeneas, and is killed by the Etruscan Arruns. As told by Virgil:

> But in the heart of the slaughter, like an Amazon, one breast bared for the fray, and girt with a quiver, rages Camilla; and now she showers tough javelins thick from her hand, now she snatches a stout battle-axe with un-wearied grasp; the golden bow, armour of Diana, clangs from her shoulders. And even when, pressed from behind, she withdraws, she turns her bow and aims arrows in her flight. (2000, 2:11.648–54)

Garcilaso's reimagined Camila rages against a new intruder, the alien image "inscribed" in the mirror. In this furious act, the chaste huntress sets herself against one of the period's cultural icons, the woman who celebrates her physical beauty by looking at herself in a mirror. Women contemplating their reflection in mirrors was a popular theme in the iconography of the female figure in paintings, such as Giovanni Bellini's *Nude Woman with a Mirror* (1515) and Titian's *Woman with Two Mirrors* (c.1512–17), which by adding a second mirror to the specular act, capture the excesses of self-contemplation. Both paintings focus our attention on the physical beauty of the women and their fixed gazes, which invite viewers to enter into a voyeuristic experience. In Bellini's painting (figure 4.1), a young nude woman looks into a small flat mirror she holds in her right hand; a larger mirror on the wall reflects the back of her head and the *reticella* – a brocade hair covering – she is presumably arranging. Rona Goffen notes that this self-referential picture is at once a representation of beauty itself and a novel commentary on the sense of sight: "while we look at the woman and at her mirror reflection, she looks at herself and into the mirror on the wall – into which she gazes indirectly, through the intermediation of her hand mirror" (1989, 255). For Goffen, she may be a type of Venus, evoked by two of the goddesses' attributes, the mirror and the pearls embroidered on the woman's Venetian *reticella*.[7] Titian's woman strikes a similar pose (figure 4.2). Partially undressed, a detail that expresses her sexuality, she employs the two types of mirrors then available, both held by a male attendant: a convex mirror that reflects her image from the back and a small flat

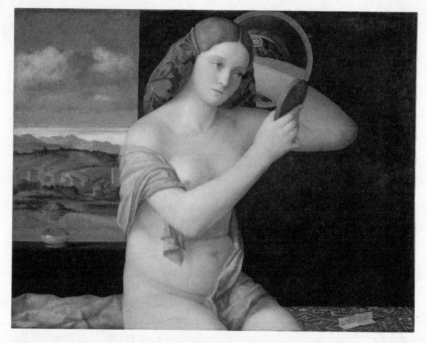

Figure 4.1: Giovanni Bellini, *Nude Woman with a Mirror*, 1515. Vienna, Kunsthistorisches Museum. Nimatallah/Art Resource, NY.

rectangular mirror from the front. If Bellini's female may be a married woman, identified as such by her *reticella*, Titian's may be a courtesan, whose gaze, locked on her reflection in the handheld mirror, evokes simultaneously an image of feminine pride and self-love, and an allegory of vanity, "a melancholy memento mori" (Phillippy 2006, 168).[8] In deliberate contrast to these iconic females, Camila refuses to fix her eyes on her image in the fountain, implicitly rejecting the mirror's dangerous lure, and its implication of both female narcissism and male voyeurism, the latter represented in the text by the shepherd's lusty eyes. She subscribes instead to an alternate model, the unblemished *speculum sine macula* symbolizing the purity of the Virgin Mary (Goldberg 1985, 121–2; Schwarz 1952, 98–100), which was popular in Europe among the Carmelites and the Franciscans.[9] But Camila's Virgilian origin offers her another virgin to emulate, Diana, chaste goddess of the hunt and the moon.

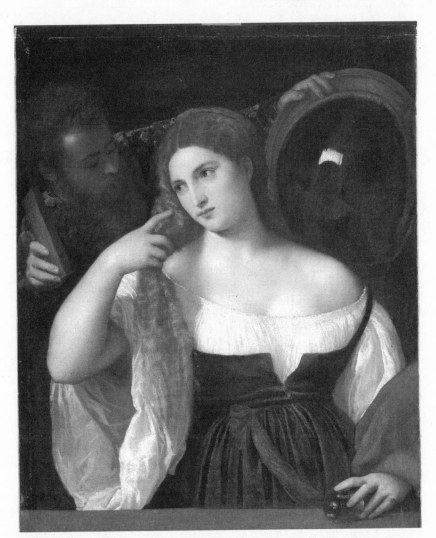

Figure 4.2: Titian, *Woman with Two Mirrors*, c. 1512–17. Paris, Musée du Louvre. © RMN-Grand Palais/Art Resource, NY.

Having told his tale of inner discord, Albanio leaves the fountain with Salicio. Camila, alone and outside Albanio's narrative, returns to the bucolic site to claim the mirror as her own. She appropriates it in order to "paint" her own portrait, but not by looking into it, for she refuses to play Albanio's game of visual self-reflection. Instead, she transforms Albanio's tainted mirror into an unreflecting and unblemished surface:

> ¡Ay dulce fuente mía, y de cuán alto
> con solo un sobresalto m'arrojaste!
> ¿Sabes que me quitaste, fuente clara,
> los ojos de la cara, que no quiero
> menos un compañero que yo amaba,
> mas no como él pensaba?

> [Oh my sweet fountain, and from how high,
> with a slight jolt, you hurled me down!
> Do you know that you took away from me, clear fountain,
> the eyes of my face, that I do not cherish
> less a companion whom I loved,
> but not as he thought?] (vv. 744–9)

Her lament ("me quitaste, fuente clara, los ojos de la cara") registers a common expression signifying the loss of a friend, here her companion Albanio. But that loss also liberates her from an imposed seeing, an imposed "reading" of her reflection, implicit in those very words ("me quitaste ... los ojos"): she saw her image through *his* eyes not her own. Freed from Albanio's representational trap, she reaffirms her singularity as virgin huntress, alluding to Diana's banishment of Callisto from her train after the nymph is seduced by Jupiter (Ovid 1984, 1:2.417–65):

> ... ¡Dios ya quiera
> que antes Camila muera que padezca
> culpa por do merezca ser echada
> de la selva sagrada de Dïana!

> [... May God grant
> that Camila die before she commits
> an offence that will banish her
> from Diana's sacred woods!] (vv. 749–52)

Camila's Body: Fountain and Statue

Camila's appropriation of the fountain, making that material site an emblem of her body, re-engages the politics of gender and vision. The fountain as an embodiment of feminine beauty recalls Ovid's Diana and her grotto, a sacred grove where "Nature by her own cunning had imitated art; for she had shaped a native arch of the living rock and soft tufa. A sparkling spring with its slender stream babbled on one side and widened into a pool girt with grassy banks" (1984, 1:3.158–62). The pastoral bower, with the fountain at its centre, converts nature into art and goes one step further by engaging sight, the sense privileged in the erotic dynamic of the text: "Las flores, a los ojos ofreciendo/diversidad estraña de pintura" [The flowers offered an extraordinary/diversity of colors to the eye] (vv. 440–1). This painterly aspect extends to the fountain:

> y en medio aquesta fuente clara y pura,
> que como de cristal resplandecía,
> mostrando abiertamente su hondura,
> el arena, que d'oro parecía,
> de blancas pedrezuelas varïada,
> por do manaba el agua, se bullía.

> [and in the middle of it all this spring,
> so clear and pure, glittered like crystal,
> so transparent that you could see the bottom;
> the sand, which might have been grains of purest gold
> was embellished with white pebbles, in places
> where the water ran rippling and bubbling.] (vv. 443–8)

Like the fountain with its scattered white pebbles and sand like gold, Camila's body is rhetorically dismembered, fetishized by Albanio, who at the beginning of the eclogue depicts her as a collection of exquisite, scattered erotic objects: "oh claros ojos, oh cabellos d'oro,/oh cuello de marfil, oh blanca mano" [o shining eyes, o lovely, golden curls,/o white, white hand, o neck of ivory] (vv. 20–1). Theresa Krier writes that at Diana's grove "Geographical boundaries are continuous with personal boundaries, and [Actaeon's] transgression of the grove continuous with transgression of her selfhood" (1990, 64). The eclogue, too, plays with porous boundaries. Like Diana's secret grove, the pastoral fountain is virgin territory:

En derredor, ni sola una pisada
de fiera o de pastor o de ganado
a la sazón estaba señalada.

[All around no footprint, nor any other
sign of living thing, nor beast nor shepherd,
was anywhere at that moment to be seen.] (vv. 449–51)

Commenting on Petrarch's fetishization of Laura, Nancy Vickers writes
that "bodies fetishized by a poetic voice logically do not have a voice of
their own; the world of making words, of making texts, is not theirs"
(1982, 107). Laura, as Vickers notes, can speak only after she dies. But
Camila resists and contests this "easy schematization." In challenging
Albanio's representation, she speaks and restores herself, "making" her
text and "remaking" herself in the process, an act of ontological neces-
sity revealing her agency.

As she lies silently asleep by the fountain. after her apostrophe,
Camila's body again becomes a source of the shepherd's visual and
erotic delight, this time not as shattered material parts but as an arte-
fact created by nature in its role as *natura artifex*. Like a jealous artist,
nature urgently destroys the mould of its incomparable creation: "una
obra sola quiso la natura/hacer como ésta, y rompió luego apriesa/la
estampa do fue hecha tal figura" [when Nature decided on this mas-
terwork/she made but the one model and then/she quickly broke the
mould in which the figure had been formed] (vv. 781–3). Two multi-
valent words –"estampa" and "figura" – converge for the figuration
of Camila's body. The *Diccionario de Autoridades* defines "estampa" as
an original mould or prototype, and "figura" as a painting or statue.
"Estampa" can also mean the "stamp or material object on which the
image to be printed is carved or engraved" [sello o cosa dura en que
está tallada la imagen que se estampa] (*Diccionario de Terreros*). Thus
"sacar en estampa" [to imprint an image] also refers to letters carved
on wood or metal or printed on a page, and here by extension to the
act of writing by a melancholy observer, who is himself a poet record-
ing the very scene he invents. It is as if the shepherd, a new Pygmalion,
were "carving" his beloved statue in writing. The breaking of the
"estampa" from which Camila's "figura" was made marks the
uniqueness of her bodily beauty. "Figura," an engraving on paper or
metal, a painting or statue, carries another meaning as well, *imago*,

representation (*Diccionario de Autoridades*), which points to Camila as a simulacrum, a kind of "absence" unavailable to her lover. Albanio refers to Camila's sleeping body as "fantasma" [phantasm], that is, a construct and projection of his imagination, a flimsy delusional imagining produced by melancholia: "¿Es error de fantasma convertida/en forma de mi amor y mi deseo?" [Is this some deceiving phantasm that has adopted/the likeness of my love and my desire?] (vv. 776–7.) Albanio tries to embrace the sleeping Camila. An angry physical and verbal struggle ensues, and she manages to escape his grasp and the bower – and the text – for good.

Madness and the Poet

Denied Camila, the lovesick Albanio slips into the manic phase of melancholia that is accompanied by schizophrenic delusions. Ovidian Narcissus's crisis of self-knowledge is carried one step further to pose a more troubling epistemological crisis for the new Narcissus of the eclogue: the impossibility of knowing the self at all. Albanio's dealings with the mirror signal moments of interiorization that accompany what melancholia provokes in the afflicted: a deep self-awareness often manifested by "opening" the body to display the spreading disease as spectacle.[10] In a particularly telling moment, Albanio aligns his self-diagnosis with humoral theory, which allows mental states and bodily matter to pass through permeable boundaries, "el mal … ha penetrado hasta el hueso" [this is a wound that's cut me to the bone] (vv. 144–5). In his madness he turns his attention outwardly, away from his inner self, to an obsession with his body, which he perceives as stolen. He remains but naked spirit:

> Espirtu soy, de carne ya desnudo,
> que busco el cuerpo mío, que m'ha hurtado
> algún ladrón malvado, injusto y crudo.

> [I am a spirit, of all my flesh stripped bare,
> I'm looking for my body, which was stolen
> by some vile thief, some wicked heartless knave.] (vv. 919–21)

Seeing not his image reflected in the mirror but his detached body frame, he begs it to return his human form: "a darme verdadera forma

d'hombre" (v. 935). In his drama of misrecognition, Albanio takes over fragments of Narcissus's speech from the *Metamorphoses* (1984, 3.448–68) to woo his body, only to conclude with a delusional "discovery," that a "thief" has dressed himself up with his flesh [revestido de mi carne] (v. 990).[11] This scene recasts Ovidian Narcissus's belief that his reflection is a "living form," luring him "from the bottom of the pool" (Melchior-Bonnet 2002, 102). In the *Metamorphoses*, as Shadi Bartsch points out, Ovid engages philosophical notions of Socrates's teachings in the *Phaedrus* about eros, reflection, and self-knowledge (2006, 84). All three are evoked in Narcissus's story of "reflection gone awry," a tale that came to stand "for an entire pathology of the self" (2006, 84). The process of discovery at the reflecting pool does not lead to higher things, as in the specular mirroring of the *Phaedrus*, but instead follows a Lucretian model of deceptive, vain imaging: it is "mired in a circularity that – far from providing the impetus for change (the 'social' mirror) or for progress towards the Forms (the 'Platonic' mirror) – cannot escape beyond two pairs of mirroring eyes, one by the water and one in it" (2006, 88).[12] Caught in the realm of *simulacra*, the illusory, fleeting images that he loves and are brought into focus by the warning of Ovid's narrating voice ("that which you behold is but the shadow of a reflected form and has no substance of its own") (1984, 1:3.434–5), Narcissus dies, as Tiresias had prophesized, dissolving by the side of the pool. Albanio offers a pathology of a different kind. Certain of his "invisibility" and oblivious to the reflecting nature of his mirror, the shepherd materializes his specular double. Seeing his image as an alien body that has assumed his flesh ultimately reveals his own interior dissolution. Removing the mirror's mediating function erases epistemological certainty and calls attention to his psychic rupture, the self's internal exile from itself. The splitting of the self, the disjunction between the observing subject and the perceived object of Narcissus at the mirror, is reworked as a symptom of Albanio's melancholia.

With the erasure of the pool as a reflecting surface, the shepherd's self-figuration is displaced into another myth of loss and absence, one with death at its centre: the tale of Orpheus, the *vates* and enchanter who cast a spell on the inhabitants of Hades to retrieve his lost Eurydice. Invoking the Thracian's voice, Albanio obsessively fixes his attention on the recovery of his body, hoping to find it in the dark kingdom of the dead:

convocaré el infierno y reino escuro
y romperé su muro de diamante,
como hizo el amante blandamente
por la consorte ausente que cantando
estuvo halagando las culebras
de las hermanas negras, mal peinadas.

[I will call on hell and the dark regions
and batter down their adamantine wall,
like the famous lover, that time he went
to rescue his missing consort, and used
his sweet song to cajole the black sisters,
beguiling the snakes in their disheveled hair.] (vv. 940–5)

The mirroring surface of the fountain not recognized as such is trans-
formed into a "muro de diamante" [diamond wall], the entrance to the
Underworld, as in the *Aeneid*, where a "huge gate" is flanked by "pil-
lars of solid adamant" (Virgil 1999, 1:6.552). In appropriating Orpheus's
magical song to "break" the unyielding surface, Albanio displays a
characteristic detected by Freud in narcissism and shared by children
and schizophrenics, an omnipotence of thought linked to the belief
in the magic of words (1978, 14:75). If Albanio lacks Orpheus's verbal
magic, his association with this Logos figure is highly significant, for it
allusively represents the shepherd as poet.[13]

Even more relevant in defining Albanio as poet is Ovidian Echo, the
nymph whose speech is curtailed by Juno as punishment for distract-
ing the goddess with her chatter from Jove's erotic dalliance with other
nymphs. Fated to repeat the speech of others, her seductive messages to
Narcissus are revealed only through her unintended echoes of his
words (1984, 1:3.379–92).[14] In the eclogue, this discursive mirroring is
borrowed for a new act of figuration, one that parallels the play with
Narcissus's mirror reflections in Albanio's intimate self-disclosure.
Echo appears in the shepherd's apostrophe to the creatures of the
woods as he seeks consolation after Camila's first rejection. Albanio es-
tablishes a special bond with Echo, who shares his unhappy fate in love
and shows some pity, answering his plaint [respondiéndome] (v. 599),
though she denies her presence: "mas no quiere mostrarse" [refuses to
show herself] (v. 601). He welcomes Echo's verbal presence, with his
own words echoing in the woods, which the invisible nymph repeats,

just as Narcissus's words rebounded to him from Echo's voice. Echo, meaning "image of the voice" in Latin, is recognized as such in Ovid's text when Narcissus is deceived by the nymph's verbal repetitions: "alternae deceptus imagine vocis" [deceived by the answering voice] (1984, 1:3.385). By mirroring himself through her voice, Albanio becomes an "echoed sound," much like Narcissus. But the "disembodied" Albanio, only a name in his imagination – "agora solo el nombre m'ha quedado" [at present I am left with only a name] (v. 936) – resembles more precisely and evocatively the nymph, who, spurned by Narcissus, wastes away into a bodiless voice that bears only a name (1984, 3.399–401). Mieke Bal writes that "Ovid exploits to the full the literary potential of the auditive mirroring through the figure of Echo, as a sonoric embodiment of the visual mirroring [of Narcissus]" (2001, 255, note 3). Acoustic mirroring opens the way for Echo to serve as an emblem of poetic voice, even if she can speak only when spoken to, abridging Narcissus's statements by repeating his final words.

Ann Rosalind Jones writes about the figure of Echo as the alter ego of Garcilaso's contemporary, the Italian poet Gaspara Stampa, whose sonnet 152 (written in the 1540s) reads in part: "an image almost identical to Echo, of woman I retain only the voice and name" [quasi ad Eco imagine simìle,/Di Donna serbo sol la voce e 'l nome]. Jones notes that Stampa's disembodiment "still leaves her with the two attributes of a poet: a voice and a name, discursive power and literary renown" (1991, 268). "Speaking as Echo ['I … answer to his final words']," Jones adds, "she reactivates the nymph's relation to language. No longer merely listening to Narcissus and abbreviating his words, Stampa's Echo becomes a speaker of her own desires …" (1991, 269). Echo-like, Albanio ascribes name and voice to himself and, like Stampa, further enriches his words as the eloquent melancholic that he has become. If Albanio, of all the melancholics in Garcilaso's poems, suffers the most extreme case of inner impoverishment, he also is the most verbally exuberant. He is an ideal example of a cultural prototype, the exceptional individual who suffers from melancholia as an "accredited pathology," an "eloquent form of mental disturbance" that Freud finds in Hamlet, the visionary and "speaker of truths," and that Ficino regarded as the special gift of the superior man of letters (Schiesari 1992, 8–9).[15] Albanio's gifted eloquence is attested by a copious discourse of 460 lines in *terza rima* describing the hunting scenes and dalliance with Camila, and 81 lines of lament in *rimalmezzo* over his lost body. This impassioned storyteller in the lyric mode figures himself metatextually as a poet.

Unable to recognize himself in the fountain, he sees instead a young man who looks like him: "Allá dentro en el fondo está un mancebo,/de laurel coronado y en la mano/un palo, propio como yo, d'acebo" [But look, under the water there's someone,/a young man crowned with laurel, with a stick/in his hand, just like mine, a holly bough] (vv. 913–15). In ancient texts, both madmen and poets were crowned with laurel (Morros 1995, 184, 494–5).

Albanio may be unaware that the water reflection is his own, but in this specular moment the text self-consciously reveals the shepherd's double identity: the mirror informs the reader of the melancholic's troubled nature and his fractured psyche – his distorted visual perception conspiring with the mirror to prevent self-knowledge or escape – but also announces his status as one of the most eloquent, albeit self-absorbed, poetic voices in Garcilaso's fiction. If Albanio seems to be rescued from his imagined immateriality by the written word (his abundant discourse), in another interpretive register something unsettling and even dangerous is brewing in the shepherd's figuration through Echo. The nymph stands for an act of precarious voicing, like Orpheus, whose "voice and death cold-tongue" mournfully call out from a decapitated head, rolling down the Hebrus river, repeating his lost Eurydice's name (Virgil 1965, Georgics 1:4.523–7). Echo's own truncated, limited speech is not devoid of its power to communicate, for in answering Narcissus's cries with partial echoes, she supplies loving phrases that he understands and rebukes (Brenkman 1976, 300–4). Yet her speech unfolds without agency of its own, her fragmented words being mere repetitions. And this uncontrolled verbal performance foreshadows Albanio's own by the end of his story, where his speech, fragmentary and dispersed, prevents coherent communication with his shepherd friends, Salicio and Nemoroso. Slapstick accompanies the swift, broken dialogue (vv. 984–1031) as the shepherds keep Albanio from throwing himself into the fountain, and then proceed to tie him up.

Painting in the Mirror

Albanio the poet, craftsman of verbal illusions, is also a painter like Narcissus. Leon Battista Alberti in his treatise on painting, De pictura (1435), declares Narcissus to be the inventor of painting, in effect the first painter. "What is painting," Alberti asks, "but the act of embracing by means of art the surface of the pool?" (1972, 63). Alberti animates in

his own way Narcissus's attempt to embrace the beloved in the pool, that is, his own reflection, by expressing the double calling of painting as a form of truth and a form of deception. As Paula Carabell puts it: "Alberti's account of the origins of painting compares image-making to the natural phenomenon of reflection; it responds to the fact that both the surface of water and that of pictorial space have the potential faithfully to reproduce reality. His parallel also establishes, however, that like its prototype, painting creates a mimetic equivalent that is illusory in nature" (1998, 53). Looking into the watery mirror before the moment of recognition, Narcissus "paints" his own work of art, his self-portrait, which is, as Paul Barolski notes, "a double illusion," for the viewer in his own self-deception is fooled into believing the reflection is at once a real person and someone "other than himself" (1995, 255).

Standing motionless, looking "in speechless wonder" at his reflection, Ovidian Narcissus seemed "like a statue carved from Parian marble" [ut e Pario formatum marmore signum] (1984, 1:3.419). Ovid's "ut ... signum," "like a statue," may also mean in its multivalence, like a mark, like an image, like a sign. Albanio at his mirror seems an equally illusory construct, a flimsy presence "painting" itself through signs, and so revealing, in the very verbal performance, its inherent fragility. Like Narcissus at first, Albanio does not recognize himself nor does he recognize the mirror for what it truly is, "a boundary between reality and fiction," a site of illusion that is as well a site of creation and artifice.[16]

Parmigianino's *Self-Portrait in a Convex Mirror* (1524, figure 4.3) offers an intriguing comparison with the eclogue, for this *maniera* painter, like his contemporary Garcilaso, explored the confusion of boundaries at the mirror as the site of illusion and artifice. The *Self-Portrait* was a gift to the Medici pope Clement VII, a discerning collector of antiquities and paintings, and may well have been hanging in the papal residence, acclaimed in its own time, when Garcilaso passed through Rome in 1532 on his way to Naples with newly appointed viceroy, Pedro de Toledo. Vasari deemed the painting a "cosa rara." As he points out in his *Lives of the Artists*:

> In order to investigate the subtleties of illusion, [Parmigianino] set himself one day to make his own portrait, looking at himself in a convex barber's mirror. And in doing this, perceiving the bizarre effects produced by the roundness of the mirror ... the idea came to him to amuse himself by counterfeiting everything. (1996, 1:934–5)

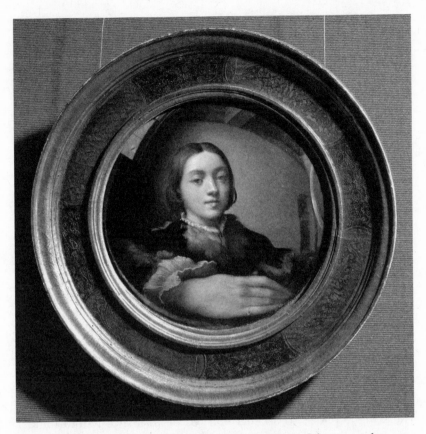

Figure 4.3: Parmigianino, *Self-Portrait in a Convex Mirror*. Oil on curved circular panel, 1524. Vienna, Kunshistorisches Museum. Erich Lessing/Art Resource, NY.

Parmigianino painted his reflection on a wooden panel shaped like a convex mirror (according to Vasari this was made by dividing a ball of wood in half). What is most compelling in this painting is not the reflected self but its distortions, most prominently the outsized scale of the hand relative to the head and the discordant planes of the eyes. The hand, the craftsman's tool calls attention in particular to the mirror as the site for creating illusions, for what the viewer sees as the right hand is actually Parmigianino's left hand. The hand transgresses the

painting's frame, spilling over from the bounded world of reflection into the viewer's own world. As Joanna Woods-Marsden writes, the painting is a "capriccio," an "amusing conceit," to demonstrate the artist's *ingegno*, a display of art at its most deceptive (1998, 137). David Ekserdjian points to a remarkable detail, omitted by Vasari, that further focuses on the ingenious play of reality and fiction – the gold-frame form to Parmigianino's extreme left, which is "the portrait the viewer is admiring set up on the artist's easel" (2006, 130).

In our eclogue, Albanio's misreadings – the projection of his ruptured psyche, the illusory images of his inner chaos – call attention to the deception of self-imaging. The *magister* Salicio, listening to Albanio's mad ravings before the fountain, captures best the artifice of the performance. Praising the gifted shepherd-poet-painter, Salicio remarks: "El curso acostumbrado del ingenio,/aunque le falte el genio que lo mueva .../corre un poco" [The accustomed *ingenium*, even when/it lacks the vital spirit that directs it,/runs on a little] (vv. 948–50). Like Parmigianino, Garcilaso – through Albanio as a new Narcissus – plays with the mirror to present his exceptional performance within the liminal spaces between fantasy and reality. For the mirror proved to be not only a durable object useful for reflecting the material world, but also a multivalent tool equally capable of de-materializing the viewer and his optics, and of confounding as well as confirming the self's image of itself.

The Urn's Tale

The eclogue passes to another spirited performance within liminal spaces, this time between history and fiction. A new cast of characters converges at a crystal urn that memorializes the House of Alba, in particular its third duke, Fernando Álvarez de Toledo (1507–82), fast companion and protector of Garcilaso. Located on the Alba estates as a unique family memorial, the urn presents a staged recollection through carved images in which historical events are reconstructed for encomiastic purposes to fashion a powerful identity for Fernando according to the model of the Castilian warrior, whose very being and repute were forged in the long march against the Moors. The urn exalts the young duke, who is twenty-five at the time, for emulating his grandfather in the Reconquista and his father in Spain's colonial wars in North Africa. And yet, if Fernando is the product of a well-rehearsed cultural model, he emerges as a somewhat dissonant, if lauded, presence.

What makes the urn such a compelling site of recollection and celebration is that it commemorates public deeds, in sharp contrast to the private, interior world reflected in Albanio's mirror. The urn's military iconography in fact resembles the one carved on Trajan's marble column (figure 4.4), which celebrates the Spanish-born emperor's victorious wars against the Germanic Dacians. Erected in 106–13 as part of the vast Forum Traiani in Rome, the column was standing in Garcilaso's time (and with renovations, it still is) and may well have inspired the poet's encomiastic urn, which links Habsburg and Roman triumphs (see below). Here Garcilaso aligns himself with contemporary historiography as practised by Annius of Viterbo, and notably Florián de Ocampo, whose political agenda while serving as the emperor's official historian was anchored in the humanist ideal of linking Spain to the classical past in order to legitimize royal authority (Dandelet 2001, 44–5, 81). Garcilaso follows this paradigm as he envisions Fernando de Toledo riding victoriously with Charles V, the new Caesar, against Suleyman the Magnificent, the new barbarian, in the Vienna campaign.

The virtues and deeds of the Alba are revealed through a layered narrative cast in multiple media. In the first layer, a set of images carved by the river Tormes on the urn's surface is transcribed by the humanist Severo, who is traditionally identified with Fernando's tutor, the Italian Benedictine monk, Fray Severo Varini (vv. 1470–1548). Severo's written account of the scenes is then read by the shepherd Nemoroso, who retells the tale to his friend Salicio. This discursive *mise en abîme* – with memorable events of the Alba migrating from crystal relief to written document to oral tale and ultimately to the poet's text – must have caught the eye of Miguel de Cervantes, a confirmed Garcilasista, who uses this technique throughout his *Quixote*. There is a further twist to the urn's tale, for Tormes recounts not only past events but also divinely inspired future events: "lo que, antes d'haber sido, el sacro viejo [el río Tormes]/por devino consejo puso en arte" [that which, before actually happening, the sacred old man (the river-god Tormes) put into art through divine counsel] (vv. 1175–6). The conceit of history as prophecy endows the encomium with an aura of wonderment, with the text privileging the terms "espanto" [awe] and "maravilla" [marvel].

The Urn as Archive

The crystal urn, "una labrada y cristalina/urna donde [Tormes] reclina el diestro lado" [a carved crystal urn on which Tormes reclines on his

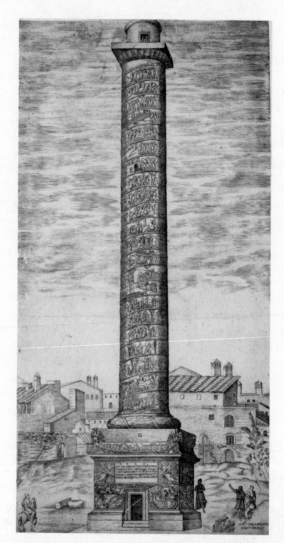

Figure 4.4: Trajan's Column from the *Speculum Romanae Magnificentiae*, published by Antonio Lefreri, c.1575. Engraving by Enea Vico, published by Antonio Salamanca, 1541–62, Rome. Reproduced by permission of the Special Collections Research Center, University of Chicago Libraries.

right side] (vv. 1172–3), stands at once for the source of the river's waters, his "fuente," and the source of the narrative carved on it.[17] Tormes's urn assumes a powerful role as an archive which preserves the cultural memory of the Alba. "Memory takes root," Pierre Nora reminds us, "in the concrete, in spaces, gestures, images, and objects" (1995, 633). Yet something more is required of a material site of memory: it must be "read" by someone who can unravel its visual vocabulary to give it a voice. Within the eclogue's fiction, that person is Severo, who is invited by Tormes into the river-god's sacred space "[el] escondrijo de su fuente" [the secret hideaway] (v. 1170) on the Alba estates, where the urn's narrative is opened to scrutiny. To understand the urn's function as archive and the intimate dynamic between its two magical figures, Tormes and Severo, it is helpful to recall the rich etymology of the term archive and the fundamental issues regarding origins, knowledge, history, and authority embedded within it.

Archive (from the Latin *archivum*) points through its Greek root – *arkheion* – to a privileged site of secrecy and power, initially the place where the *archons*, the magistrates, guarded official documents by virtue of their authority.[18] Tormes fulfils the *archon*'s function as maker and guardian of an archive whose sacred, quasi-mythological presence confers authority upon the material "documents" gathered within it, documents that lie as yet outside the flow of history. By sharing his archive with Severo, the river-god entrusts the tutor and scholar with his own "hermeneutic right," a divinely inspired task to interpret the archive's contents. It is as if Tormes, the dispenser of the law, were silently commanding Severo to take on the role of historian, one who "remembers" by decoding and recording the urn's scenes. Archive, again through the Greek root – *arkhe* – points to origins, beginnings, and it is no accident that the origin of the river's waters is also the site of the origin of discourse: the urn's mute tale is the Ur-text, the master narrative underlying storytelling brought to life – and into the present – by Severo's reading and transcription. Severo's narrative functions, in effect, as the urn's inscription, legitimizing Tormes's master narrative and bringing it into the public sphere, as required by panegyric. The reader encounters the visual narrative transformed into the written text in the guise of Nemoroso's oral retelling.

Tormes locates Fernando's identity firmly in his lineage, for character flows from ancestry. Lineage not only moulds the self, it breeds cultural and religious values, determines political ideologies, and cements moral attitudes.[19] That highly charged notion, with its emphasis on nobility

of blood, dictates that the eclogue begin with Don García Álvarez de Toledo (1430–88), founder of the House of Alba, whose portrayal sets a compelling script for Fernando to follow. Tormes chooses to celebrate not Don García's prominent role in the civil wars in Castile in service to Ferdinand and Isabel, notably the important victory at Toro (March 1476), which had long been commemorated with much fanfare at Alba de Tormes, but rather García's earlier rebellion against King Juan II, who held the duke's father captive. Courage ("pecho corajoso" [valiant breast]) (v. 1182), combined with a certain nobility of spirit and independence ("brío desdeñoso") (v. 1181), was put in service to filial duty and allegiance to his clan [bando nobiliario]: "cruda guerra movía despertando/su ilustre y claro bando al ejercicio/d'aquel piadoso oficio" [he waged a harsh war, summoning his illustrious and honourable clan to that pious enterprise] (vv. 1185–7). That sense of independence resonates in the urn's nuanced portrayal of Fernando.

Not at all nuanced are the acts of Fernando's grandfather Fadrique (1460–1531) and his father Don García (1490–1510), who fought against the Moors. Fadrique epitomizes the intensity with which the Alba pursued their dreams of military glory and service to the Crown. "While other clans," writes William Maltby, "were withdrawing from active political life and retiring to live off the riches that Ferdinand and Isabella had been wise enough to confirm, Fadrique simply refused to take the hint. He raised his sons to be professional soldiers and encouraged them to believe in their moral obligation not only to fight for but to advise the Crown" (1983, 7). A formidable soldier, Fadrique battled the French in the siege of Salsas in 1503 and the battle of Navarre in 1514. But what profoundly marked him, as it did other Castilian nobles, was the earlier struggle for Granada in 1492, which engendered "a crusading mentality that developed with time into a passionate hatred of the infidel" (Maltby 1983, 8). Fadrique instilled that crusading mentality in his sons and grandsons.

Severo reads the materiality of warfare inscribed on the urn – instruments of battle, bodily parts and wounds – to define Fernando's valiant and violent lineage, expanding historical traces into spectacles of blood and courage against which the young Fernando will be measured. Fadrique's armour is bloodied in combat against the French in the Navarre campaign: "con el arnés manchado de otra sangre" [his armor red with enemy blood] (v. 1205). Against the Moors at Granada, the tenacity and courage of this Christian warrior, "caudillo del cristiano" [the leader of Christians] (v.1198), are embodied in his very flesh:

"ejercitó la mano y el maduro/seso y aquel seguro y firme pecho" [he exercised his hand, his wise judgment, and that sure and firm breast] (v. 1199–1200). Fernando's father Don García de Toledo, commander of Spain's Mediterranean fleet, who was entrusted with containing the Muslim pirates sailing from North African ports, has his heroism written on his wounds as he is "pierced and broken by a thousand blades" [atravesado y roto de mil hierros] (v. 1251), in a re-imagining of his death in 1510 on the island of Djerba off the coast of Africa. In addition to the actual events recounted by soldiers who escaped to Spain, we find invented details of the goriest of struggles, with García's hand, singled out through synecdoque, featured as both a killing instrument and courage itself, dismembering the bodies of his enemies:

> Unos en bruto lago de su sangre,
> cortado ya el estambre de la vida,
> la cabeza partida revolcaban;
> otros claro mostraban, espirando,
> de fuera palpitando las entrañas,
> por las fieras y estrañas cuchilladas
> d'aquella mano dadas ...

> [Some rolled around in the harsh pool of their own blood, their life line already cut, their heads slashed open; others clearly showed, as they died, throbbing entrails gushing out of the fierce and strange sword-wounds exacted by his hand ...] (vv. 1242–8)

The punitive hacking of human flesh, with the eviscerated body exposing its entrails, is one of the most violent passages in Garcilaso's poetry and a foil to raise García's valour to epic proportions. It echoes the spilling of organs in Homer's *Iliad*, where Philides "struck [Amphiclus] at the top of the leg where a man's muscle is thickest; and around the spear point the sinews were torn apart" (1999, 2:16.314–16), and Patroclus, victorious over Zeus's mortal son Sarpedon, "setting his foot on his chest, drew the spear out of the flesh, and the midriff followed with it; and at the same time he drew out the spear point and the soul of Sarpedon" (1999, 2:16.503–5).

But the telling of García's death is built on the dismembering tradition of the anatomical blazon, with bodily images cast in lyrical touches rather than epic gore. His broken body spilling on the scalding African sand recalls scenes of the dying nymphs of the Third Eclogue, in

particular the sensual and violent picture of Eurydice's delicate body, with its floral simile, succumbing to death after having been bitten on her white foot by a poisonous snake: "descolorida estaba como rosa/ que ha sido fuera de sazón cogida" [she was pale like a rose/that has been plucked out of season] (vv. 133–4). In García's case, beauty and violence are similarly juxtaposed at the moment of dying to dramatize his own vulnerable passage to colourless exile from the living, the face making visible the death of the body:

> puso en el duro suelo la hermosa
> cara, como la rosa matutina,
> cuando ya el sol declina al mediodía,
> que pierde su alegría y marchitando
> va la color mudando; o en el campo
> cual queda el lirio blanco que'l arado
> crudamente cortado al pasar deja,
> del cual aun no s'aleja presuroso
> aquel color hermoso o se destierra,
> mas ya la madre tierra descuidada
> no le administra nada de su aliento,
> que era el sustentamiento y vigor suyo,
> tal está el rostro tuyo en el arena,
> fresca rosa, azucena blanca y pura.

[He put his handsome face on the hard ground, like the morning rose that loses its freshness when the sun sinks at noon and, wilting, gradually changes its colour; or like the lily, which, cut down harshly by the plough and left behind, still retains its whiteness, but fades away, mother earth neglecting to give it the life that was its sustenance and vigour; so your face lies on the sand, a fresh rose, a white and pure lily.] (vv. 1253–66)

The hand and the face stage with great immediacy the world of death and bloodletting. Yet as material signs, these bodily parts connect with the world of interiority, where they reflect García's exemplary character. If the hand wielding the sword stands for courage and heroism, the lyrical meditation on the beautiful face in the throes of death – engaging as it does the early modern belief in physiology as a reflection of interior life – points to the virtues and moral perfection characteristic of the Alba warrior.

The Third Duke Fernando

Fernando's ancestors at war dictate the duke's military and moral trajectory from his earliest years. Fadrique was especially instrumental in moulding the child Fernando "into an edged weapon against the enemies of Christendom. All the warlike and crusading traditions of the house, all the military knowledge of this formidable grandfather were brought to bear, with terrifying intensity, upon the child" (Maltby 1983, 10). At six Fernando was taken by his grandfather to the battle of Navarre and at thirteen, fascinated by the art of war, the boy learned by heart Vegetius's *De re militari*, a late Roman treatise on military tactics (c. 400). The urn has the tutor Severo introduce Fernando to the weapons of Mars (vv. 1354–5), essential for the making of a skilled warrior: "Obraba los engaños de la lucha;/la maña y fuerza mucha y ejercicio/ con el robusto oficio está mezclando" [He practiced the games of war; cunning, strength and exercises combined with the toils of war] (vv. 1359–61).

The urn posits a supernatural dimension in the construction of Fernando's identity as soldier and courtier even from birth, which it celebrates in the tradition of a natal poem (*genethliacon*), following examples by Statius and Ausonius, and – closer to Garcilaso's time – Ariosto's *Orlando furioso*, where a tapestry portrays astrological gods gathered to exalt the newly born Hippolytus, the son of Ercole d'Este, duke of Ferrara, and Eleanor of Aragon (2008, 46.84–6). The *Orlando* has the baby's name inscribed on his "swaddling clothes," while Tormes writes "don Fernando" on the infant's crib (v. 1283). The inscription guides Severo in deciphering the urn's iconography and introduces Fernando to the gods, the evocative "don" resonating with Mercury and Mars who, in Severo's words, see the "great courtier and warrior shrunk in the body of the newly born" [el gran caballero que'ncogido/ en el recién nacido cuerpo estaba] (vv. 1293–4).

Joining the gods in celebrating young Fernando are two historical characters, his tutor Severo and his *ayo* Juan Boscán. "It was customary among the wealthier nobles," writes Maltby, "to provide both a tutor who dealt with academic subjects and an *ayo*, who was generally a young man of good family and knightly attainments." The *ayo* provided "companionship and informal teaching in the arts of war, athletics, deportment, and civilized conversation" (1983, 11). The tutor Severo is astonished to see a faithful rendition of himself, his "body, age, and face," as if he were looking into a mirror [como si en espejo se mirara,/

en cuerpo, edad y cara eran conformes] (vv. 1317–18). He realizes from his reflection that he was fated before birth "to be the one to instruct the divine soul" of his charge [que habia de ser quien diese la doctrina/al ánima divina deste mozo] (vv. 1324–5). The self-admiring "I would be the one" becomes programmatic of his role as celebrant of Fernando, his word and voice carrying Fernando's virtues from the secluded urn into the open. The *ayo* Boscán, poet and translator of Castiglione's *Il Cortegiano*, instructs Fernando in courtly virtues: manners, good breeding, courtesy, and gentleness (vv. 1340–6).

The urn displays the double life of Fernando as warrior and lover by placing Mars and Venus side by side in his upbringing, leading the reader to suppose that a notion popular among early modern philosophers and antiquarians, *discordia concors* (the taming of the god of strife by the gentle goddess of love from which Harmony is born), is firmly bred in the young Alba. The text pauses on the materiality of war, as Venus takes Fernando away from "aquel áspero trato y son de hierro" [that harsh manner and clang of iron] (v. 1365) instilled by Mars, revealing as an error "armar contino el pecho de dureza,/no dando a la terneza alguna puerta" [to arm continuously the breast with hardness, not giving tenderness an entrance] (vv. 1367–8). Implicit in the text is Venus making Fernando abandon his armour – line 1367 signalling by equivocation both the armour's breast plate and the hardening within – a reminder of Venus's "defeat" of the god of war, as depicted in paintings like Botticelli's *Mars and Venus* (figure 4.5), where *putti* dressed as little satyrs play with the surrendered weapons of a sleeping Mars, while a serene Venus watches the scene.

For all the praise in constructing Fernando's identity as courtier, soldier, and tender lover, a certain disharmony in his character emerges. The sweetness and tenderness brought to him by the goddess of love turn to erotic frenzy on his wedding night. *Eros* is part and parcel of the tradition of the epithalamium (witness Catullus: "since openly you take your desire and do not hide your honest love," 1988, 61.197–8), but Fernando's is excessive:

Apenas tienen fuera a don Fernando,
ardiendo y deseando estar ya echado.

[Hardly had don Fernando been let loose, burning and desiring to mate.]
(vv. 1415–16)

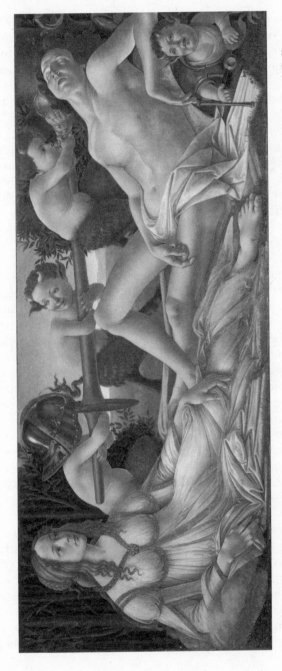

Figure 4.5: Botticelli, *Venus and Mars*. Tempera and oil on panel, c. 1485. London, National Gallery.© National Gallery, London/Art Resource, NY.

The line "ardiendo y deseando estar ya echado" deeply offended the Neoplatonist Fernando de Herrera, who writes in his commentary: "Bajísimo y torpe verso en número y sentencia. Esto no sé cómo lo dijo Garci Lasso, que muy ajeno es de su modestia y pureza" [Lowly and awkward line in number and meaning. I don't know how Garcilaso could have said this, so alien it is to his accustomed modesty and purity] (Gallego Morell 1972, 546).[20] Garcilaso's close friendship with the duke confers a special authority on the telling of the wedding night and seems to confirm contemporary accounts of Fernando's impulsive and unruly streak.[21] The duke's immodest "fire," recorded in lowly language by Severo, is jarring in an encomium. Yet his unruliness will reappear in a different register in Fernando's dealings with the Turks, once again striking a dissonant note.

The Vienna Campaign

In the summer of 1532 Fernando carried his family's combative spirit to Vienna to meet the forces of Suleyman the Magnificent threatening the city.[22] Fernando had become third duke of Alba at the death of his grandfather in October 1531 and quickly responded to the emperor's call to repel the Turks. His enthusiastic response was grounded in an ingrained hatred of the infidel but also in self-promotion, for only in service to the emperor could he advance the interests of his house. He had little to offer beyond a name and a sword. The Ottomans were feared for their military sophistication and ruthless expansionism, especially after Suleyman's forces penetrated the Danube valley, invaded the kingdom of Hungary, and reached the outskirts of Vienna in 1529. Charles V assumed the defence of his Habsburg inheritance and the Christian west. For the young duke "it must have seemed the perfect overture to a great career: a crusade for the protection of all Christians fought on a distant battlefield against the most formidable of opponents" (Maltby 1983, 25).

The urn stages Fernando as a Castilian crusader. The duke's journey to Regensburg prepares the way for a new encomium anchored in Roman military triumphs. As he crosses the Rhine, memory of an earlier history animates the urn-archive, "la memoria ... [del] vencedor latino" [the memory of the Latin victor] (vv. 1473–4): Julius Caesar, who crossed the Rhine in 55 BCE to fight the Germans, becomes an exemplar for the Castilian warrior confronting the new barbarian.[23] At Regensburg, where Charles had convoked a Diet to deal with the impending war,

and later at the "battle" outside Vienna, Fernando is linked allusively to another Roman military hero, Emperor Trajan, who fought Germanic tribes on the Danube. The marble column commemorating Trajan's victories, one of Rome's best known ancient monuments, finds discursive analogues in the urn, where Fernando is placed side by side with Charles, sharing in his role as the new Trajan.[24]

The column, which commemorated the Roman emperor's victorious campaigns against the Dacians (101–6 CE), had a privileged place at the colossal Forum Traiani within a colonnaded court flanked by Greek and Latin libraries, two semicircular complexes, an enormous basilica, and a triumphal arch.[25] By Garcilaso's time only the column remained as an iconic presence and popular tourist site. During his visits to Rome, he may have been inspired by the narrative monument dedicated to a Spanish-born emperor. In the tradition of friezes on Roman temples, monumental altars, and triumphal arches, Trajan's Column embodies a powerful official history of empire, just as the crystal urn's sculpted scenes project an authorized history of the military exploits of the Alba. Like Trajan's narrative, which begins with a river god, the Danube, the urn's tale begins with the river Tormes, as if the gods themselves worked their will through Trajan and Fernando. At the base of Trajan's Column an inscription informs the viewer that the monument was dedicated to the emperor (Lepper and Frere 1988, 203, note 4), while the urn's own epigraphic impulse is announced by the inscription on the duke's crib – "don Fernando." From the base of Trajan's Column, a spiral band of figures in relief details the emperor's campaigns: a Council of War, Trajan addressing his troops, the boats crossing the Danube, the flight of the Dacians and their captivity, the gathering of enemy helmets and shields in a pile, the appearance of personified Victory. Reading scenes of Trajan's campaigns into the urn's parallel narrative reveals the poem's imperial register in which both Charles and Fernando share. The urn proclaims that Charles convoked the Diet of Regensburg as a war council (vv. 1505–7) and gathered troops from many nations (vv. 1523–4), but it is Fernando who addressed the soldiers – Flemish, Spaniards, Italian, Germans – winning them over through his persuasive voice and generous hands [su mansa lengua y largas manos] (v. 1564). For the Italians, Fernando is even identified with Scipio Africanus (vv. 1550–4), the designation commonly applied to Charles, as in Garcilaso's "A Boscán desde La Goleta" (see chapter 2). After the enemy surrenders, the allegorical figure of Victory embraces both Charles and Fernando (vv. 1675–8). Enemy soldiers flee

their camp, are taken captive, and are tied in Roman fashion to the wheels of carts, which carry their possessions in piles, the booty of war: "broken lances, helmets and banners, light armour, broken shields" [lanzas rotas, celadas y banderas,/armaduras ligeras de los brazos,/ escudos en pedazos divididos] (vv. 1686–8).

The Barbarians and Their Luxury Goods

Both in the West and the East, luxury fabrics, silk in particular, were markers of power, success, status, and taste. The Ottoman Sultans, most notably Suleyman (r. 1520–66), who was a patron of the arts and architecture, had a passion for objects made of precious materials, exquisitely illustrated manuscripts, fine metalwork, ceramics, brocaded satin and velvet kaftans and furnishings, and textiles in keeping with the power and wealth of his empire, hence the rubric the Magnificent (Atil 1987, 113–75). Ottoman silk, threaded damask, and velvets were exported to Venice, which in time developed a silk-weaving industry of its own, with its brocades, damasks, and velvets desired all over Europe (Jardine 1996, 120). Giovanni Bellini's portrait of Doge Leonardo Loredan in splendid robe and bonnet (figure 4.6) was a reminder not only of Venice's luxury and wealth but of the East's opulence, which had spawned such a tradition in textiles. But in the urn's depiction of the battle against Suleyman at Vienna, luxury goods take on a different hue, relying on a cultural stereotype to characterize the defeated Turks, an excessive fondness for rich fabrics and splendid clothing: "hábitos y sedas variadas" [habits and a variety of silks] (v. 1685), denoting moral depravity. "Hábito" points both to custom and costume, equating luxury with a cultural way of life, riches with behaviour, a notion made explicit in the phrase: "el vestido a su costumbre" [the dress according to their custom] (v. 1517). Fleeing in panic, they leave behind not only their riches (v. 1652) but also their tents, which the urn identifies as spaces of sloth, lust, and brute vice [do pereza y do fornicio/con todo bruto vicio obrar solían] (vv. 1653–4). The Turks are defined by the term "bárbara": "bárbara jactancia" [barbarous arrogance] (v. 1513); "gente bárbara" [barbarous people] (vv. 1682–3). For Garcilaso and his contemporary readers, these material markers, imposing an otherness on the enemy born of religious, political, and military conflicts, reinforced a recent memory of the "recovery" of the kingdom of Granada (which Fernando's grandfather

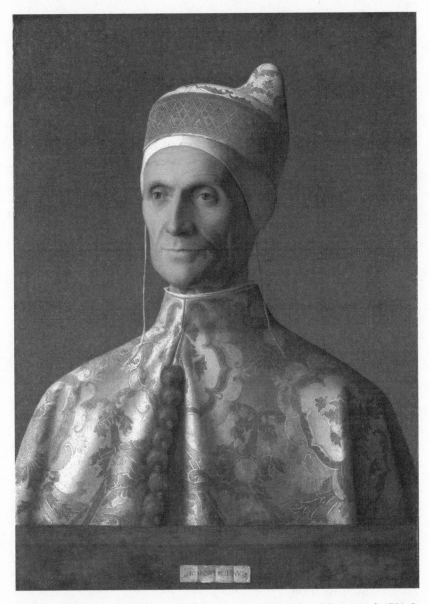

Figure 4.6: Giovanni Bellini, *Portrait of Doge Leonardo Loredan*. Oil on panel, 1501–2. London, National Gallery. © National Gallery, London/Art Resource, NY.

helped reconquer), and which here is grafted onto the scene on the Danube. Lavish buildings, baths, and the luxury items of the conquered Moors in faraway Andalusia lingered in the Spanish imaginary that overlays the urn's iconography. The urn captures one detail of the fleeing Turks, their "faldas" [skirts], part of their customary dress most visible at the moment when the Christians pursue them ("el áspero enemigo a las espaldas,/que les iba las faldas ya mordiendo" [at their back the fierce enemy, almost biting their skirts] (1659–60), and which denote feminine behaviour and attribute weakness and cowardness to the enemy. The feminization of the male warrior is a stereotypical image imposed by the Christian on the Other, be it the Amerindian in the New World or the Muslim in the Old.

The most famous luxury item at Vienna, which does not appear on the urn, is Suleyman's elaborate helmet, commissioned from Venetian artisans and worn on his march to battle Charles (figure 4.7). The Venetian diarist Marino Sanuto recorded on 13 March 1532 that he had seen a magnificent helmet: "surmounted by a plume in an elaborate crescent-shaped mount, at whose center was an enormous turquoise surrounded by rubies, diamonds, pearls and emeralds; its headband was studded with pointed diamonds … [and] four removable crowns encircled the helmet; each of the four crowns' 12 points was topped with an enormous pearl; in addition the three larger crowns were each set with four diamonds, four rubies, four emeralds …" (Jardine 1996, 379). Commissioned specifically to announce Suleyman's might, the crown-helmet was paraded by the sultan along with other regalia of imperial power, ceremonial objects like a sceptre and a throne (Necipoglu 1989, 407). Jardine points out that it was part of a "highly choreographed triumphal procession outside the walls of Vienna in May 1532," designed in order to outdo Charles's procession in Bologna, where he wore his ceremonial crown after his coronation as emperor. The iconography of Suleyman's procession represented him as the second Alexander the Great to rival Charles's claim to be the second Caesar (1996, 381). It also served as a backdrop to the urn's tale of luxurious artefacts from the East, and as a sign for the representation of Ottoman power in a political and cultural rivalry between East and West.

The Castilian Warrior

Fernando's zeal in battle, as the Turks flee the scene, sets off a confrontation with Charles, in which their distinct political and military goals

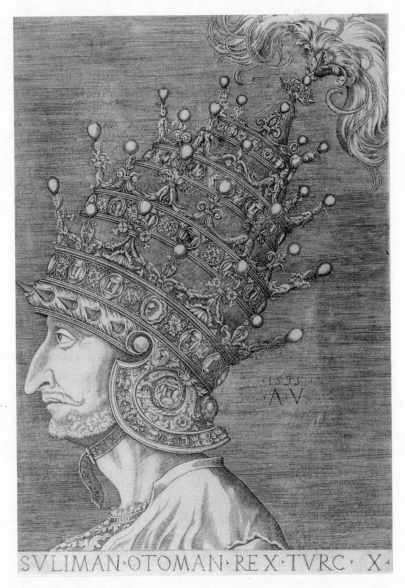

Figure 4.7: Agostino Veneziano, *Sultan Suleyman the Magnificent Wearing the Venetian Helmet*. Engraving, 1535. The Elisha Whittelsey Collection. The Metropolitan Museum of Art, NY. © The Metropolitan Museum of Art/Art Resource, NY.

clash. Fernando – identified with an Irish hound – impatiently attempts to pursue the enemy, while Charles restrains him. The epic simile enacts the young duke's violent surge of energy and thirst for blood:

> César estar teniendo allí se vía
> a Fernando, que ardía sin tardanza
> *por colorar su lanza en turca sangre.*
> Con animosa hambre y con denuedo
> forcejea con quien quedo estar le manda,
> como el lebrel de Irlanda generoso
> que'l jabalí cerdoso y fiero mira;
> rebátese, sospira, fuerza y riñe,
> y apenas le costriñe el atadura
> que'l dueño con cordura más aprieta:
> así estaba perfeta y bien labrada
> la imagen figurada de Fernando.

[Caesar is seen restraining Fernando, who is burning *to colour his lance in Turkish blood*. With boldness and courage, he struggles with the one who orders him to stay still. Like the noble Irish hound that looks at the bristly and fierce boar, he resists, sighs, strains and fights, and is barely constrained by the leash that the master wisely tightens: so was Fernando's figure, so perfectly sculpted [on the urn]. (vv. 1661–72; my emphasis)

The struggle between Fernando and Charles is in fact an invention. Suleyman's army fled before the duke and the emperor reached Vienna, and neither saw the Turkish retreat as represented on the urn. It is known that Fernando and Charles clashed at the Diet of Regensburg (17 April–27 July 1532), where the emperor and the Lutheran princes were debating over how to engage the advancing Turks. The Protestant estates suspected that the troops requested by the emperor to fight Suleyman would be used instead by Charles's brother Ferdinand for his private war to claim the Crown of Hungary. "Once assured that the sultan's army was indeed marching up the Danube towards Vienna," writes James Tracy, "the estates voted a 'Turk tax,' but stipulated that imperial troops were not to be deployed beyond the borders of the empire" (2002, 138–9). Fernando was among those who wanted to pursue the enemy into Hungary (Maltby 1983, 27), in opposition to Charles, who agreed with the majority of the princes because he could not afford

to disrupt the fragile balance of power in that part of the empire being torn apart by the Protestant Reformation. It is this disagreement about fighting the Turks (who retreated in August or early September, while Fernando and Charles were still at Regensburg) that Tormes may have carved on the urn. The fictional reconstruction of an historical event placed in an epic frame – in which Fernando appears as a fractious subject, opposing the emperor's will – allows the urn to contrast their characters and aims.

That scene takes on added meaning in light of a famous portrait painted by Titian about the same date as the poem (1532–3), where Charles, in splendid imperial dress, holds a hunting dog by the collar (figure 4.8). Charles's clothing and posture point to the majesty and presence appropriate to his exalted self-image. In this evidently self-promoting painting, Charles in his "power suit" dominates the dog, a symbol of loyalty. Fernando, the unruly "hound" straining at the leash, "que ardía sin tardanza/*por colorar su lanza en turca sangre*" [who is burning *to colour his lance in Turkish blood*], far from signalling his betrayal of Charles or a defiance of his authority, displays graphically the duke's zeal in acting out what had been instilled in him by his ancestors – a singular hatred of the infidel – and recalls as well his great-grandfather Don García's earlier act of rebellion against his own king. It is no coincidence that Fernando had experienced a traumatic event at the age of fifteen, when he witnessed his father's dead body, returned by the Moors, paraded solemnly through the Alba estates for days before being buried "at San Leonardo after a magnificent funeral with a Solemn High Mass" (Maltby 1983, 13). Fated by ancestry, indeed a prisoner of his personal and cultural memory, Fernando embodies perfectly that single-minded quest to purge the world of the infidel. On Tormes's urn, Fernando is defined against another, more flexible model of conduct represented by Charles and embedded in those memorable lines: "apenas le costriñe el atadura/que'l dueño con cordura más aprieta" [is barely constrained by the leash that the master wisely tightens].

The political and religious arena of Central Europe in the 1530s was far more complex and nuanced than Spain's. The gravest threat to Charles – Protestantism – compromised the emperor in facing the Turks. Though as much a crusader against Islam as Fernando, he was compelled to follow a prudent, less confrontational course with the Lutheran princes than the one driving the duke. Fernando's model of

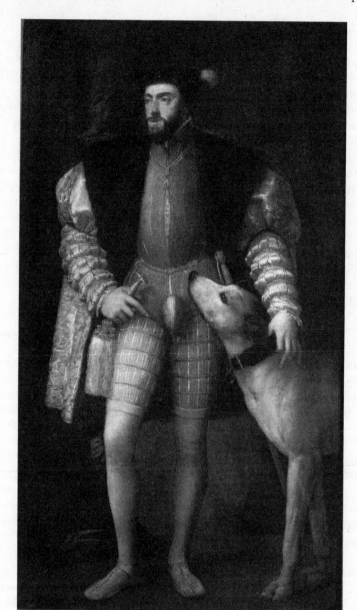

Figure 4.8: Titian. *Portrait of Charles V with a Dog*. Oil on canvas, 1533. Madrid, Museo del Prado. Scala/Art Resource, NY.

intense, almost blind, ferocity was misplaced here. His rightful place in history lay in the future, beyond the urn and Titian's painting. Three decades later, as Philip II's leading general, Fernando would colour his lance in Flemish blood and become known as the "butcher of Flanders." Despite some evidence that he was not as cruel as reputed, Fernando was the perfect tool of the king's political and religious agenda in the Netherlands. In carrying out Philip's repressive policies, he was ultimately responsible for the massacre of thousands of innocents, considering it better, in his own words, "to lay waste a country than leave it in the hands of heretics" (Kamen 2004, preface, 1).

Fernando's impetuous nature surfaces again, as he returns to his wife "en amoroso fuego todo ardiendo" [burning in amorous fire] (v. 1702), and is received triumphantly by the fertile plain of the Tormes, conceived as a pastoral bower rejoicing exuberantly at the duke's return (vv. 1720–37). Severo is puzzled by a luminous glow on the urn, which he compares to a comet but cannot quite make out (vv. 1766–71). Tormes explains that it represents Fernando's future deeds, but the glow is so brilliant that the naked eye cannot see them, just as when coming out of a dark space one is blinded by the sun, "el sol ardiente, puro y relumbrante" [the burning sun, pure and shining] (vv. 1790). Recalling Plato's myth of the cave, this allusion is more expansive, reminiscent of images in Sannazaro's *De partu Virginis* (1515), whose crystal urn with its engraved prophecies (2009, 3.78–81) is a model for Tormes's urn. In Sannazaro the images are messianic; in the eclogue they prophecy future military glories for Fernando. The end of the urn's tale, a blending of recollected history, magic, and myth, makes Fernando larger than life in a veritable apotheosis.

Language and the Material

Having read and memorized Severo's written account, Nemoroso retells it orally to his shepherd friend, giving presence to the absent artefact. But to convey the urn's "strange and marvellous things" [cosas/estrañas y espantosas] (vv. 1154–5), Nemoroso needs a special voice. To loosen his tongue "in sweet and subtle ways" he invokes the nymphs and other creatures of the woods [soltá todos/mi lengua en dulces modos y sotiles] (vv. 1157–8), then celebrates Severo's "gentle song and sweet lyre" (v. 1162), as if to acquire by linguistic contamination the magician's verbal skill and Orphic powers (vv. 1161–8). Verbal magic rightfully accompanies the healer's function as seer, a

visionary capable of "reading" the deeds of the Alba carved in relief. Although Nemoroso cannot match Severo's incantatory powers, he nonetheless achieves the verbal efficacy that Renaissance poets aspired to, establishing his authority as the teller of Severo's magical song. His reaction to Severo's song ("Yo estaba *embebecido* ... atento al *son* [I was *fascinated* ... attentive to his *song*]) (vv. 1107–8; my emphasis) parallels Salicio's own reaction to Nemoroso's song at the end of his story ("me tienes ... al *son* de tu hablar *embebecido*") [I am *fascinated by the sound* of your speech])(vv. 1829, 1831; my emphasis). Fascination results both from the story itself and, more important, from its telling, for here Nemoroso rehearses an intimate knowledge of early modern pictorial and rhetorical techniques. In a life-like reproduction of Don García de Toledo, Fernando's father, in the disastrous Gelves expedition, Nemoroso comments on the power of the silent image to evoke life:

El está ejercitando el duro oficio,
y con tal arteficio la pintura
mostraba su figura, que dijeras,
si pintado lo vieras, que hablaba.

[He is exercising his harsh duty, and the painting showed his figure with such artifice that, if you saw it, it would seem that he was speaking.] (vv. 1228–31).

Nemoroso recalls ancient pictorialist doctrine, the double dictum that Plutarch attributes to Simonides of Ceos (c. 556–467 BCE): painting is "mute poetry," and poetry a "speaking picture." The shepherd plays with Simonides's terms as he tells Salicio that the warrior's voice seems to be contained within the urn's silent image ("painting"). We know, however, that it is Nemoroso's own voice that breaks through the silence, for he is the "orator" who practises *enargeia*, "the rhetoric of presence," which gives life to the mute image, placing it before Salicio's "eyes" in accordance with Erasmus's prescription: "Instead of setting out the subject in bare simplicity, we fill in the colours and set it up like a picture to look at, so that we seem to have painted the scene rather than described it, and the reader seems to have seen rather than read" (1978, 24: 577). An eloquent example occurs in the urn's inscription of a fragment from Botticelli's *Primavera* (figure 4.9) at the moment of Fernando's birth:

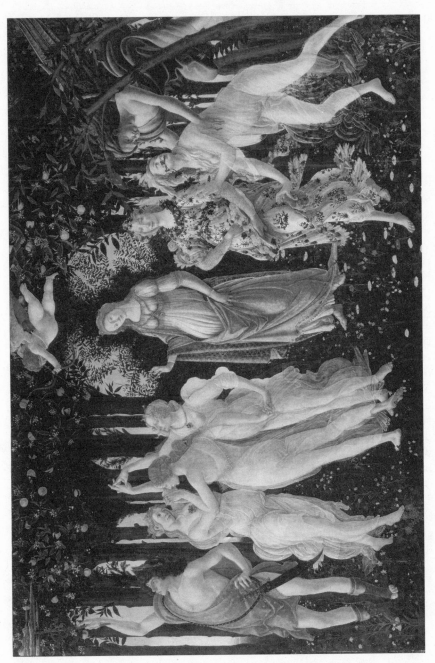

Figure 4.9: Botticelli. *Primavera*. Tempera on panel, c. 1482. Florence, Uffizi. Scala / Art Resource, NY.

De vestidura bella allí vestidas
las gracias esculpidas se veían;
solamente traían un delgado
velo que'l delicado cuerpo viste,
mas tal, que no resiste a nuestra vista

[The sculpted graces appeared, dressed in beautiful garments; their
delicate bodies were covered only by a veil so thin that our eyes could
see through it]. (vv. 1271–5)

The term veil brings to mind the notion of *integumentum*, the word as a
veil behind which lies the semantic concept, although here the veil be-
comes one with the body it covers like a dress ("un delgado velo que'l
delicado cuerpo viste"). This image, evoking Erasmus's technique of a
verbal excess or supplement joining *res* and *verba* to achieve linguistic
plenitude and presence, foregrounds metatextually the plenitude of
Nemoroso's own rhetoric of presence. Fittingly, the figure of Chlora to
the far right of the Graces in Botticelli's painting – which stays outside
Nemoroso's narrative but perhaps was recalled by the informed Salicio,
a courtier in disguise – offers a visual enactment of this linguistic enter-
prise, with its focus on the material nature of words. Eugene Vance
comments on the corporealizing of verbal signs in the portrayal of this
figure: "As Chlora looks intently into Zephyr's face, she is physically
'inspired' during the transgression [Zephyr's erotic advances], and out
of her mouth flows an eloquence not of words but of flowers. Chlora is
simultaneously transformed by Zephyr's *pneuma* into Flora, whose
dress is now *ornamented* with the living flowers of Chlora's breath, and
whose swollen lap is filled with even more real flowers. Flowers also
bloom copiously in the grass at Flora's feet" (1986, 337; emphasis in the
original).

At the end of Severo's "reading" of the carved images, which the
tutor has faithfully recorded, Nemoroso draws attention to the effica-
cious verisimilitude with which the artist Tormes has executed the
images:

[Severo] contaba muy de veras que, mirando
atento y contemplando las pinturas,
hallaba en las figuras tal destreza,
que con mayor viveza no pudieran
estar si ser les dieran vivo y puro.

[Severo recounted with much truth, while looking attentively and contemplating the paintings, how the figures were rendered so skillfully that they could not be more life-like, even if they were brought to life. (vv. 1747–51)

If Severo himself wrote with efficacy presenting the images before the "eyes" of his reader, Nemoroso in turn does the same in his oral narrative, "painting" the figures, especially of Fernando, and setting them before Salicio's "eyes" in accordance with the advice that Erasmus had so enthusiastically put forth for the use of *enargeia*. Salicio does not disappoint:

> acá dentro me siento,
> oyendo tantos bienes
> y el valor deste príncipe escogido,
> bullir con el sentido
> y arder con el deseo
> por contemplar presente
> aquel que, 'stando ausente,
> *por tu divina relación ya veo.*

[Listening to so much praise and the courage of this chosen prince, my senses stir and I burn with desire to see in person the one who, though absent, *I already see through your divine account.*] (vv. 1832–9; my emphasis)

Conceding the power of Nemoroso's word to make him "see" the absent Fernando in his mind's eye, Salicio desires more, the duke's actual presence. Knowing this to be impossible, he posits an alternative: "¡Quién viese la escritura,/ya que no puede verse la pintura!" [How good it would be to see the writing since the painting cannot be seen!] (vv. 1840–1). Nemoroso, the encomiast and panegyrist, commands the proper speech to give presence to the urn's images as recorded by Severo. Within the fiction of the text, Nemoroso is only a mediator and his words are oral signs, ultimately unstable and unreliable. By seeking the material fixity of Severo's manuscript, Salicio reveals the limits of orality. The written text, being closer to the urn and to Fernando, creates a more authentic figuration of the duke. Yet ultimately, the images carved by the river god on the crystal urn, Severo's written record of those images, and Nemoros's oral retelling survive only on the poet's printed page.

The poem lacks closure. The story comes to an end with brief words about Severo's healing Albanio and Salicio's ironic remark: "al hato iré

derecho,/si no me lleva a despeñar consigo/d'algún barranco Albanio, a mi despecho" [I will gather the herd right away, if Albanio does not throw himself down a cliff and drag me down with him] (vv. 1882–4). The hurried ending gives us a clue that once storytelling is done, the curtain must fall.

5 Eros at Material Sites

A recurring interest in Garcilaso's Neapolitan poems is the relation between the psyche and the body, interiority and materiality, in a self destabilized by melancholy eros. The lover's affliction is a cultural malaise stemming from a profound sense of loss that evokes sadness and despair, but is typically conceived as an exulted condition. A lack of fixity, a sense of in-betweenness, endows the melancholic by long tradition with extraordinary powers of perception and artistic excellence. The Florentine Marsilio Ficino, following Aristotle, understood melancholia as a "unique and divine gift," the exclusive subjectivity of the man of letters.[1] In the four poems I analyse in this chapter, Garcilaso examines the world of the melancholy lover through acts of introspection and projection at material sites. In the first two poems those sites are external. In Sonnet 11 the subject seeks healing from river nymphs in their crystal palaces; in Sonnet 13 a spectator reenacts Ovidian Daphne's bodily transformation and is drawn into Apollo's melancholy spectacle. In the next two poems melancholy subjects materialize their psychic interior. One stages self-reflexive fantasies, products of his humoral and phantasmatic imagination (*Canción* 4). The other, working as well with the phantasmatic tradition, imagines his beloved as a writer who inscribes her face on his soul as if it were a tablet (Sonnet 5).

Weaver Nymphs in Crystal Palaces

The melancholy lover of Sonnet 11 attempts to negotiate an escape from his condition by addressing self-absorbed river nymphs who live in luminous mansions:

Hermosas ninfas, que en el rio metidas,
contentas habitáis en las moradas
de relucientes piedras fabricadas
y en columnas de vidrio sostenidas,
 agora estéis labrando embebescidas
o tejendo las telas delicadas,
agora unas con otras apartadas
contándoos los amores y las vidas:
 dejad un rato la labor, alzando
vuestras rubias cabezas a mirarme,
y no os detendréis mucho según ando,
 que o no podréis de lástima escucharme,
o convertido en agua aquí llorando,
podréis allá despacio consolarme.

[Slender nymphs who dwell within the river,
contentedly inhabiting those halls
constructed of shining stones
and underset by crystal columns,
 whether bowed over your embroidery,
or toiling at the weaver's delicate art,
whether sitting in little groups apart
making your loves and lives into a story,
 set aside for a moment what you are doing
and raise your lovely heads to view my plight;
and don't take long, for such is my present state
 that either for pity you will shrink from listening
or, when weeping turns me into water here,
there'll be time enough to comfort me down there.]

These naiads are sixteenth-century counterparts to Virgil's weaver nymphs, who answer the shepherd Aristaeus's call when, after losing his bees to hunger and sickness, he stands by the river Peneus seeking his mother's Cyrene's help. The nymphs have names, individualized clothing, and lovely fetishized bodies: Ligea and Phyllodoce have "shining tresses floating over snowy necks" (1999, *Georgics* 1:4.336–7), Arethusa has golden hair, and Clio and Beroe, daughters of Ocean, are huntresses arrayed in gold and "dappled hides" (1:4.342). Their bodies are defined by the very material they are spinning, fleeces of Miletus, "dyed with rich glassy hue" (1:4.335), reflecting, as we imagine, the

translucent quality of the flesh of these watery creatures. Garcilaso's nymphs lack names and clothing but are fetishized ("rubias cabezas") and distinguished by their delicate tapestries [telas delicadas]. Most distinctive are their sumptuous "moradas," translucent dwellings of luminous stones and crystal columns, whose textual antecedents are well known. Virgil's nymphs inhabit a chamber deep in the river with a roof of pumice stone, where they sit on crystal thrones (1999, 4.333, 350, 374–5). Sannazaro's *Arcadia* (Book 12), an embellished version of Virgil's *Georgics*, places them in caverns of "rough pumice stones," "drops of congealed crystal," and pillars made of "translucent glass" (1966, 12, 135). But if we locate Garcilaso's "moradas" within the context of his encounter with Italy, they take on a specific cultural dimension.

In the summer of 1532, on his way from Vienna to Naples, Garcilaso spent ten days in Rome with his friend and protector Pedro de Toledo, the newly appointed viceroy of Naples. They may have stayed at the lavish Villa Medici-Madama, which Raphael designed for Cardinal Giulio de' Medici, future Pope Clement VII, and which became an official lodging for visiting dignitaries. Although damaged in the sack of Rome in 1527, the villa was still in use in 1532 for ceremonial entries into Rome and as a centre for public events through the sixteenth century (Coffin 1979, 150, 255). A distinguishing feature of the Madama garden was the nymphaeum, which Giorgio Vasari ascribes to Giovanni da Udine: in the luscious landscape stood a "fountain in the hollow of a torrent-bed surrounded by a wood; causing water to flow in drops and fine jets from sponge-stones and stalactites, with beautiful artifice," as in a natural grotto (1996, 2:492). This fountain of stones and stalactites dripping and shining with water, perhaps simulating crystal pillars, resembles Garcilaso's "moradas." Leonard Barkan identifies a practice among early modern Romans of using artefacts as occasions for storytelling (1999, 210). The Madama fountain described by Vasari may have occasioned Garcilaso's own cultural and aesthetic reconstruction of a site where the material and the discursive meet, where his own imagined antiquity could be projected on nymphs and their dwellings, with a recast Virgilian narrative supplying the script. Garcilaso certainly visited other palaces during his stay in the city, such as the Palazzo Venezia, built by Pope Paul II (1464–71), which was attached to the titular church of S. Marco and used as a papal summer retreat. There, an enclosed garden resembled a monastic cloister, with a fountain at the centre and surrounded by trees, an idyllic retreat celebrated

in two Latin poems supposedly inscribed on the garden walls. One claims that visitors came to the site "to relax the soul and to drive away harsh cares," while the other, closer to our sonnet, evokes "the gardens and dwellings of the dryads and lovely greenswards surrounded by porticoes and snow-white columns" (Weiss 1958, 40–1). The sonnet's nymphs inhabited a similar restorative space.

When the lyric subject implores the nymphs to raise their heads of blond hair [rubias cabezas] above the water to look at him, he recalls Virgilian Arethusa, who raises her "golden head" (1999, 1:4.352) to look at Aristaeus and to tell Cyrene that her son is calling out to her.[2] The sonnet's subject, too, seeks comfort from the nymphs, who as weavers and lovers with intimate knowledge of the workings of desire are eminently suited for the task. Above all, their Virgilian origin marks them as maternal and nurturing. In the *Georgics*, the nymphs soothe and comfort Aristaeus. Cyrene steeps his body in a stream of fragrant ambrosia: "a sweet effluence breathed from his smoothened locks, and vigour and suppleness passed into his limbs" (1999, 1:4.415–18). Garcilaso's melancholic, a close reader of Virgil, brings his weaver nymphs into his own cultural milieu, perhaps imagining them within their own *villeggiatura* [villa life]. "Early modern villa culture," writes Tracy Ehrlich, "was shaped by the ancient Roman ideal of *otium* ... as an antidote to urban *negotium*" (2002, 1). Despite its use for ceremonial political affairs, the villa was primarily a quiet retreat for relaxation and recreation, a salutary withdrawal from the business activities and intrigues of urban centres, as the poems on the walls of Pope Paul's Roman villa prescribe.

The nymphs live in luminous abodes in *otium*, which the lyric self seeks as an antidote to his own special kind of *negotium*, the business of love melancholy, a malady he contracted, we may suppose, in court circles. It is instructive to remember that Marsilio Ficino, who considered himself a melancholic and thus an exceptional and gifted man of letters, found his own sanctuary in a *villetta* at Careggi, a gift from his patron Cosimo de' Medici. That refuge, which he called the Academia, was an ideal place to soothe his melancholy while living close to nature in quiet contemplation, pursuing his studies of Plato. Earlier Petrarch had revived the ancient idea that the contemplative life of *otium* made possible artistic and philosophical creativity in the solitude of the countryside. Withdrawing from the activity of the papal court, Petrarch chose to live in a modest *villetta* in the Vaucluse, near "a grotto with the source of the Sorgue."[3] There he wrote the *Solitary Life* and his poems to

Laura, where his subject broods in melancholy nostalgia, "alone and filled with care," walking through deserted fields, "with steps delaying and slow" (1976, Sonnet 35). In Garcilaso's sonnet the subject seeks refuge from psychic dissolution in a riverine countryside, and calling out to the nymphs, he pursues the business of poetry in his *otium* in the manner of Ficino and Petrarch.

In Virgil, Aristaeus's call is answered by golden Arethusa, who "looks forth" (1999, 1:4. 351–2), but in Garcilaso's sonnet, where the lyric voice seeks fixity and stability from the nymphs in order to escape the profoundly unstable, mobile field of desire, his look is not met. If we draw on psychoanalysis, the nymphs belong to the field of the Imaginary, the realm of mirror images. Living in water, the privileged reflecting medium in myth and pastoral, they serve in effect as a mirror for the lover, who seeks a salutary reflection of himself in an image of wholeness and harmony, like the wholeness and harmony of the naiads. By raising their heads to return his look, they would reveal their presence and provide him his desired specular image.[4] But Garcilaso's nymphs, in their distant, fictive autonomy, personify otherness, and thus remain somewhat hazy, undefined presences. That they lack names and remain silent intensifies the sense of distance, as does their precious, otherworldly setting. Denied admission to their restorative world, the melancholy lover is doomed to psychological and ontological instability.

The poem's language both shapes and reflects the instability of the subject caught in a moment devoid of containment or closure. The structure "either-or" is projected on the nymphs practising their craft: "agora estéis labrando embebescidas/o tejendo las telas delicadas" [either bowed over your embroidery,/or toiling at the weaver's delicate art] and on his view of himself: "que o no podréis de lástima escucharme,/o convertido en agua aquí llorando" [either for pity you will shrink from listening/or, when weeping turns me into water here]. "Either-or" enchains disparate actions, but as a sign of linguistic instability it exposes his disjunction and disquiet. At the moment of utterance, "either-or" is a moment-in-between, with psychological indecision translated into linguistic indecision, language becoming an accomplice of desire.[5] Destabilized language is, in effect, the language of Ovidian metamorphosis, where individuals are gradually transformed according to Hellenistic models. Imprisoned in an interval of bodily dislocation, they appear neither fully human nor fully animal, tree, or stone.

The sonnet ends in a state of irresolution, hinting at the lover's eventual transformation into water: "convertido en agua aquí llorando,/

podréis allá despacio consolarme" [when weeping turns me into water here,/there'll be time enough to comfort me down there], echoing Petrarch's *Canzone* 23, where the weeping subject is transformed into water, "a fountain at the foot of a beech" [una fontana a piè d'un faggio] (1976, v. 117), an emblem of his inner impoverishment. That fall within, which makes him a stranger to himself and to the world, is modelled on Ovidian Byblis who, consumed by tears after her brother's rejection of her incestuous love for him, is converted into a fountain (1984, 2:9.663–4). In the *Metamorphoses*, Lelegeian nymphs counsel Byblis on how to cure her love, but failing to comfort her, they finally bestow their greatest gift, "a vein of tears that could never dry" (1984, 2:9.657). For the sonnet's subject, transformation would be the only means to bridge the gap separating him from the nymphs. Converted into water, he would enter their liquid element to become another love anecdote for their delicate tapestries, as in the Third Eclogue (see chapter 1). Unlike Petrarch and Ovid, however, Garcilaso offers only an intimation of transformation. The melancholy lover is left in the gap between two states, in a final nowhere land of indecision. Incapable of action and more narcissistic than his narcissistic Italian predecessors, he takes centre stage, "poor and empty," alone with his sense of loss, pleasurably exhibiting and recording his unmitigated sorrow.

Apostrophe, the sonnet's most prominent trope, evokes the lyric subject's rhetorical presence as poet. Invocation, argues Jonathan Culler, is "a figure of vocation" (1981, 142). "If asking winds to blow or seasons to stay their coming or mountains to hear one's cries is a ritualistic, practically gratuitous action," he writes, "[it] emphasizes that voice calls in order to be calling ... to summon images of its power so as to establish its identity as poetical and prophetic voice." Calling for the nymphs' look and presence, if not quite gratuitous, is an occasion for literary virtuosity. Ostensibly a failure in eliciting a visual dialogue, the lover's apostrophe to the nymphs evokes a fruitful dialogue with other texts and with other fictive nymphs to construct his own text. Apostrophic fiction ultimately becomes a ritualistic staging of his poetic voice and his poetic genius.

Daphne's Scenographic Body

In Sonnet 13 the subject engages a textual spectacle from Ovid's *Metamorphoses* to portray a melancholy drama of loss centred on Daphne's body. Ovid's seductive text of fractured bodies and extremes

of erotic passion was a fertile source for Renaissance writers, and the fetishized body as a fragile construct was a particular lure. The sonnet is familiar:

> A Dafne ya los brazos le crecían
> y en luengos ramos vueltos se mostraban;
> en verdes hojas vi que se tornaban
> los cabellos qu'el oro oscurecían:
> de áspera corteza se cubrían
> los tiernos miembros que aun bullendo 'staban;
> los blancos pies en tierra se hincaban
> y en torcidas raíces se volvían.
> Aquel que fue la causa de tal daño,
> a fuerza de llorar, crecer hacía
> este árbol, que con lágrimas regaba.
> ¡Oh miserable estado, oh mal tamaño,
> que con llorarla crezca cada día
> la causa y la razón por que lloraba!

> [Daphne's arms were growing: now they were seen
> taking on the appearance of slim branches;
> those tresses, which discountenanced gold's brightness,
> were, as I watched, turning to leaves of green;
> the delicate limbs still quivering with life
> became scarfed over with a rough skin of bark,
> the white feet to the ground were firmly stuck
> changed into twisted roots, which gripped the earth.
> He who was the cause of this great evil
> so wildly wept the tree began to grow,
> because with his tears he watered it himself.
> O wretched state, o monumental ill,
> that the tears he weeps should cause each day to grow
> that which is cause and motive for his grief.]

The lyric voice, revealed by the "vi" [I saw] of the third line of the first quatrain, positions himself as the eye of a camera. That position of mastery of the visual field is sanctioned by Leon Battista Alberti's theory of perspective in *De pictura* (c. 1435), which calls on geometry and optics to present the world as a picture, framed and centred, as viewed from an open window. Stephen Heath calls Alberti's conception of space

"scenographic," in the sense of a "space set out as spectacle for the eye of a spectator. Eye and knowledge come together; subject and object and the distance of the steady observation that allows the one to master the other" (1981, 30). A woodcut by Albrecht Dürer from *The Teaching of Measurement* (1525) illustrates Alberti's prescriptions in a way that is instructive for interpreting Garcilaso's viewer: a painter draws a nude woman as he gazes through a glass grid, reproducing her on his paper grid, linear perspective imposing a controlling order over her body (figure 5.1).[6] We may envision Garcilaso's lyric speaker – if not as a painter then as a pictorial imagist – framing and positioning Daphne's body Albertian-like in space, establishing himself as master of his spectacle.[7]

The sonnet's imagist works within another system of visual representation, which is animated by Erasmus's rhetorical principle of *enargeia*, "the capacity of words to describe with vividness that, in effect, reproduces an object before our very eyes" (Krieger 1992, 6). *Enargeia* (*en-argeia*) means "bringing into light," that is, bringing things into the field of vision (Cave 1976, 6). Erasmus offers the most comprehensive early modern theoretical formulation of *enargeia* and the specific techniques to achieve it, prescribing for the writer what Alberti prescribes for the painter, the creation of a spectacle for the eyes. "We can take an action which is either in process or completed," writes Erasmus, "and instead of presenting it in bare and insubstantial outline, bring it before the eyes with all the colours filled in, so that our hearer or reader is carried away and seems to be in the audience at a theatre" (1978, 24:577). By "colours" Erasmus means all that which makes the description appear like a picture, including "circumstantial details" and figures of speech – "similes and contrasts," "metaphors," and "epithets" that "will light up a topic" (1978, 24:579) – apt instructions for the lyric speaker, who positions himself as the audience of his "play" and whose powerful "vi" calls readers to join him as spectators.

Daphne's scenographic body is a luminous material presence for the viewer's eyes, with true colours (green, gold, white) as well as "colours" in the Erasmian sense – rhetorical figures, mainly epithets and antitheses. She is described according to the rhetoric of the blazon, a poem in praise of the female as a collection of exquisite body parts, linking her to an ideal type, the Petrarchan lady.[8] If a painting or a tapestry inspired the speaker's pictorial imagination, Ovid's Daphne prompted the representation of her body. In the *Metamorphoses*, Daphne – seeking to escape Apollo, who is following her through the woods, his breath upon her shoulders and hair – asks her father Peneus to

Figure 5.1: Albrecht Dürer, *Draughtsman Making a Perspective Drawing of a Reclining Woman*. Woodcut, c. 1527. The Metropolitan Museum of Art, NY. © The Metropolitan Museum of Art / Art Resource, NY.

destroy her beauty, which so obsesses the god. Through transformation her body is "dismembered," though with smooth equipoise:

> [A] down-dragging numbness seized her limbs, and her soft sides were begirt with thin bark. Her hair was changed to leaves, her arms to branches. Her feet, but now so swift, grew fast in sluggish roots, and her head was now but a tree's top. Her gleaming beauty alone remained. (1984, 1:1.548–52)

The smooth blending of forms conveys the ontological implications of metamorphosis governed by a primitive cosmology, according to which all living things are animated by a life-principle or spirit capable of migrating from body to body. In a sense Daphne survives "behind" the bark, still resplendent in her beauty. Aetiology reinforces the intimate link between woman and tree, for this is a tale of origins, of the laurel, which was one of Apollo's attributes.

Like Ovid's narrator, the sonnet's lyric speaker depicts the transformation in a gradual, detailed unfolding. Missing, however, is the ancient premise of migrating spirits, for here transformation produces an intensely transgressive deformation of the body. Daphne's arms stretch into branches, her golden hair – in a clashing chromatic change – turns into green leaves; "áspera" [rough] substitutes for the Ovidian "tenui" [soft], as the clutching rough bark smothers a delicate, throbbing body, and white feet, thrust into the ground, twist into gnarled roots.[9] Mutilated by the tree and the dismembering rhetoric of the blazon, each body part becomes a fetish. Reified Daphne conforms to Stephen Heath's assessment of the fetish as spectacle and the viewer as spectator in terms that recall Erasmus's viewer as audience: "[The fetish] is a brilliance, something lit up, heightened, depicted, as under an arc light, a point of (theatrical) representation; hence the glance: the subject is installed (as at the theater or at the movies) for the representation" (1974, 107).

The speaker "at the window" of his imagined theatre sees and writes, creating a discursive "moving" picture of the transformation and so figuring himself as author and authority of the performance. We hear only his voice, whereas in Ovid's *Metamorphoses* we hear two voices, Apollo's and that of the narrator, who records how the god, as an idealizing voyeur, pleasurably studies Daphne's body, breaking it into fetishes that will become laurel: "He gazes at her hair ... he looks at her eyes gleaming like stars, he looks on her mouth ... he praises her fingers and her hands and her arms ... [W]hat is hidden, he deems still

lovelier" (1984, 1:1.497–502). Delighted by the sight, the god runs after her, wooing her in urgent but failed persuasion (1:1.502–24); after the transformation, he proclaims the laurel his symbol in a paean that also praises Rome (1:1.557–65). Lynn Enterline comments on the collapse of the rhetorical and the erotic in the tale, which is centred on the two material objects that fascinate Apollo, the female body and the laurel. She notes how Ovid turned stories about bodily "form" into commentary on poetic form:

> Daphne's *forma* provokes the god of poetry and so it is her *figura* that she prays to lose (1.489, 530, 547). Indeed, the struggle between "the one and the other" (*alter* and *altera*) becomes as much one of the god of poetry's ability to persuade Daphne as to catch her ... In this metarhetorical scene of failed persuasion, Ovid systematically couples the erotic story with various aspects of rhetorical speech. He turns to trope by making Daphne's *figura* the body and the "figure" that the god of poetry wants – Apollo's similes being the verbal means deployed to lay his hands on that figure – and shifts from tropological to semiotic self-reflection when Apollo plucks the laurel, the sign for poetry. His ensuing paean then plays on the much loved palindrome in Latin on the words for love and for Rome (Amor Roma). (2000, 92)

In the sonnet, however, rhetoric and eros disengage. Apollo does not speak. Verbal plenitude belongs to the lyric speaker who, as the transcriber of a new fiction of desire, appropriates Daphne's fetishized body which, denied to the god, is displayed as his linguistic construct. The speaker erases Apollo's divine aura and verbal acumen, and so the god's status as poet. On his tiny stage in front of the tree, Apollo acts out a role scripted for him by the speaker: of a melancholy lover lamenting Daphne's absence in tearful, inescapable grief. The drama of loss becomes a drama of authority whereby the lyric I confers upon himself the act of speaking (and writing). The demonstrative "aquel," literally "that one," in the first tercet stresses the distance and undercurrents of rivalry between him and Apollo. The laurel loses its semiotic complexity as the symbol of poetry and political glory. A mere tree [árbol], it becomes a tomb for Daphne, a shrine to her memory and, substituting for the body, also a fetish in its own right on which Apollo sheds his tears of adoration in remembrance.

But the lyric voice, commiserating with Apollo, in a sense "lends" the god words to utter his inconsolable grief in "Oh miserable estado, oh mal tamaño" [O wretched state, o monumental ill], compromising the

distance between them. Precarious and off-balance, the speaker's presence seems to merge with the god's own tenuous presence, for in a curious linguistic ambiguity, the words seem to come from Apollo himself. Drawn into the god's world of love melancholy, the speaker/poet loses, if only for an instant, his privileged position as sole possessor of visual mastery and voice, indeed, his power over the very signs that determine his identity. His confrontation with Apollo parallels the tension between Alberti's quattrocento perspective – with the narrator as the master of space and representation – and unmet desire understood here as a decentring force in the visual field. Apollo the carrier of desire, the powerful Other that "traps" the speaker within its boundaries, makes him lose control over his own space, relocating him precariously within the mythological spectacle.[10]

Film theory illuminates this dynamic of mastery and displacement in terms of a nexus between camera, eye, and a dream sequence. Jean-Louis Baudry and Christian Metz explain the meshing of the viewer and the camera in the cinematic experience according to notions of Renaissance perspective, Alberti's monocular vision, in which the centre of space and point of control coincides with the eye. For Baudry, the viewer's imaginary alignment with the camera, with "what stages the spectacle ... obliging him to see what it sees," ensures his position of transcendence and mastery (1986a, 295). The viewer is set up as the "active center and origin of meaning" (1986a, 286). For Metz, this transcendent viewer, looking from a stable point outside spectacle, is equally "all-powerful" and "all-perceiving," since his look is identified with "the 'focus' of all vision," the projector of the camera (1982, 49). Yet, both theorists later dismantle this notion of the perceiving, stable self. Viewing in cinema, they explain, is not a meshing of camera and eye but rather a dream experience in which the distance between film and spectator disappears. In an essay based on Freud's theory of dreams (1986b, 311), Baudry explains that cinema, like a dream, is founded on porous boundaries that allow for "a fusion of the interior with the exterior": the spectator becomes enveloped by the cinematic image as the dreamer is enveloped by the dream.[11]

What allows for the permeability of boundaries in Garcilaso's sonnet, and permits the lyric speaker's crossing over into spectacle is paradoxically the "vi" [I saw] of the beginning, through which he constitutes his presence as spectator and establishes his mastery over the scene. The mythological scene, fashioned as a recollected revelation (a flashback, in a sense) takes on a visionary, dream-like quality. Whereas the present

speaks of hard facts, the past frees the mind to invent a "memory" of things. Memory, by its very nature, allows for a distorted, fantastic vision which is then projected as if onto a "dream screen": a world of the imagination where it is plausible for a nymph to be transformed into a tree that grows, watered by her lover's tears. The speaker is then drawn into the field of his own "dream."

The "vidi" [I saw] of the subject's transformation into the laurel in Petrarch's *Canzone* 23, based on Ovid's version, surely prompts Garcilaso's "vi" (Navarrete 1994, 97):

i capei vidi far di quella fronde
di che sperato avea già lor corona,
e i piedi ... diventar due radici ...
e 'n duo rami mutarsi ambe le braccia!

[I saw my hairs turning into those leaves which I had formerly hoped would be my crown, and my feet ... becoming two roots ... and my arms changing into two branches!] (1976, vv. 43–9)

The subject is both spectator and spectacle in this narcissistic fantasy, which is an emblem of self-alienation and of the desire for Laura and the laurel of poetic glory, for Petrarch places the laurel famously as one of the material objects for telling his story of melancholy loss. A lover of his Daphne and a new Apollo throughout the *Canzoniere*, the subject, like the god in Garcilaso's sonnet, sheds his tears on the laurel, which is as well a scene of writing:

Vomer di penna con sospir del fianco
e 'l piover giù dalli occhi un dolce umore
l'adornar sì ch'al ciel n'andò l'odore,
qual non so già se d'altre frondi unquanco.

[My pen, a plow, with my laboring sighs, and the raining down from my eyes of a sweet liquid have so beautified it, that its fragrance has reached Heaven, so that I do not know if any leaves have ever equaled it.] (1976, Sonnet 228)

The pen and the sighs are the instruments of celebration in which the rain of tears is emblematic of the act of writing. In Garcilaso's text Apollo owns the tears. The lyric speaker owns the pen, and even though

he merges with Apollo for an instant, he silences the deity and robs him of his rightful role as god of poetry.

Mapping the Humoral Interior

In the Fourth *Canción* a brooding melancholic in erotic crisis looks inward in a self-reflexive fantasy to materialize his psychic dislocation, with reason and desire – corporealized as warring figures, as in a medieval psychomachy – clashing on a field of battle. But materializing goes beyond conventional allegorical warring, for reason is itself endowed with a bodily interior and a frightened heart [corazón medroso] (v. 33) and bears the symptoms of humoral disharmony: "la sangre alguna vez le callentaba,/mas el mismo temor se la enfriaba" [its blood sometimes would become warm but fear would make it cold] (vv. 39–40). The lyric subject's imaginary projections operate within the early modern understanding of the elemental link between mind and body, selfhood and materiality. Implicated in this coupling is Galenic theory, by which a physiological imbalance in the humoral fluids – blood, phlegm, yellow bile, and black bile – disrupts physical health and psychic disposition.[12] The self-portrait of a sick Albrecht Dürer is illustrative of this twin condition (c. 1512–13; figure 5.2). Inscribed above the figure are the words: "There where the yellow spot is and the finger points, there it hurts me." The index finger of the right hand points to the spot on the skin exactly where, inside, resides the spleen, the organ that secretes black bile and produces melancholia (Foister 2008, 254).[13] Dürer's keen awareness of his illness and its location – typical of melancholics – is shared by Garcilaso's subject, who "points" to his heart to identify his own melancholia as an erotic affliction. David Hillman, commenting on Shakespeare, focuses on this physical-mental double scene, which is based on a pre-Cartesian belief system:

> [This system disallowed] any attempt to separate the vocabulary of medical and humoral physiology from that of individual psychology. When, therefore, characters on the early modern stage speak of "my heart's core, ay ... my heart of heart" (*Hamlet* 3.2.73), or of "the heat of our livers" (2 *Henry IV* 1.2.175) ... of being "inward searched" (*Merchant of Venice* 3.2.86) or afflicted with "inward pinches" (*Tempest* 5.1.77) – we would do well to regard these as far from merely metaphorical referents, and to try to discover how they figure into an overall understanding of bodily – and therefore psychological – interiority in a given play. (1997, 83)

Figure 5.2: Albrecht Dürer, *Self-Portrait of the Sick Dürer*, Pen and ink with watercolour, c.1512–13. Bremen, Kunsthalle. Foto Marburg/Art Resource, NY.

Garcilaso's introspective subject views inwardness in the same corporeal terms, with psychic dislocation embodied through physical symptoms of humoral imbalance and disarray of internal organs. In the Second Eclogue the self-appointed physician Salicio, looking at the sleeping Albanio, recalls one of the prescribed remedies for melancholia: "el sueño baña con licor piadoso,/curando el corazón despedazado" [sleep bathes him in its merciful waters/and heals the fractures of a broken heart] (vv. 90–1). The desiring Albanio later confirms his condition to Salicio, "el mal ... ha penetrado hasta el hueso" [this is a wound that's cut me to the bone] (vv. 144–5). Both the observant physician and the melancholic understand how the bodily interior charts a psychic condition.

In his study of human dissection in the sixteenth and seventeenth centuries, Jonathan Sawday observes that opening up the body was above all a quest for knowledge, an attempt to make sense of the world within the corporeal frame (1995). In the Fourth *Canción*, the lyric subject's lucid self-diagnosis anticipates the opening of his own body to discover the effects of his erotic illness and, more important, to re-conceive his fractured identity through a scrutiny of his visceral interior. He was afflicted, he says, through a visual wounding, when the woman's eyes shot noxious rays that worked a baleful magic within his body:

> Los ojos, cuya lumbre bien pudiera
> tornar clara la noche tenebrosa
> y escurecer el sol a mediodía,
> me convertieron luego en otra cosa,
> en volviéndose a mí la vez primera
> con la calor del rayo que salía
> de su vista, qu'en mí se difundía;
> y de mis ojos la abundante vena
> de lágrimas, al sol que me inflamaba,
> no menos ayudaba
> a hacer mi natura en todo ajena
> de lo que era primero. Corromperse
> sentí el sosiego y libertad pasada,
> y el mal de que muriendo estó engendrarse,
> y en tierra sus raíces ahondarse,
> tanto cuanto su cima levantada
> sobre cualquier altura hace verse;

el fruto que d'aquí suele cogerse
mil es amargo, alguna vez sabroso,
mas mortífero siempre y ponzoñoso.

[The eyes, whose light could well turn bright the dark night and darken
the noonday sun, transformed me then into something else, as she turned
towards me the first time with the radiant heat of the ray emanating from
her eyes, which spread within me; and the abundant vein of tears from
my own eyes did not help lessen the [heat] of the sun that inflamed me,
making my nature totally alien from what it was before. I felt my calm
and freedom destroyed, and the sickness from which I am dying take
hold, its roots driving deep into the soil so firmly that its top can be seen
from any height; the fruit that is picked from it is a thousand times bitter,
sometimes sweet, always deadly and poisonous.] (vv. 61–80)

Marsilio Ficino writes on the dynamic of the materialist theory of spir-
its in *De amore* (Latin text, 1469; Italian translation, 1474), a commentary
on Plato's *Symposium*: when an eye shoots the poison darts of its rays,
which become lodged in the heart of another, it causes blood to be "im-
pure, thick, dry, and black" ... "[H]ence lovers become melancholics
..." and "melancholy ceaselessly troubles the soul day and night with
hideous and horrible images" (1985, 6.9.15–18).[14] The esoteric mysti-
cism and magic of fifteenth-century Neoplatonic thought combine in
Garcilaso's text with reminiscences from Ovid and Petrarch, as the sub-
ject internalizes the myth of Ovidian Daphne's transformation into a
laurel tree, as rewritten in Petrarch's *Canzoniere*, with the bitter Laura as
the laurel (her emblem as an antitype of the unavailable Daphne): "sol
per venir al lauro onde si coglie/acerbo frutto" [only to come to the
laurel, where one gathers bitter fruit] (Sonnet 6). The *Canción* combines
the fruit's bitterness with sweetness (Petrarch's Laura is sometimes
"dolce"), with implicit reference to Ficino's noxious blood in the epi-
thets "mortífero" [deadly] and "ponzoñoso" [poisonous].

Petrarch famously placed myth in the psyche, with his lyric subject
taking on a series of Ovidian shapes (*Canzone* 23), in the process "cloth-
ing" the intangible imaginings of psychological dislocation with a
semblance of corporeality. His suffering self becomes a new Actaeon,
who, transformed into a stag, is dismembered by his own hounds
(vv. 158–60), or a new Daphne, with his hair turned to laurel leaves,
his feet to roots, and his arms to branches (vv. 43–9).][15] Whereas the

Canzoniere signals the subject's broken psyche through a bodily trans-formation, Garcilaso's subject, informed by the sixteenth-century fasci-nation with the human interior, signals his dislocation through a strange anatomical excursion within the body, where his love melancholy ap-pears in the likeness of a tree bearing both sweet and bitter fruit, causing internal turmoil; where we would expect to find a heart or the impure black gook of Ficino's humoral scene, we see instead vegetative life.

The subject's internal fracture echoes the anatomical fantasy of the body in bits and pieces, illustrated evocatively in Lacan's *corps morcelé* – a psychological construct that stands for a self in permanent discord. "[This fantasy] appears [in dreams] in the form of disjointed limbs," writes Lacan, "or of those organs represented in exoscopy, growing wings and taking up arms for intestinal persecutions – the very same that the visionary Hieronymus Bosch has fixed, for all time, in paint-ing" (1977, 4–5). For the *Canción*'s subject, melancholia is materialized in the form of a tree shooting forth roots and lethal fruit in the manner of organs in this dream scene, where they grow wings and take up arms for "intestinal persecutions": "sentí …/el mal de que muriendo estó engendrarse,/y en tierra sus raíces ahondarse" [I felt … the sickness from which I am dying take hold, its roots driving deep into the soil]. It is as if Bosch's panels, where body parts move seamlessly within the human sphere, were commissioned to depict the mental landscape of the *Canción*'s reader or, perhaps more plausibly, the poet was replicat-ing Bosch's fantasy in lyric.

Phantasm as Autobiography

The subject's fragmented vision belongs to a larger discursive field, that of autobiography conceived as a history of the self in love, like Petrarch's *Canzoniere*, no matter how elusive and ambiguous the telling.[16] Constituted in the language of myth and melancholia – and totally alien from his former self [Mi natura en todo ajena/de lo que era pri-mero] (vv. 71– 72), echoing Petrarch's "I felt myself drawn from my own image" (*Canzone* 23, 157) as the lyric I becomes a solitary wander-ing stag – the *Canción*'s lover takes on a fluid errancy, passing from the scene of the fragmented body to other scenes, all stemming from his fantasy [fantasía] (v. 121), a product of his ever-changing imagination [imaginación tan varïable] (v. 122). In these two lines the lover reveals his familiarity with the language of the phantasmatic tradition, which

feeds his discursive image-making. In his now classic *Stanzas: Word and Phantasm in Western Culture*, Giorgio Agamben draws from a host of sources, from the ancients through Ficino to Freud, to identify fantasy as the imaginative faculty that engenders mental images to create lasting impressions upon the soul. These images are of objects external to the body and perceived by the senses, and objects imagined within the body manifested as visions and in dreams (1993, 23). Well aware that philosophers, artists, and poets are associated with the melancholy temperament, Agamben singles out Dürer's engraving *Melencolia I* (figure 5.3) as an exceptional representation of melancholy's production of phantasms. The imposing angel at the centre of the engraving stands for an extraordinary revelation: it is "the emblem of man's attempt, at the limit of an essential psychic risk, to give body to his own fantasies and to master in an artistic practice what would otherwise be impossible to be seized or known" (1993, 26).[17] In the *Canción* the subject as verbal artist turns to myth to embody the imaginings of his melancholy erotic condition which is, as Ficino prescribes, all but "disjunction and excess" (cited in Agamben, 1993, 17).

To represent his melancholy entrapment, the subject draws three fantastic images (vv. 81–107), of which the third is the most materially evocative. It is a reworked episode taken from Demodokos's song in Homer's *Odyssey* 8, later retold in Ovid's *Metamorphoses* (4.171–89) and in countless other texts (Morros 1995, 428). Mars and an adulterous Venus, caught in bed by a mesh fashioned by the betrayed Vulcan, serve as a public spectacle for the Olympian gods to mock. Garcilaso's subject renders the episode as follows:

> De los cabellos de oro fue tejida
> la red que fabricó mi sentimiento,
> do mi razón, revuelta y enredada,
> con gran vergüenza suya y corrimiento,
> sujeta al apetito y sometida,
> en público adulterio fue tomada,
> del cielo y de la tierra contemplada.

> [Woven of gold hair was the net that was fashioned by my feelings, where my reason, rolled and tangled, with great shame and embarrassment, was taken by appetite, held and subdued in public adultery, contemplated by heaven and earth.] (vv. 101–7)

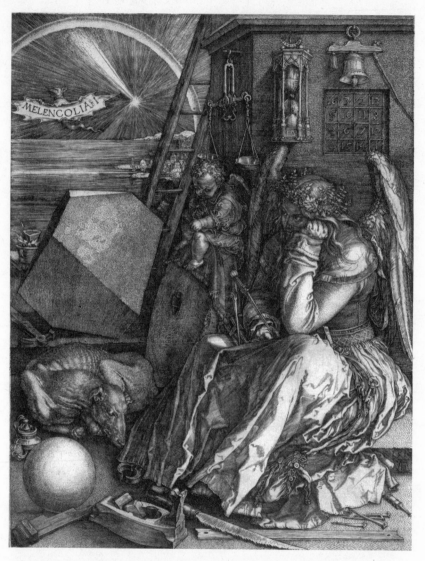

Figure 5.3: Albrecht Dürer, *Melencolia I*. Engraving, 1514. The Metropolitan Museum of Art, NY. © The Metropolitan Museum of Art/Art Resource, NY.

The seductive opening echoes its close Italian model, Petrarch's Sonnet 181, which portrays the lover trapped in Cupid's net:

> Amor fra l'erbe una leggiadra rete
> d'oro e di perle tese sott' un ramo
> dell'arbor sempre verde ch'i' tant'amo ...
> Così caddi a la rete, et qui m'àn colto
> gli attti vaghi et l'angeliche parole
> e 'l piacer e 'l desire et la speranza.

[Love set out amid the grass a gay net of gold and pearls, under a branch of the evergreen tree that I so love ... Thus I fell into the net; and I have been captured here by her sweet bearing, and her angelic words, and pleasure and desire and hope.]

Garcilaso's text readily qualifies Petrarch's vague, delicate imagery by mentioning the woman's hair as a gold net, which in the Italian poem remains unnamed and suspended in stilnovistic elusiveness. The exultant entrapment of Petrarch's subject, caught in the net of pleasurable yet highly intangible riches of female sweetness and words, yields in the *Canción* a stark, erotically charged staging of an allegorical moral drama. In effect it restages the battle between corporealized reason and appetite at the beginning of the text, the lover's feelings being the very agent that set the drama into motion as the weaver who weaves the strands of hair into the imprisoning net. Unlike Petrarch and the ancients – the latter full of playful banter, the famous laughter of the gods – the *Canción*'s spectacle carries a moral dimension.[18] Desire, labelled appetite [apetito], subdues reason in public shame, in what is actually a rape scene.

As the poem winds down, the subject reflects on the state of his discourse, which he sees as hopelessly lost since reason and judgment no longer rule: "Esto ya por razón no va fundado,/ni le dan parte dello a mi jüicio,/que este discurso todo es ya perdido" [All this is not based on reason, nor is my judgment involved, since this entire discourse is already lost] (vv. 132–4). Melancholy crisis has turned into a crisis of writing: signs becoming dispersed like the subject, who defines himself as "perdido" [lost] (vv. 152, 158). Loss of identity, self-division, and a sense of wandering and exile accompany his moral scattering. Memory and its double, forgetting, play a fundamental role in the subject's dispersal. While memory makes possible recollection, its singular failure here

marks the self and his narrative. Lines 157–8, with their elusive syntax, register the psychological, moral, and linguistic disorientation attendant to the loss of identity in terms of forgetting: "un temor que m'ha puesto en olvido/aquélla por quien sola me he perdido" [a fear that has made me forget myself, [caused by] the one who is the sole reason I have lost myself].[19] In Petrarch's *Canzone* 23, the lyric subject is forced to forget himself through an overriding thought (of Laura) as a prelude to his transformation and inner exile:

> *E se qui la memoria non m'aita*
> *come suol fare*, iscusilla i martiri
> et un penser che solo angoscia dàlle,
> tal ch'ad ogni altro fa voltar le spalle
> e *mi face obliar me stesso a forza*,
> ch' e' ten di me quel d'entro, et io la scorza

> [*And if here my memory does not aid me as it is wont to do*, let my torments excuse it and one thought which alone gives it such anguish that it makes me turn my back on every other and *makes me forget myself beyond resistance*, for it holds what is within me, and I only the shell.] (1976, vv. 15–20; my emphasis)

In the *Canción* the act of forgetting touches the woman as well, when the subject observes how pain makes him forget the object of his erotic desire [el bien], if there ever was one (v. 138). Only the fury and anguish of his malady [el mal presente] remains (v. 140).

"Forgetting" the beloved is far from a betrayal, however, for her textual presence is precarious from the start. Agamben, an insightful reader of Freud – for whom the lost object of desire remains unknown and mysterious since "one cannot see clearly what it is that has been lost" (1978, 14:245) – calls on the alchemists (and their notion of *Nigredo* [blackness]) to elucidate the image-making of the melancholic and his "unreal object," a process that consists "in giving a body to the incorporeal and rendering the corporeal incorporeal" (1993, 26). And so it is for Garcilaso's subject, who corporealizes his melancholy condition and sense of loss, but whose beloved – fragmented and fetishized, absent and deferred – emerges as a kind of nostalgic, distant ideal resisting representation. She appears only in flimsy, scattered details: a pair of luminous eyes, a net of golden hair, impersonal linguistics fragments – a "quien" [a who] fleeing from him (v. 82), an "aquélla" [that one]

who causes his own scattering (v. 158), or "la que" [the one who] torments him (v. 23).[20] She exists only in terms of his disordered state.

Confession and Narration

With both subject and object fragile and scattered, each in its own way, it is writing, or more concretely the act of "publishing" and printing, that offers a way to anchor the self. Early in the poem the subject announces his narrative plan as a public confession: "sabrá el mundo la causa por que muero,/y moriré a lo menos confesado" [the world will know why I am dying and I will die at least having confessed] (vv. 5–6). The poem's moral overtones, in which desire is linked with appetite (v. 105) and feelings of shame (v. 104), recall Augustine's *Confessions*, where in meditations on writing, *confessio* becomes *narratio*. Brian Stock observes:

> [Augustine's] story hovers between thought and the world before it enters the world in words that are intended to be interpreted by others ... Furthermore, he establishes the view that knowledge about the self is revealed when the moral habits and internal patterns of a life proceed from the private to the public realm; when they pass willfully through stages of thought, language, and expression and are, so to speak, published. (1996, 16)[21]

Garcilaso's text shares this strict logic. The speaker's narration-as-confession unveils his inner self as it proceeds from the private to the public, for all the world to know: "sabrá el mundo la causa por que muero" [the world will know why I am dying]. Roger Chartier has argued that in the early modern period there was a desire to preserve "texts of all kinds from oblivion. Stone, wood, fabric, parchment, and paper all served as substrates on which the memory of events and men could be inscribed ... [T]he mission of the written was to dispel the obsession with loss" (2007, vii). If we give a slight twist to this argument, the agenda of our subject's writing takes on a fuller meaning; for the world to know is, in the *Canción*, for the reader to "sing" his song ("cantando," v. 85; "canto," v. 87, v. 161). To "sing," for a poet living in a print culture, is to write, and to write is to publish and render visible, in effect to materialize a voice and anchor a text and, by extension, a self as well. Walter Ong's observations on print culture are relevant here: "Print replaced the lingering hearing-dominance in the world of thought and

expression with the sight-dominance, which had its beginnings with writing but could not flourish with the support of writing alone. Print situates words in space more relentlessly than writing ever did" (2002, 119). Before Garcilaso's poem was published posthumously in book form by Juan Boscán's widow in 1543, it undoubtedly was printed and circulated in "pliegos sueltos" [chapbooks], as was customary at the time. Print offers the writer a stable surface on which to fix his wayward thoughts and unstable self. The poem's *envoi*, where the subject addresses his *Canción*, brings into focus the project of writing as a material enterprise:

> Canción, si quien te viere se espantare
> de la instabilidad y ligereza
> y revuelta del vago pensamiento,
> estable, grave y firme es el tormento.

> [Canción, whoever sees you would be horrified by the instability and fragility and chaos of my wandering imagination, stable, somber and firm is my anguish.] (vv. 161–4)

Fixed on the page, the *Canción* becomes a material entity, a written artefact for the reader's eyes, "si quien te viere" [whoever sees you, that is, whoever reads you]. Materializing the text on a page, that is, within a performative space, shapes the self and legitimizes him as author, his fragile melancholy state and the woman being mere pretexts for the writing project. Put another way, the lover/poet's invocation to the *Canción*, his writerly "stage," is a self-referential moment of praise for his literary accomplishment.

This self-congratulatory enterprise aligns with Ficino's melancholic as a man of extraordinary attributes, whose melancholia is a gift which defines the man of letters. For Freud, who develops that notion, the melancholic, a keen observer of the inner self, is someone remarkable who needs to speak out, finding "satisfaction in self-exposure" (1978, 247), like Shakespeare's Hamlet. Freud finds "something virtuous and exceptional in Hamlet," writes Juliana Schiesari, "whose illness makes him a possible speaker of truths and a visionary. In other words, Hamlet's melancholic humor elevates him above ordinary men – as in Ficino's model. It is what we could call an *accredited pathology*, justified by the heightened sense of conscience that the melancholic is said to display ostentatiously" (1992, 9; emphasis in the original). Like Hamlet,

the subject of Garcilaso's *Canción* is a "visionary" and a "speaker of truths." Looking inward, he displays himself ostentatiously in self-absorbed, dramatic scenes of instability and loss, all the while flaunting his gift as a writer, which legitimizes his public confession as text.

Tablet of the Soul

The melancholy subject of Sonnet 5 conceives of his body's interior as a space for phantasms to create lasting impressions of the beloved upon the soul:

> Escrito 'stá en mi alma vuestro gesto
> y cuanto yo escribir de vos deseo:
> vos sola lo escribistes; yo lo leo,
> tan solo, que aun de vos me guardo en esto.
> En esto 'stoy y estaré siempre puesto,
> que aunque no cabe en mí cuanto en vos veo,
> de tanto bien lo que no entiendo creo,
> tomando ya la fe por presupuesto.
> Yo no nascí sino para quereros;
> mi alma os ha cortado a su medida;
> por hábito del alma misma os quiero;
> cuanto tengo confieso yo deveros;
> por vos nací, por vos tengo la vida,
> por vos he de morir y por vos muero.

> [Your countenance is written in my soul,
> and everything I'd wish to write about you;
> you wrote it there yourself, while all I do
> is read – still with an attitude that's fearful.
> This is, and will always be, my occupation;
> and though for all I see my soul lacks space,
> I still believe in a good beyond my grasp,
> given that faith's the primary assumption.
> I was only born so I could love you:
> my soul has cut you to its own dimensions,
> as my soul's own habit I must have you;
> everything I have I know I owe you;
> for you I was born, for you I hold my life;
> for you I will die, am dying, here and now.]

The first stanza recalls the images created by philosophers and poets to illustrate the inner workings of the soul in terms of writing, engraving, and drawing. Plato, in particular, offers apt metaphors. In the *Philebus* Socrates, probing the nature of truth and falsehood, conceives the soul as a "book," where memory and sense-perception, along with the passions, are like a "scribe" who writes words, which are then illustrated by a "painter" (1993, 39a–b).[22] Garcilaso's lyric subject, too, envisions the soul as a scriptable surface. But for him the scribe is the beloved who "writes" her face on his soul to mark her presence permanently within him. Having conferred on her his agency as writer, he is but a reader. Since "escrito" also stands for "engraved" or "inscribed," the soul functions as a tablet, as in Plato's *Theaetetus*, where the soul appears as a wax tablet on which memory is impressed as with a signet ring (1990, 325). Fernando de Herrera connects "escrito" to the Greek γράΦειν, which in addition to write, means to sculpt or to paint (Gallego Morell, 325). So the beloved is also a "painter," who draws or paints herself on the subject's soul. He is the spectator.

To reinforce the image of the woman indelibly branded on his soul, the subject shifts to another materially evocative figure, the dialogic "hábito." His soul, like a skilled tailor, trims her to its own size as if she were a piece of cloth in order to make a garment for itself. But "hábito" means more than a cloak for his soul, since it signifies not only costume but custom. The *Diccionario de Autoridades* focuses on "hábito" as a garment that defines individual identity and a cultural way of life, "el vestido o trage que cada uno trahe segun su estádo, ministério o Nación: y con particularidad se entiende por el que usan los Religiosos y Religiosas" [it is the dress or clothing that each one wears according to his state, profession or national origin: and in particular those worn by the ecclesiastics, male and female].[23] The poem's beloved emerges as the force that dictates a code of conduct for the lover, an all-encompassing habitual behaviour. "En esto 'stoy y estaré siempre puesto" [This is, and will always be, my occupation], says the lover as he "reads" her, "contemplates" her, and later adds: "cuanto tengo confieso yo deveros" [everything I know I owe you], including his life and death.[24]

The phantasmatic imagination at work here reached the sixteenth century through an amalgam of ideas from Plato, Stoic thought, and reformulations by medieval theologians and Neoplatonists. It appears most emphatically in the line "por hábito del alma misma os quiero" [as my soul's own habit I must have you], with the woman's image as the

phantasm impressed powerfully on the subject's soul and cherished in contemplation ("reading it" [yo lo leo] as his "occupation"). Garcilaso's highly charged material language, with the mental image exerting the force of a real presence through "hábito," reminds us of the influential work of Hugh of St Victor. Inspired by the Neoplatonic theory of spirits as the mediator between corporeal and incorporeal, the rational and irrational, Hugh's *De unione corporis et spiritus* reassesses the notion of fantasy and imagination (Agamben 1993, 97). Particularly relevant here is his discussion of the garment of the soul:

> If reason acquires imagination through contemplation alone, the imagination acts as a garment that stands outside and enfolds it, so that reason can easily dispense with it and denude itself. If, on the other hand, reason adheres to it with delight, the imagination becomes like a skin for it, so that reason cannot detach itself without pain, because it had attached itself with love. (cited in Agamben 1993, 98)

Garcilaso's image of the woman as a garment dressing the lyric subject's soul eroticizes Hugh's striking image of the imagination enfolding reason like a garment. It qualifies and surpasses in sensuality the sonnet's own image of the woman writing her face in the soul, superseding traditional images supplied by the love tradition and exemplified in a host of writers, most tellingly by Giacomo da Lentino's "within my heart I bear your figure" and "painted as if on a wall," and in poets of the *dolce stil nuovo*, like Dante's allusion to Beatrice's "image in the heart" of the *Purgatorio* (Agamben 1993, 70).[25]

The four poems in this chapter explore the dynamics of the melancholy condition. The subject who appeals to the river nymphs in their *villeggiatura* but is ignored anticipates a watery end. The spectator to Daphne's bodily transformation breaches the boundaries of Apollo's melancholia, pulled into the spectacle by the force of the god's affliction. The subjects of *Canción* 4 and Sonnet 5 interiorize their melancholy condition through phantasms; one suffers his melancholy entrapment in self-absorbed scenes, the other surrenders happily to the beloved. In the end each subject exhibits his exceptional capacity to write a brilliant lyric performance, melancholia's gift.

6 Staging Objects in Pastoral

The amoebean song of Garcilaso's First Eclogue, a diptych of intimate moments of complaint and lyric self-reflection, maps out two inner journeys of rupture and discord. Oral performance, whether melancholy complaint or soulful mourning, enters the pastoral to stage the material construction of the departed beloved. A jealous, melancholy Salicio portrays his stony Galatea, who has left him for another, as a kind of statue but harder than marble. Nemoroso portrays his gentle Elisa as a delicate cloth torn by Death, the strands of her hair as a relic, and her lovely neck as a white column. In this chapter I use objects in the sense that Catherine Richardson conceives them in her study of material culture in Shakespeare: as "good for thinking with" and, in their "prominence and durability," for thinking through the intensity of feelings (2011, 3–4).[1] Remembered or imagined, objects define the nature of Galatea and Elisa, the feelings of the shepherds, and the quality of the lovers' relationships. The materializing of the inner self and of sound and voice further serve for the shepherds' self-portrayal. The discursive nature of the material is underscored by the privileged figure of the text as mirror (the classical and Italian model that at each step subtends the poem) and by the pastoral waters as mirror, a site that is for Salicio an ambiguous tool that simultaneously affirms and deceives, and that for Nemoroso serves as a mirror of memory.

Falling in Love with a Statue

Salicio's apostrophe to Galatea at the beginning of his lament sets the tone and locates the material point of reference for viewing his love object, himself, and his world:

¡Oh más dura que mármol a mis quejas
y al encendido fuego en que me quemo
más helada que nieve, Galatea!

[O harder than marble to my complaints,
and to the raging fire with which I burn
colder than freezing snow, O Galatea!] (vv. 57–9)

The very mention of marble in relation to Galatea – reinforced by a
twin image, "freezing snow" – is particularly apt, since the term par-
tially derives from the etymology of her name, brought to our attention
by Fernando de Herrera: "Una de las Ninfas Nereidas, llamada así por
su blancura del esplendor y claridad de las espumas del mar; porque
γάλα es leche en el lenguaje griego" [one of the Nereids, so called be-
cause of her whiteness, from the splendor and clearness of the sea's
foam, because γάλα means milk in Greek] (Gallego Morell 1972, 480;
Rivers 1974, 270). The name of Salicio's unfaithful beloved, Galatea,
inevitably invites comparison with the eponymous sea-nymph of
Theocritus's Idyll 11 and Ovid's *Metamorphoses* 13, and the material ob-
jects she resembles. Theocritus's spurned Polyphemus calls out to his
"white Galatea": "Whiter to look at than cream cheese, softer than a
lamb" (2002, 11.19–20). In Ovid, Polyphemus praises the beauty of his
unavailable Galatea, who is in love with Acis, but also berates her: "O
Galatea, whiter than snowy privet-leaves" (1984, 2:10.789) ... "harder
than ancient oak," "more immovable than these rocks" (2:10.799, 801).
Salicio's Galatea is harder still, harder even than marble, a lovely yet
malleable stone as defined by the *Diccionario de Autoridades*: "Piedra
durísima y dificultosa de labrar: la qual despues de pulida queda mui
limpia y lustrosa, y tiene diversos colóres" [Very hard rock and difficult
to carve; after it is polished it is very clean and lustrous, and of different
colours]. So the mention of marble in the lament's first line evokes
something more than just stone, for as *Autoridades* implies, marble is
typically meant for carving, sparking in the reader's imagination the
idea of a statue, like one of the many pieces of antique statuary that
abounded in Garcilaso's Italy. Within this context, Salicio's complaint to
the unmoved Galatea shares in the fantasy of the animated statue in the
story of Pygmalion, the sculptor who falls in love with the statue he had
carved, a statue of what is – in his own imagination – perfect beauty.
Pygmalion's "ivory woman," softening at his touch, comes to life and
takes on human form, becoming "pliable, responsive ... female life as

he would like it to be" (Gubar 1985, 292). But "harder than marble" Galatea, made of a material not as pliable as marble or ivory, stays beyond the logic of Pygmalion's story. She remains as unresponsive as Polyphemus's stony Nereid and the familiar, elusive, and mysterious *donna petrosa* of Petrarch's *Canzoniere*.

If she cannot be "carved," Galatea nonetheless can be "scripted" as she enters Salicios's fiction in another artistic construct, the *scripta puella*, "the written girl" of Roman elegy, which the Renaissance inherits. "The elegiac mistress is a work of art," writes Sarah Annes Brown, "brought into being by the poet's stylus just as Pygmalion's statue is a product of the sculptor's skill," in short, the sculptor's chisel (2010, 667).[2] In the eclogue's dedication to Pedro de Toledo, Garcilaso promises, in a typical *recusatio*, that when his *otium* is restored he will take up the pen –"verás ejercitar mi pluma" [you will see how my pen takes up the task] (v. 24) – to sing the viceroy's virtues. Instead he takes up the pen to "write" his pastoral, to inscribe Galatea on the page while recording the song of his shepherd, who sings within his own pastoral *otium*, the space of leisure and creativity. The poet's inscription reinforces metatextually Salicio's very words –"más dura que mármol a mis quejas" [harder than marble to my complaints] – where his complaints become like failed chisels that cannot "carve" Galatea into "what he would like her to be." The nexus between writing, orality, and the implicit failure at a verbal sculpting readily underscores the failure of words, which in turn calls forth from Salicio's memory an image of a dominant female presence permanently still.

Salicio's verbal failure emerges once again when he aligns himself with Orphic magic, drawing to himself an attentive, participatory, and prophetic audience from which Galatea is excluded:

> Con mi llorar las piedras enternecen
> su natural dureza y la quebrantan;
> los árboles parece que s'inclinan;
> las aves que m'escuchan, cuando cantan,
> con diferente voz se condolecen
> y mi morir cantando m'adevinan;
> las fieras que reclinan
> su cuerpo fatigado
> dejan el sosegado
> sueño por escuchar mi llanto triste.
> Tú sola contra mí t'endureciste.

[At the sound of my weeping, stones dissolve
their natural hardness and disintegrate;
the trees seem to bow down respectfully;
the birds that hear me, when they sing,
change their tune to express their sympathy
and in their song my approaching death predict;
 wild animals that rest
 their tired bodies
 abandon peaceful sleep
to listen to my melancholy tears.
You alone have hardened yourself against me.] (vv. 197–207)

Orpheus's song stands for celebration and harmony, but it is also a song of mourning and sorrow, rupture and loss, as the singer fails to bring Eurydice back from the dead. In assuming Orpheus's language, Salicio assures both the failure of his song and his melancholia. Charles Segal writes that "the early Greek vocabulary for the appeal of song draws a parallel between the literally 'fascinating' (Latin *fascinum*, 'magical charm') power of language and the power of love, between erotic seduction and the seduction exercised by poetry" (1989, 10). Salicio's verbal magic, which is above all an attempt at erotic seduction and "a plea for Galatea's return" (Woods 1969, 148), contains its own failed promise. By appropriating Orphic song, like the rhetor in the *Ode ad florem Gnidi* (see chapter 3), the shepherd affirms the correctness of his message and the authority of his voice. But stony Galatea, like the *Ode*'s unresponsive Violante, stays outside the magic circle of Salicio's voice – absent, silent, and out of reach. In an inversion of the alluring figure of the Medusa, whose piercing eyes and hair of tangled snakes turned men into stone, Galatea herself hardens, becoming "petrified" against Salicio.[3]

Rehearsing the oculocentric dynamic prevalent in early modern poetry and art, Salicio sings to Galatea's eyes, exquisite corporeal objects that belong to the rhetoric of the anatomical blazon, to unveil her betrayal: "Tus claros ojos ¿a quién los volviste?" [Your bright eyes, on whom did you turn them?] (v. 128). But her withdrawal from the visual field challenges and defeats the incantatory magic of his song:

los ojos aun siquiera no volviendo
 a los que tú hiciste
salir, sin duelo, lágrimas corriendo.

[not even turning back your eyes
towards those [eyes] from which you made
abundant tears freely and swiftly flow]. (vv. 208–10)

The ocular reciprocity of Petrarchan poetics, that "interactive visuality
that produces both anxiety and pleasure in the perceiving subject"
(Bergmann 2004, 152), as in the visual wounding by the woman in
Canción 4 and Sonnet 18, is conspicuous by its absence here. In denying
her eyes, Galatea signals her inaccessibility. The withheld look charac-
terizes her as the elusive Other that determines and fixes Salicio as a
diminished melancholic, revealed by his own weeping eyes: "los [ojos]
que tú hiciste salir, sin duelo, lágrimas corriendo" [those (eyes) from
which you made abundant tears freely and swiftly flow], a refrain re-
peated in 11 stanzas. He seeks her eyes not only for their promise of
immediacy and presence but for a much sought after recognition, an
unconditional "yes" that would restore his inner harmony and stabili-
ty, much like the lover who seeks the eyes of nymphs who dwell in the
realm of the Imaginary in Sonnet 11 (see chapter 5).

The ocular dynamic appears in Salicio's play with the mirror, an em-
blem of both his narcissism and the inner discord caused by Galatea's
absence. As reflected in the waters of the pastoral brook, he finds him-
self not so bad looking:

> No soy, pues, bien mirado,
> tan diforme ni feo,
> que aun agora me veo
> en esta agua que corre clara y pura.

> [I am not, in point of fact
> so ugly or deformed,
> for now I view myself
> in this brook which runs so clear and pure.] (vv. 175–8)

By fashioning a flattering, winning presence, Salicio establishes a phe-
nomenology of looking as he tries to engage Galatea's eyes, subtly en-
couraging her to align them with his, resulting in a correct look: "bien
mirado" ("bien" literally "in the right way"). That is, if you look at me
in the right way, from the proper angle, in the way I want you to see me,
I am not so unattractive: "No soy ... tan diforme ni feo" [I am not so
ugly or deformed]. This narcissistic image invented for the moment is

complemented – and validated – by another mirror image, which immediately precedes it: Salicio's memory of Galatea's recognition of his voice, his song, as being superior to Virgil's: "De mi cantar, pues, yo te via agradada/tanto, que no pudiera el mantüano/Títero ser de ti más alabado" [With my singing I saw you once so pleased/that not even Virgil, the Mantuan/Tityrus, could by you have been more praised] (vv. 172–4). Salicio's desire for Galatea to mirror him as he sees himself is momentarily satisfied in recollection. But Salicio's ideal image of himself, despite Galatea's recognition, is illusory, for he is not only looking at himself in a mirror but also "looking" into a text, an ancient poem that offers a fictional image to construct his own.

Writing about the reflecting waters of Ovid's Narcissus, Lynn Enterline has called attention to how the use of the mirror as model or exemplar by early modern authors "informs their moral and social discourse about the self" (1995, 8). Here the model is Virgil's Second Eclogue, where the shepherd Corydon tries unsuccessfully to impress the scornful Alexis with a catalogue of riches and self-praise that focuses on his singing and his reflection in the water:

> I sing as Amphion of Dirce used to sing, when calling home the herds on Attic Aracynthus. Nor am I so *deformed* [nec sum adeo informis]; on the shore the other day I looked at myself, when by grace of the winds, the sea was at peace and still. (1999, 1:2.23–6; my emphasis)

Corydon's song is, in turn, a reworking of portions of Polyphemus's unsuccessful wooing of Galatea in Theocritus's Idyll 11, combined with fragments from Idylls 3 and 6.[4] Loss, therefore, is inscribed in the very words Salicio utters, and in the very image he invents for himself at the mirror, not only because his words are borrowed and, in fictional identification, he is a mirror image of frustrated ancient lovers, but also because these ancient lovers come to him through a fragile intertextual enterprise. Salicio's song is in effect a rewriting of a rewriting, a pastoral fiction within a pastoral fiction: the failed voice of Polyphemus echoes in the failed voice of Corydon, now echoed in Salicio's voice. The *en abîme* structure mimics the shepherd's fragmentation and foreshadows the unhappy outcome. Galatea remains unmoved and Salicio's inner turmoil will continue, his fragmentation subtly inscribed in the very mirror that reflects his image: "esta agua que corre clara y pura" [in this brook which runs so clear and pure]. These flowing waters offer by their very nature a fractured reflection. Salicio's enchanting singing,

Orphic magic in the mouth of a Polyphemus figure, further heightens the drama of loss, of the unanswered call implicit in the line: "Tú sola contra mí t'endureciste" [you alone have hardened yourself against me] (v. 208).

As his song comes to an end, Salicio draws on visuality one last time to tell Galatea that he will leave the bower so she may enjoy it once again, perhaps with her new lover. Re-elaborating Galo's call to Lycoris from Virgil's Tenth Eclogue, he urges her to see, to bring her eyes and her presence to the bower, in a call stressed by anaphora:[5]

> *Ves aquí* un prado lleno de verdura,
> *ves aquí* un' espesura,
> *ves aquí* un agua clara,
> en otro tiempo cara.

> [*Here you can see* a meadow of lush green grass
> *here you can see* a wood,
> *here you can see* the running
> water once so dear to us.] (vv. 216–19; my emphasis)

Salicio's departure from the bower represents Galatea's final triumph and his surrender, his voice silenced by the strength of her own silence. His exit is also a concession to the exigencies imposed by pastoral on its inhabitants. To silence his song is to erase melancholy desire from the landscape and with it the memories of lost happiness, present pain, and an unenviable future – the disorder that disrupts the bower's peace and harmony. The shepherd's song, with its discordant images, suggests that it is Galatea who disturbs the natural order: his dream of the Tagus changing its course (v. 122), his vision of Galatea's desertion and unfaithfulness in terms of ivy torn from a wall and clinging to another (vv. 135–6), or the famous adynata, ancient and biblical, of the union of the wolf and the lamb, and of the quiet nesting of fierce serpents with gentle birds (vv. 161–5). But these images, according to the melancholic's habit of internalizing loss in material terms, are products of a pained imagination, the castoffs of a shattered inner landscape. Even the images that confirm Salicio's harmony with nature cited earlier, or those mentioned by the lyric narrator after the shepherd ends his melancholy lament, paradoxically reflect nature disturbed by his song:

queriendo el monte al grave sentimiento
d'aquel dolor en algo ser propicio,
con la pesada voz retumba y suena;
 la blanda Filomena,
 casi como dolida
 y a compasión movida,
dulcemente responde al son lloroso.

[In its deep bass the mountain, wishing to be
of service and to aid the expression of
such feelings of sorrow, echoes and resounds.
 Fair Philomela,
 as if in pain herself
 and moved to pity,
warbles a sweet reply to the doleful sound.] (vv. 228–34)

It is a disaffected Salicio who disrupts the bower. If finally silenced, he leaves behind (like Albanio in the Second Eclogue) a text that, though full of scattered bits of his psyche, is the product of a potent verbal power originating with Polyphemus and Orpheus, the very voices that shaped his melancholy self. Self-alienated and fractured, unable to rescue himself through narcissistic fantasy or to win back his Galatea, Salicio nonetheless stages a lament that testifies to full poetic agency.

The voice of the lyric narrator weakens as Salicio's song ends (v. 238). Echoing Virgil's Eclogue 8, where having sung the song of Damon, the poet asks the Muses to sing the song of Alphesiboeus because the power of his voice is spent (1999, 1:8.62–3), the eclogue's narrator invokes the Pierides, asking them to sing Nemoroso's song, for he neither can nor dares. The narrator's voice weakens in sympathetic response to Salicio's pain caused by his failure to move Galatea. But the narrator's loss of authority over his discourse is duplicitous, like the linguistic performance of Petrarch's lyric subject, who tells how the intensity of his erotic failure enfeebles his voice yet does so in lovely, graceful verses: "Amor ... di saver mi spoglia,/parlo in rime aspre et di dolcezza ignude" [Love ... strips me of all skill, I speak in harsh rhymes naked of sweetness] (1976, *Canzone* 125, vv. 14–16). The lyric narrator of Garcilaso's text continues to "sing" Nemoroso's lament in brilliant, powerful rhymes.

Mourning Becomes Material

Unlike the narcissistic Salicio, who begins his oral performance by apos-
trophizing Galatea, Nemoroso begins by addressing the pastoral bower:

> Corrientes aguas puras, cristalinas,
> árboles que os estáis mirando en ellas,
> verde prado de fresca sombra lleno,
> aves que aquí sembráis vuestras querellas,
> hiedra que por los árboles caminas,
> torciendo el paso por su verde seno.

> [Pure streams of crystal water blithely flowing,
> trees that stand admiring your reflections
> green countryside full of refreshing shade,
> birds that fill the air with your complaints,
> ivy making your way up in the trees,
> twisting and turning through their hearts of green.] (vv. 239–44)

Whereas the self-absorbed Salicio seeks reassurance by looking at
himself in the waters' mirror, Nemoroso looks beyond himself to the
trees looking at their reflection in the waters, as if admiring their own
beauty. For Nemoroso, idyllic nature is a mirror of memory, of happy
moments with Elisa: "por donde no hallaba/sino memorias llenas
d'alegría" [all the places that I knew,/where I found nothing but sweet
memories of joy] (vv. 251–2). Only the complaints of birds [querellas],
responding in Orphic communion with the lover, hint at his troubled
inner state.

Elisa now gone, Nemoroso evokes objects to define her and to pre-
serve her memory, objects that express his pain as well. He imagines
her as a delicate cloth rent by Death:

> ¡Oh tela delicada,
> antes de tiempo dada
> a los agudos filos de la muerte!

> [O delicate fabric,
> before its time surrendered
> to be cut to shreds by the sharp shears of Death]. (vv. 260–2)

"Delicate fabric," alluding to the threads spun and cut by the Fates (Morros 1995, 132), more intimately echoes the "telas delicadas" woven by the river nymphs of Garcilaso's Sonnet 11, which remind us of aristocratic women embroidering in their private quarters. But here Elisa *herself* is the delicate cloth, like the ones she may have stitched in the company of her friends in her own domestic space, for she is, within the pastoral fiction, a courtly lady in disguise. In the Third Eclogue, the nymph Nise memorializes Elisa by weaving her story in a tapestry, then inscribing her name and "voice" in an epitaph within a cartouche on the bark of a tree (vv. 237–49; see chapter 1). The tapestry, with its inscription, endows Elisa with a material life after death and beyond the bower:

> y ansí [su muerte] se publicase de uno en uno
> por el húmido reino de Neptuno.

> [so that the news of her death would spread from mouth to mouth
> throughout Neptune's humid realm.] (vv. 263–4)

Nise's memorial to Elisa is a luxurious hanging intended for viewing in the public sphere (and by extension recorded by the poet), creating a cultural monument and countering brooding Nemoroso's image of Elisa as a cloth torn to shreds. It is as if Nise were reweaving the dead Elisa in a new cloth inscribed with her name and her words. But Nemoroso, too, creates a memorial to Elisa: he bears a lock of her hair enshrouded in a white cloth next to his breast: "Tengo una parte aquí de tus cabellos,/Elisa, envueltos en un blanco paño,/que nunca de mi seno se m'apartan" (vv. 353–4). Unlike Nise's public memorial, woven for those unfamiliar with the sad tale told from the idyllic bower, Nemoroso's memento is private and the site for the performance of an idolatrous ritual: he dampens her hair with his tears, dries and touches – as if caressing – each strand, then binds them with a thread (vv. 352–63; Rivers 1980, 71).[6] These strands of hair – body parts as fetishes – function as a relic, a venerated remnant of the beloved that is carefully preserved, tucked away, with the white cloth like a reliquary enclosing Elisa's remains. Nemoroso's intimate form of devotion is part of the cult of Elisa, a way of possessing her, although he is also possessed by her image and her death. The ritual offers him some consolation since a relic typically has curative powers: "Tras esto el importuno/dolor me

deja descansar un rato" [This done, the tormenting grief/allows me just one moment of relief] (vv. 364–5). [7] Guy Lazure tells an anecdote regarding Philip II, a famous collector of relics, which is relevant here:

[Philip] in an effort to imitate the holy martyrs and transfer their thaumaturgic power to his own person ... asked, during his final days, to have relics corresponding to his aching limbs directly applied to his open wounds. He claimed that the presence as well as the contact with a part of Saint Sebastian's knee, one of Saint Alban's ribs, or the arm of Saint Vincent Ferrer, soothed his pains and helped him prepare for the sufferings to come. (2007, 59)

Nemoroso's recollection of Elisa through material reminders, anchoring memory and making the absent present, no matter how illusory, is reinforced in the *ubi sunt* passage by a celebratory blazon of exquisite fetishes – bright eyes, delicate white hand, golden hair, white breast (vv. 267–76) – ending with her lovely neck and hair cast in architectural terms: "¿Dó la columna que'l dorado techo/con proporción graciosa sostenía?" [Where is the white column, so graciously/proportioned, which upheld the golden roof?] (vv. 277–8).[8] Feminine beauty depicted as a well-proportioned column recalls a work widely read by Renaissance humanists, Vitruvius's *De architectura* (15 BCE), in which the Ionic column is said to mimic a woman's graceful form, delicacy, and proportion, with its capital draped "as if for hair ... [with] volutes on either side like curled locks" (1999, 4.1, 55; Morros 1995, 466) (figure 6.1). Resembling the column's volutes are hair fashions of the times, exhibited in Leonardo da Vinci's *Study for the Head of Leda* (figure 6.2), a preliminary drawing for his now lost painting *Leda and the Swan*, which survives in a copy by Cesare Sesto (1515–20). We might imagine this hair style behind Nemoroso's praise for Elisa, her golden hair in volutes, her neck elegant like a graceful column.

If Elisa is remembered and memorialized through cloth (echoed in Nise's tapestry) and her hair as a relic, Nemoroso's lamenting voice is anchored in a textual memory, scripted through the image of a nightingale grieving the loss of her young. Its model is Virgil's *Georgics* 4, where Orpheus mourns the dead Eurydice:

Month in, month out, seven whole months, men say beneath an airy cliff by lonely Strymon's wave, he wept, and, deep on icy caverns, unfolded his tale, charming the tigers, and making the oaks attend his strain; even

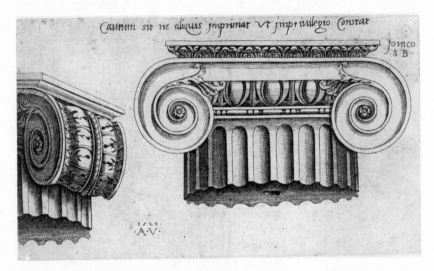

Figure 6.1: Agostino Veneziano, *Ionic Capital*. Engraving, 1528. The Metropolitan Museum of Art, NY. © The Metropolitan Museum of Art / Art Resource, NY.

like the nightingale, mourning beneath the poplar's shade, bewails the loss of her brood, that a cruel ploughman had spied and torn unfledged from the nest: but she weeps all night long, and perched on a spray, renews her piteous song, filling the region round with sad laments. (1965, 4.507–15)

Nemoroso follows closely the Virgilian text, which is modified and amplified:

Cual suele'l ruiseñor con triste canto
quejarse, entre las hojas escondido,
del duro labrador que cautamente
le despojó su caro y dulce nido
de los tiernos hijuelos entretanto
que del amado ramo estaba ausente,
 y aquel dolor que siente,
 con diferencia tanta
 por la dulce garganta,
despide, que a su canto el aire suena,

y la callada noche no refrena
su lamentable oficio y sus querellas,
 trayendo de su pena
el cielo por testigo y las estrellas,
 desta manera suelto yo la rienda
a mi dolor y ansí me quejo en vano
de la dureza de la muerte airada;
ella en mi corazón metió la mano
y d'allí me llevó mi dulce prenda,
que aquél era su nido y su morada.

 [As the nightingale, singing of heartbreak,
complains from where she's hidden in the leaves
of the cruel laborer who stealthily
despoiled that dear beloved nest of hers,
robbing her of her tender chicks, while she
was absent from the familiar branch,
 and the pain she feels
 with such rich variations
 pours so profusely forth
from her tuneful throat, that the air echoes with
her song, and the silent night does not restrain
this office of lament and accusation,
 as she calls on heaven
and the stars to bear witness to her pain:
 just so do I give free rein to my grief,
thus do I in vain accuse the cruelty
of unrelenting death that shows no mercy;
it reached with its cruel hand into my heart
and took away from there my dear beloved,
for there she had her nest and dwelling-place.] (vv. 324–43)

Nemoroso's comparison of his song to the fragile, grieving nightin-
gale's "tune" gives the passage a powerful visual quality. With his in-
imitable talent for compression, Garcilaso points to the nightingale's
skilful song with one word, "diferencia," which in the musical vocabu-
lary of the time meant variation (Mele 1930, 221; Rivers 1974, 295):
"aquel dolor que siente,/con diferencia tanta/por la dulce garganta,/
despide" [the pain she feels/with such rich variations/pours so pro-
fusely forth/from her tuneful throat] (vv. 330–3). Implicit in these rich

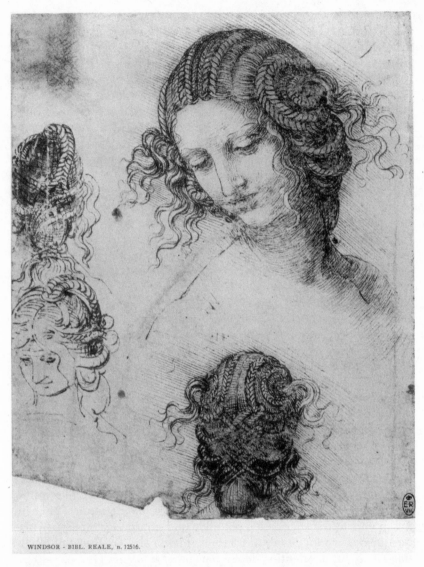

WINDSOR - BIBL. REALE, n. 12516.

Figure 6.2: Leonardo da Vinci, *Study for the Head* of *Leda*. Facsimile-Original in the Windsor Collection. Gabinetto dei Disegni e delle Stampe. Florence, Uffizi. Scala/Art Resource, NY.

variations is a sequence of musical notes, signs that render the nightingale's wailing in visual terms, in essence a materializing of sound strengthened by the reference to the bird's "dulce garganta" [tuneful throat], the very instrument that produces and projects it.

Visuality is manifested in two other registers, Nemoroso's spoken words, which reproduce the nightingale's lament, and the words recorded on the page by the poet. Emilie Bergmann comments on how Sor Juana's *Primero sueño* encodes sound in a "visually apprehensible form" in terms that apply here: "Words on a page function symbolically as visual and aural signs, whether voiced aloud or in imagination, while their sounds are commonly described phonetically in terms of spatial relationships and visual imagery – 'high' and 'low' pitch, 'bright' and 'somber' tone quality" (2013, 148). Homer and Petrarch use precisely the same type of visual encoding, which here subtends Nemoroso's nightingale passage and gives it subtextual force. Homer's nightingale "rills out and tilts her note, high now, now low," the variable song to which Penelope compares her wandering thoughts, wavering between decisions as she awaits Odysseus (1992, 19.568–9). Sonnet 311 of Petrarch's *Canzoniere* speaks of the "many grieving, skillful notes" [tante note sì pietose et scorte] of the nightingale's sweet song that accompanies the lover and reminds him of Laura's death (1976, 490).

The eclogue's rendering of the aural in visual signs foregrounds Nemoroso's pain, and night, the lament's temporal setting, makes its visual representation more vivid and immediate. María Rosa Lida comments on the role of Virgil's night: "el ruiseñor doliente se agiganta en la soledad y aislamiento de la noche" [the pained nightingale grows large in the solitude and isolation of the night] (1975, 105). In Garcilaso's poem, Virgilian night is qualified by Homer's epithet "quiet" (1992, 19.566), which converts the temporal into the spatial, where air resounds [el aire suena] as if sharing in the act of mourning. What is magnified in this "callada noche" [silent night], functioning like a huge echo chamber, are sound and voice. But voice, no matter how enchanting, points to the shepherd's plaintive and accusatory lament: "y ansí me quejo en vano/de la dureza de la muerte airada" [I in vain accuse the cruelty/of unrelenting death that shows no mercy] (vv. 339–40).

Rounding off the passage's mapping of the material is the "dulce prenda," which recalls the "dulces prendas" of Sonnet 10, a replay of Virgilian Dido's "sweet relics" [dulces exuviae], the clothing left behind by Aeneas, who abandons the Carthaginian queen in his quest for empire (1999, 1:4.651). Here, however, by inversion, "prenda" stands for the woman's body: "[La muerte airada] en mi corazón metió la mano/y

d'allí me llevó mi dulce prenda/que aquél era su nido y su morada"
[[Death] reached with its cruel hand into my heart/and took away from
there my sweet beloved,/for there she had her nest and dwelling place]
(vv. 341–3). We know that Elisa is another name for Dido, who is subtly
connected to Nemoroso's Elisa through the hair-as-relic motif, a mem-
ory marker like the clothing that Aeneas left on Dido's bed (Cruz 1988,
101). The eclogue's "dulce prenda," echoing the Virgilian text, is an
even more powerful memory marker, pointing to Elisa's physical loss.

In an attempted recuperation of Elisa, Nemoroso envisions her mate-
rially: "Divina Elisa, pues agora el cielo/con inmortales pies pisas y
mides,/y su mudanza ves, estando queda" [Divine Elisa, for now it is
the sky/you tread and measure with immortal feet,/and watch its
changes while remaining still] (vv. 394–6). Both movement and stillness
define Elisa in her celestial dwelling; her body, though immortal, is con-
ceived materially, fetishized as her feet tread the heavens and her eyes
(present in the verb "ves") survey its changes. He begs her to pray for
his death, typically envisioned as an act of liberation from the body
conceived as a torn veil: "este velo/rompa del cuerpo y verme libre
pueda" [this veil/of the body will be torn and I be free] (vv. 398–9), a
mirror image of Elisa as the delicate cloth shred by death. He then con-
jures up a pastoral fantasy through a Ptolemaic cosmology, mapping
the woman's heaven (Venus's sphere) as an idyllic bucolic space for
them to meet:

> y en la tercera rueda,
> contigo mano a mano,
> busquemos otro llano,
> busquemos otros montes y otros ríos,
> otros valles floridos y sombríos
> donde descanse y siempre pueda verte
> ante los ojos míos,
> sin miedo y sobresalto de perderte?
>
> [Then in the third sphere
> with you hand in hand
> we will seek another plain,
> other mountains, other flowing rivers,
> other flowering shady valleys,
> where I can rest forever and ever have you
> before my happy eyes,
> without the fear and shock of losing you.] (vv. 400–7)

Nemoroso's topography of the heavenly bower derives from his look-
ing into a textual mirror, Eclogue 5 of Sannazaro's *Arcadia*, where
Androgeo's heaven is anchored within a pastoral fiction:

> *altri* monti, *altri* piani,
> *altri* boschetti e rivi
> vedi nel cielo, e più novelli fiori.
>
> [*Other* mountains, *other* plains,
> *other* woods and banks
> you see in heaven, and fresher flowers.] (1961, vv. 14–16)

David Quint notes that, while the anaphoric repetition of *altri* suggests
a transfer to a Christian heaven, the real emphasis is on the similarity of
the heavenly and earthly bowers: "The pastoral reduces all experience
to the terms of its finite code, and triumphs over death by admitting no
discontinuity between the way it describes the happy existences en-
joyed by its living and dead shepherd" (1983, 54). If Nemoroso's heav-
en, like Androgeo's, suggests a transfer to a higher, metaphysical plane,
he speaks of its pastoral delights in terms similar to the *Arcadia*'s: "otro
llano ... /otros montes y otros ríos,/y otros valles floridos y sombríos"
[other mountains, other flowing rivers, other flowering shady valleys].
The setting is clearly earthbound, the repetition of *otro* revealing the
bucolic paradise of Venus's sphere as a double, a mirror of the earthly
bower the shepherd seeks to leave behind.[9]

Nemoroso's textual allusion to Sannazaro's *Arcadia* is qualified by
Petrarch's *Canzoniere*, which places fellow poets like Dante and Guittone
d'Arezzo on the planet Venus, the traditional dwelling of the souls of
dead poets (1976, Sonnet 287). In a vision from a poem *in morte* (1976,
Sonnet 302), Petrarch's lover/poet encounters Laura, who tells him that
one day he will live with her in the third sphere ["In questa spera/sarai
ancor meco"]. Nemoroso puts himself in this celebrated band, indirect-
ly identifying himself as poet, and a happy one. His earlier identifica-
tion with the nightingale implicitly carried this notion of the shepherd's
poetic agency, since for Renaissance writers, as for the ancients, the
nightingale was an emblem of creativity as well as lament. María Rosa
Lida calls the Virgilian nightingale "el pájaro artista" (1975, 101). Behind
it stands Orpheus, the *vates*, the lyrical embodiment of the creative ca-
pacity of language. If the Virgilian nightingale points to Nemoroso's
fashioning as the subject of mourning, it also calls attention to the

fashioning of his poetic voice, for like his friend Salicio, he possesses a potent linguistic agency.

Nemoroso's last words fittingly identify him with Orpheus, but this time with the *vates* turned successful lover of Ovid's *Metamorphoses* 11. Virgil ended his Orpheus tale with the head of the singer floating down the Hebrus, but Ovid, the urbane Augustan, ends his tale on an optimistic note: the decapitated head reaches the shore of Lesbos, where a serpent attacks it. Phoebus saves the head by transforming the serpent into stone. Orpheus's ghost passes to the Underworld and finds Eurydice in the Elysian Fields:

> And [he] caught her in his arms. Here now side by side they walk; sometimes he follows as she walks in front, sometimes he goes ahead. Now he may safely look back upon his Eurydice. (1984, 2:11.63–6)

Orpheus's gaze, which had lost him Eurydice when he disobeyed Pluto's injunction not to look back while leading her to the upper world, now confirms her presence. In his pastoral paradise, Nemoroso's words echo Ovid's: "y siempre pueda verte/ante los ojos míos,/sin miedo y sobresalto de perderte" [and ever have you before my happy eyes, without the fear and shock of losing you]. Nemoroso's quest for a sense of harmony in his imagined pastoral double with Elisa is a solution for pastoral, as is Salicio's silencing his song and exiting the bower. In introducing the contingencies of time and history in their troubled adventures of desire and death, the shepherds had imposed on the bower, as David Quint observes in another context, "a temporal narrative sequence which is at odds with pastoral's present tense" (1983, 47).[10]

By the end of the poem nothing is resolved. Nemoroso and Salicio are alone, the failure of their calling confirmed by the lyric narrator, who remarks unceremoniously: "solo el monte oía" [only the mountain was on hand to hear] (v. 410). The exuberant eloquence of the shepherds is cut short by the coming of dusk, and the eclogue ends with a Virgilian sunset, with "that vespertinal mixture of sadness and tranquility" that Erwin Panofsky sees as Virgil's "most personal contribution to poetry" (1955, 300):

> Nunca pusieran fin al triste lloro
> los pastores, ni fueran acabadas
> las canciones que solo el monte oía,
> si mirando las nubes coloradas,

al tramontar del sol bordadas d'oro[11]
no vieran que era ya pasado el día;
 la sombra se veía
 venir corriendo apriesa
 ya por la falda espesa
del altísimo monte, y recordando
ambos como de sueño, y acusando
el fugitivo sol, de luz escaso,
 su ganado llevando,
se fueron recogiendo paso a paso.

 [Never would those shepherds have put an end
to their sad lament, nor the songs concluded,
which only the mountain was on hand to hear,
 had they not realized, looking at the
colored clouds of sunset, gold-embroidered,
that the day was already past and done.
 Darkness could be seen
 speeding ever nearer
 over the imposing flank
of the high mountain, and the two as if
awakening from a dream, as the fugitive
sun was dying and gave but little light,
 rounded up their sheep
and slowly drove them homeward to the fold.] (vv. 408–21)

This pastoral fiction ends with a final materializing act as the shepherds look up at the sky. A significant detail – the clouds of sunset "embroidered in gold" – is a subtle reminiscence of Elisa as a cloth, with the strands of her golden hair, following the metaphorical context, having served, we may suppose, as thread for its restitching. It is as if nature had entered the narrative to memorialize Elisa, just as Nise in the Third Eclogue weaves her name and words on a tapestry as a public monument.

Epilogue

With the rise of Spain as a trans-European and global power, the heroic culture of the Reconquest and the Castilian warrior was superseded by new social, political, and aesthetic ideals exemplified by a "new poetry" and a new subject, aligned with the court, empire, and modernity (Middlebrook 2009). Garcilaso, a courtier and soldier who travelled across the Continent in Charles V's entourage and military forces, was the initiator for Spain (along with Juan Boscán) of that aristocratic, erudite lyric in the vernacular.[1] Culturally a European in the widest sense and a humanist, he possessed a broad and deep understanding of ancient texts and the works of contemporary Italians with whom he associated and from whom he freely borrowed. It is the argument of this book that, beyond establishing the verse forms and imitation practices of the Italian humanists, and crafting an imperial subject for Spanish letters, Garcilaso was a pioneer in another sense, that is, in engaging the material culture of his time and making objects central to his poems as sites of lyric discourse and cultural exchange. He was intimately familiar with Europe's ruins and antiquities, with its newly commissioned sumptuous objects, and with the abundance of religious and practical objects filling up the physical and mental landscape of writers and artists of the early sixteenth century. In the poems analysed in the preceding chapters, objects range from canvasses and frescoes to those made of cloth, marble, metal, crystal, as well as other material presences, such as the body and sites of battles in Europe and North Africa. Garcilaso's interest in materiality was a product of the intellectual and cultural agendas that critics like Paula Findlen have linked to the Renaissance. "The historical and aesthetic consciousness and antiquarian impulses we associate with humanism," writes Findlen, "served to

focus scholars' interest on tangible products of the past, viewed in the mirror of the present" (1998, 87).

Looming large in Garcilaso's poetics of the material is the dual project of *translatio imperii* and *translatio studii* inherent in the alliance of the new lyric with the imperial agendas of Charles V and his court, portrayed nowhere better than in the images carved on Tormes's crystal urn in the Second Eclogue. The urn, channelling Trajan's Column, compares Roman imperial exploits with the deeds of Charles and the duke of Alba, and paints the Ottoman Turks besieging Vienna as vanquished new barbarians, their effeminate "skirts" and "silks" signs of cowardness and moral corruption. But the urn also places in relief the political and cultural ideals of the Spanish past and those associated with the Habsburg court: the ancestral values of Reconquest carried from Spain to Germany by Fernando de Toledo confront Charles V's "cordura" [good sense] and restraint, as the emperor imposes his political agenda in the Vienna campaign of 1532, framed within the twin threats posed by Suleyman the Magnificent and the Protestant princes. Fernando's unruly behaviour, as he struggles to pursue the fleeing Turks, was not appropriate to a Renaissance courtier. In curbing the duke's excesses, Charles not only exercises his royal authority but also projects the flexibility of mind and moderation that should also have been Fernando's, and more so since, as the carved images inform the reader, this Spanish aristocrat had been instructed by Boscán in the art of courtiership [cortesanía] (v. 1345).[2] Charles's own excesses will appear in Garcilaso's famous "A Boscán desde La Goleta" and the "Ode to Ginés de Sepúlveda" on the Tunis campaign of 1535, which expose the underside of imperial wars in the blood-soaked soil of North Africa, near the ruins of Carthage, where the lyric subject's appropriation of Virgilian legend and ancient history critique the emperor.

If the crystal urn and the fields of Tunis are here material sites at the service of a political spectacle, exposing clashing ideologies, the objects strewn through Garcilaso's other texts serve for the constitution of the subject in other significant ways. Karen Harvey puts the matter succinctly: "Through their very materiality – their shape, function, decoration and so on – [objects] have a role to play in creating and shaping experiences, identities, and relationships" (2009, 5). That lack of autonomy places Garcilaso's subject far from Burckhardt's individual, that "uomo singolare" who "stands before and apart from the object of his attention, confident of his ability to make the object compliant with his political or scientific or artistic will," as de Grazia, Quilligan, and

Stallybrass have observed (1996, 3). Caught up in the material allure of the object, Garcilaso's subject depends on the object for its very identity. Salicio shapes his melancholy self against a harder-than-marble Galatea, and Nemoroso casts his mourning self in reference to a shrouded relic and a delicate cloth, representing the dead Elisa. A protean object like the mirror, one of Garcilaso's favourite devices, reveals to the melancholy Albanio, his inner impoverishment in his configuration as a new Narcissus, yet at the same time confirms Camila's own sense of selfhood as subject.

The historical Garcilaso, too, enters his texts in relation to objects, most memorably his Third Eclogue, where he appears as a malleable subject constituted by luxurious tapestries as a verbal craftsman and flattering courtier. Fernando Checa Cremades has drawn our attention to the role that objects in royal treasuries played in court life, especially for Charles V, as "vehicles of representation for the prince's power, magnificence and splendour" (2010, 30). The emperor shaped his image through tapestries, sculptures, and paintings, following the example of his grandfather Maximilian, who "marketed" himself through his manipulation of objects and visual images crafted by artists like Albrecht Dürer. Woodcuts, medals, and a tomb monument all served for his self-fashioning in order to display his imperial authority (Silver 2008). The courtier Garcilaso was highly influenced by this use of the symbolic value of luxury items, as his own use of sumptuous gifts for the vicereine attests.[3]

Garcilaso's excursions into ancient myth and history connected orality, memory, and writing. Acutely aware of living in a print culture, he was drawn to the volubility and malleability of memory, even when materialized by inscription on durable surfaces. If Nemoroso preserves Elisa's shrouded locks as a relic for the performance of a private ritual, the river nymph Nise memorializes her by weaving her sad tale, her name, and her "voice" in a tapestry for public display. Both the shepherd and the nymph anchor memory in the material. But memory is always a matter of negotiation, especially in connection with oral performance. In the case of the duke of Alba, whose deeds preserved on an urn-archive are interpreted, written down, and then transmitted orally, the process of retrieval is not wholly satisfactory, which is why the listener Salicio would prefer to see Severo's written text in the absence of the urn itself, rather than accept fully Nemoroso's spoken word. The complicity of multiple authors constructing a text delighted Miguel de Cervantes, who proclaimed Garcilaso as his favourite poet and who

shared his play with multiple narrators and the mutability of text and memory. Cervantes also shared with Garcilaso an Italian sojourn, where a rich material culture inspired him as much as the riches of Spain and Flanders (de Armas 1998, 2006, and Laguna, 2009). If Cervantes found so much to admire in Garcilaso, it was because they were kindred spirits – and masters of ingenious imaginings.

Notes

Introduction: Engaging the Material

1 Here I follow Garcilaso's biographer, Fernández de Navarrete (1850, 44), who suggests that the poet travelled to Rome (and then to Naples) with Pedro de Toledo from the Danube region, where Charles had been engaged in the Vienna campaign against Suleyman the Magnificent and where he had Garcilaso confined to an island (see p. 7 and note 10 below). Keniston (1922, 114–16) suggests that Garcilaso may have travelled to Naples with the duke of Alba's entourage.

2 On Heemskerck, see Christian (2010), 157–9, 340–3 and Bober and Rubinstein (1986).

3 For Garcilaso's service at court, see Keniston (1922, 42–102).

4 Empress Isabella had her own collection of tapestries, jewelry, and other luxury objects in royal residences at Valladolid, Madrid, Granada, Toledo, and Barcelona. On her possessions, see Redondo Cantera (2010, 2:1245–78, 1279–2322).

5 Margaret's 176 paintings included Jan van Eyck's *Arnolfini Wedding*, panels by Juan de Flandes, works by Hieronymous Bosch, Rogier van der Weyden, and Jan Gossaert, and an official gallery of portraits of the Burgundy-Habsburg dynasty (Eichberger 1996, 269–71, and Eichberger and Beaven 1995). Detailed inventories list as well 130 tapestries, 52 sculptures, and an assortment of prints, drawings, precious stones, jewellery, and decorative objects (Eichberger 2010, 3:2351–63, 2365–542). Margaret's library held 380 books and velvet-bound manuscripts "often used as gifts for royal connections" (Blockmans 2002, 15).

6 Morán and Checa offer details of the collections of Spanish nobles of the first half of the sixteenth century (1985, 44–5). An extraordinary collection

that could rival that of Emperor Charles was owned by Mencía de Mendoza (1508–54), a member of the illustrious Mendoza family, who would marry Fernando of Aragon, duke of Calabria and viceroy of Valencia. On that important collection, see García Pérez (2004 and 2009). On her library, see García Pérez (2006) and Cruz (2011, 45–9).

7 Even before the arrival of Habsburg rule in Spain, strong commercial ties between Castile and its northern allies introduced an abundance of foreign-made artefacts in the Peninsula, not only tapestries but also sculptures, illuminated manuscripts, and luxury clothing; Italy, too, had made important inroads in Spanish art in the fifteenth and early sixteenth centuries (Brown 1998, 7–28). On the art scene, see also in particular Checa Cremades (1988, 65–163).

8 As Christian puts it, "Matching up the places of Rome" with events described in Livy "overwhelmed Petrarch's own sense of sight, to such an extent that the Capitoline cliff that Manlius had defended, or the spot where lightning had struck Tullus Hostilius, attracted more of Petrarch's attention than the city's temples and triumphal arches. Everywhere he looked, Petrarch saw Rome's imperial destiny" (2010, 13).

9 This is the new classicism that Barkan finds in Renaissance humanism: "the search for a common ground between the writings that permit moderns to imagine antiquity and the material remains that might, in however limited a way, satisfy the senses" (1999, 47).

10 The duke and other family members opposed the marriage because the groom was a commoner and the "son of a *comunero*" to boot (Maltby 1983, 26). Charles sent a *cédula* (4 September 1531) from Flanders to Empress Isabella, who was tending to the affairs of state at Medina del Campo, urging her to prevent the wedding (Fernández de Navarrete 1850, 208–9). Though it was too late, she began an inquest. In February 1532, on his way to Regensburg with Fernando de Toledo to join Charles's campaign against Suleyman the Magnificent, who was besieging Vienna, Garcilaso was intercepted at Toulouse by Isabella's emissary. At first evasive when confronted with the empress's questions in her royal *cédulas*, Garcilaso finally admitted participating in the wedding and was immediately banned from the emperor's court and ordered to be sent to the fortress of Salvatierra de Alba (Fernández de Navarrete 1850, 218). Fernando, disobeying the imperial decree with the characteristic daring that made him one of the most colourful players in Garcilaso's Neapolitan poems, continues the journey with the poet. Upon reaching Regensburg, however, and this is the accepted version of events, Garcilaso was promptly shipped to the Danube island.

11 On Bembo and Garcilaso, see López Grigera (1988). I have profited from
 Morros (1995, xxxv–xxxvi) and Rivers (1974, 15–16) for details on
 Garcilaso's stay in Naples. For the text of Bembo's letter of praise, see
 Gallego Morell (1976, 168–9). For biographical and historiographical de-
 tails on Garcilaso, including his death, see Hermida Ruiz (1999). On
 Garcilaso's biography, see Vaquero Serrano (2002).
12 On Garcilaso's education in Spain, see Keniston (1922, 18–41).
13 On Garcilaso and the "new" European poetry, see Helgerson (2007).
14 Kirkbride's *Architecture and Memory* is the printed text of the work which
 appears in the Gutenberg-e on-line history series (http://www.gutenberg-e
 .org). The online version contains the text, in addition to digital images,
 artwork, audio, video, and hyperlinks. On Federico's *studioli*, see also
 Cheles (1986) and Raggio (1999). In the Gubbio *studiolo*, now housed at the
 Metropolitan Museum of Art, supposedly hung Justus Ghent's seven por-
 traits of figures kneeling at the feet of the Liberal Arts as goddesses, offer-
 ing a bound volume or a symbolic object. Only four of these portraits have
 survived, including those of Federico with Dialectic and Guidobaldo, his
 son, with Rhetoric (Kirkbride 2008, 22). The Urbino *studiolo* contains paint-
 ings of twenty-eight "illustrious men," including popes and scholars like
 Petrarch and Dante. As for the books Federico read in his *studioli*, they
 were as much artefacts for display as for reading. His book buyer de-
 scribed the lavish binding of the Bible, the cornerstone of his collection,
 covered with gold brocade, and books on medicine, history, and the Greek
 and Latin doctors and philosophers bound in scarlet and silver (Jardine
 1996, 140, 185).
15 Isabel Torres's *Love Poetry in the Spanish Golden Age: Eros, Eris and Empire*
 (Woodbridge: Tamesis, 2013) came to my attention too late to be included
 in this study.

1. Weaving, Writing, and the Art of Gift-Giving

An earlier version of this chapter appeared as "Gifts for the Vicereine of
Naples: The Weavings of Garcilaso's Third Eclogue." In *Objects of Culture
in the Literature of Imperial Spain*, edited by Mary E. Barnard and Frederick
A. de Armas, 3–30. Toronto: University of Toronto Press, 2013.

1 On Renaissance tapestries, see in particular Campbell (2002, 2007),
 Delmarcel (1999, 2000), Thomson (1973, 189–276), and Balis, et al. (1993).
2 On the identity of María, see Keniston (1922, 255–8).
3 For details on Garcilaso's exile, see the introduction.

4 Spain had a thriving industry of fine cloth making in silk, gold, and silver threads (especially in Granada, Toledo, Cordoba, Seville, and Valencia), as well as embroidery in particular for the nobility and church. Toledo at one point had thirteen thousand *telares*. However, there was no significant tapestry industry that could compete with the Flemish and the French until the establishment of the Real Fábrica de Tapices (first known as the Fábrica de Tapices de Santa Bárbara) by Philip V in the eighteenth century (Sánchez Cantón 1950, 105, and Junquera 1985, 49). For details on the tapestry industry in Spain, see Junquera (1985, 43–9) and Herrero Carretero (1999). On embroideries and other weavings in fine cloth, see Martín I Ros (1999) and González Mena (1999). There is some evidence that Garcilaso was a consumer of "tejidos." Aurora Egido (2003, 187) reminds us that in his last will and testament, the poet includes the following: "Debo a Castillo, tejedor de oro tirado, vecino de Toledo, veinte mil maravedís" [I owe Castillo, a resident of Toledo and weaver in gold threads, twenty thousand maravedis]. The citation comes from Morros (1995, 285), who identifies the weaver as Bartolomé Castillo (d. 1550).

5 On Maximilian's staging of images – including books, medals, armour, and a tomb monument – to enhance his authority and spread his imperial ideology, see Silver (2008). On the famous set of commemorative woodcuts commissioned by Maximilian, see Appelbaum (1964).

6 This inventory of the viceroy's possessions records a number of tapestry chambers, including several based on mythological or classical themes (seven tapestries woven in silk and gold of the legend of Paris and Helen, two on Vulcan, ten on Lucretia, and six on Romulus and Remus). Others were listed by genre, millefleurs (verdura) appearing among other types, such as "ystoria" [history], "figuras" [figures], and many with religious themes (Hernando Sánchez 1993, 51).

7 In her study of Isabella's inventories, Redondo Cantera comments on the objects the empress used for needlework in her private chamber: "The empress could not escape what was then considered an ineludible activity pertaining to her female status – devoting part of her time to needlework. References to this pastime, which was regarded as befitting a privileged female space, are found in other related items: a press for making *dechados* [samplers], molds for making mesh, *las quatro argollitas con unos alfileres para poner en el almohadilla donde labra su majestad* [four small rings and a few pins to put on a small cushion for her majesty's embroidering], the embroidery stretcher *en que su majestad labra a las vezes* [on which her majesty embroiders on occasion], and the jewels in the form of sewing instruments" (2010, 2:1271).

8 For a discussion of the relation between weaving and painting in the ec-
logue within the context of the visual language of ekphrasis and the rheto-
ric of *enargeia* as conceived by Erasmus, following Quintilian, see Barnard
(1992). For the use of *enargeia*, see also Smith (1988, 43–77). On artistic di-
mensions of the eclogue, see also Bergmann (1979), Paterson (1977), and
Rivers (1962). See Barnard (1992) on the interrelation between weaving
and writing, which I expand upon below. Egido (2003) makes important
observations on this dual enterprise, especially on the double meaning of
the word "tinta," purple dye as well as ink (188, n.19).

9 For details on this request, made in a letter dated 1 September 1534, see
Lumsden (1952). In a second letter, dated 20 January 1535, Pedro asks the
emperor for the postponement of a suit Garcilaso had brought against the
powerful Mesta, a request that was denied (Keniston 1922, 131).

10 Mauss extended his observations on gift-giving to ancient Rome, India,
and Germany, inviting by implication further inquiry into this cultural
practice in other areas and periods. For studies tailoring Mauss to practic-
es in the early modern period, see in particular Davis (2000), Klein (1997),
Shephard (2010), and Warwick (1997).

11 Chartier reminds us that "The logic of the gift, which assumes friendship
… intersects with that of the contract, which demands payment. As
Natalie Zemon Davis has noted, this was the rule in pre-modern societies,
which saw no contradiction in combining remuneration with generosity"
(2007, 4–5). Placed within this context, Garcilaso's verses from the dedica-
tion, which make no claim to reciprocity, seem disingenuous: "lo que pue-
do te doy, y lo que he dado,/con recebillo tú, yo me'nriquezco" [I give you
what I can; if you receive it, that is the greatest wealth that you can give
me] (vv. 51–2).

12 Using Mauss as a point of departure, Lisa Klein has examined gift-giving
customs at the court of Elizabeth I. Among Klein's examples is the gift pre-
sented to the queen by Elizabeth Talbot, countess of Shrewsbury, whose
dynastic ambitions in marrying her daughter to the son of Mary Stuart's
mother-in-law, Charles Stuart, made the queen suspect the countess's loy-
alty. The countess presented a "hand-wrought" gift, an embroidered cloak
chosen and designed for Elizabeth to reassure the queen of her "love and
fidelity." The gift was memorable, as "the color, trimming, and expense"
of the cloak called forth Elizabeth's praise and "promises of continued fa-
vor" (1997, 472). Sánchez Cantón (1950, 92–5) comments on gifts of tapes-
tries made by family and friends to Isabel of Castile, which though not
"hand-wrought" by the donors were evidently offered to establish person-
al bonds with the queen, as noted in the formulaic inscription in the royal

register: "dado para servicio de su Alteza" [given in service to her Majesty] (92). Among these are the gifts of the Marquesa de Moya, "fidelísima amiga y servidora" [most loyal friend and servant] (92–3) and the small tapestry given by the treasurer, Rui López, "muy rico, con oro e alguna plata" [very rich, with gold and some silver] (94).

13 On models, see Morros's extensive notes (1995, 230–7, 518–26). See also Cruz (1988, 106–22) and Lapesa (1985, 158–66), who stress an *ars combinatoria*; Fernández-Morera (1982, 73–100), who focuses especially on the Virgilian sources; and Navarrete (1994, 124–5), who singles out Castiglione's notion of *sprezzatura* as the basis of Garcilaso's "graceful, seemingly artless" lyric. On Garcilaso's imitation of classical mythology, see Cammarata (1983) and Guillou-Varga (1986).

14 Following Virgil, Sannazaro in his *Arcadia* has nymphs weave tapestries, including one with the story of Orpheus and Eurydice, which Garcilaso uses as a model (1966, 12.136).

15 On violence, language and the body in Ovid's account of Philomela, see Enterline (2000, 1–5). From the extensive bibliography on Philomela, see in particular, Jones (1991), Joplin (1984), Marder (1992) and Martín Rodríguez (2008).

16 For various interpretations of the spinners in the foreground, including the old woman as Athena herself, see Jones (1996, 205–6) and Welles (1986, 149–50).

17 In his discussion of the Orphic allusion, Paul Julian Smith suggests that "while Garcilaso appears to appeal to 'voice' as authentic, eternal utterance, he knows that the preservation of that voice is dependent on its duplication by the written word" (1988, 52). Egido offers a similar interpretation (2003, 185), adding that pen and paper are the true protagonists, part of "la poética de una *laudatio* que convierte el acto de escribir en una empresa heroica y, a la par, en un acto de entrega amorosa" [a poetics of celebration that converts the act of writing into a heroic enterprise and, at the same time, into an act of amorous surrender] (185). In Egido's reading, María represents the beloved.

18 Armando Petrucci documents this graphic culture in early modern Italy, which had its antecedents in ancient epigraphic practices (1993, 16–61). Petrucci offers numerous examples of tombstones, including the one erected by Giovanni Pontano in Naples in memory of his wife, Adriana, with inscriptions imitating classical lettering on its façade and flanks (1993, 22). Garcilaso may have seen it, along with other epigraphic funerary monuments, during his stay in the city.

19 The term decapitated (*degollada*) has caused much controversy. El Brocense, schocked by the violence of the image, substituted *igualada* (*amortajada* [shrouded]) for *degollada* (Gallego Morell 1972, 301), accepted by Morros (1995, v. 230). Fernando de Herrera uses *desangrada* [bled to death] (Gallego Morell 1972, 582). On the controversy, see McVay (1993), Martínez-López (1972), and Porqueras-Mayo (1970). Martínez-López argues persuasively for decapitated as the meaning of *degollada*.

2. Empire, Memory, and History

1 One of Charles's objectives was to check the expanding forces of the Ottoman Empire by reinstalling his vassal Mulay Hassan, whom Barbarossa had ousted from Tunis. The campaign was also directed against Francis I of France, Suleyman's ally. When Francis met Pope Clement VII at Marseille in 1533 to make final preparations for the marriage of Catherine de Medici to his son Henry, duke of Orléans, he told the pope that he would "favour" a Turkish attack on "Christendom" so as to recover the duchy of Milan, which he felt the emperor had unjustly taken from him (Tracy 2002, 145). Francis proposed an attack on the east coast of Naples as well as war against Venice, so as to prevent the latter's military and naval aid to the emperor's campaign (Junquera [de Vega] 1968, 42).

2 For details on this commemorative entourage, see Horn (1989, 1:15).

3 Carruthers links memory to creativity: "[Memory] includes 'creative thought,'" she writes, "but not thoughts created 'out of nothing.' [Memory resides in] structures 'located' in one's mind as patterns, edifices, grids, and – most basically – association-fabricated networks of 'bits' in one's memory that must be 'gathered' into an idea" (1998, 23). See also Carruthers (2008) and (2009), a convenient synthesis of her main ideas on memory and recollection, especially as they relate to visual images. On the art of memory, see also Yates (1966), Rossi (2000), and Bolzoni (2001). For studies on the workings of artificial memory in Spain's early modern period, see in particular Cacho Casal (2009), De Armas (2005), Egido (1990) and (1991), and Rodríguez de la Flor (1996).

4 For other tapestries that commemorate Charles's military victories, see Junquera [de Vega] (1968).

5 Prose translation in Horn (1989, 1:181). Horn includes transcriptions of all Latin and Spanish captions, along with translations. Transcriptions appear as well in Junquera [de Vega] (1968) and in Junquera de Vega and Herrero Carretero (1986), who include illustrations of the ten tapestries.

6 Charles took Nebrija's words to heart, for he proclaimed the Laws of Burgos (1512–13) to teach and write Castilian in the New World. In 1535 and again in 1540 he proclaimed that Amerindians were to learn "Christianity, decent morals, good government, and the Castilian language." However, Walter Mignolo notes that even though teaching the natives how to read and write Castilian was a major concern of the Crown, the Amerindian languages were privileged for purposes of conversion. Castilian was the language of oral communication and Latin the language of learning (1995, 53–7).

7 On early modern cartography and empire, see Padrón (2004).

8 As the Spanish caption indicates, this tapestry shows the cartographic information of the lands, the seas, the cities and, as mentioned above, the ports from which they sailed (Horn 1989, 1:181). Other tapestries contain on the right hand border information to orient the viewer as to the topography found in the images.

9 On the *Plus Ultra* device, see also Rosenthal (1971). In the end the expansionist project remained at the level of image-making, of propaganda for Charles and his tapestries, for the victory at Tunis proved ephemeral and Barbarossa soon returned to the city. Bunes Ibarra (2006), contrary to Horn, contends that the Tunis expedition was not a crusade. He is essentially correct, for its immediate purpose was practical, to protect the Mediterranean coasts and shipping routes. But the purpose of the tapestries was to present the campaign as a kind of crusade, a holy war against the Muslim infidel, as the first tapestry makes amply evident; it conveyed a hidden message to the European "heretics," the Protestants who were placing Christendom in danger, as Charles saw it.

10 Drawing on notions of spectatorship, those of Andrea Nightingale in particular, Luis Avilés sees Vermeyen in this self-portrait as actor and spectator, conceiving his act of painting sketches as another action in the field of battle (2008, 94).Vermeyen as a man of action strengthens his self-representation in the first tapestry as the artist with authority, who recuperates and manipulates his function as witness. I have profited from Avilés's insights for my analysis.

11 Thomas Campbell cites a letter Mary sent to Charles 17 December 1550: "As for the tapestry of Tunis I cannot accompany it on this trip, because apart from all the delays of the workers, it has pleased God to take for himself the painter master Pieter" (2002, 388). "The meaning is quite obvious," writes Campbell, "the project, already slowed by delays in the weaving of the tapestries, had been further impeded by the death of the second

painter, Master Pieter. A few lines later Mary states that it will now be necessary to engage 'un aultre peintre'" (2002, 388).

12 Richard Helgerson argues that the scenes in the lower left-hand corner of tapestries showing the suffering of civilians display commiseration and sympathy for the victims on Vermeyen's part (2007, 51): "an old man, a woman, and a child mourning the fall of Goleta" (seventh tapestry); "three imperial soldiers gambling for possession of a Moorish woman and child" (ninth tapestry); "a soldier thrusting his musket into the back of a woman fleeing the sack of Tunis" (tenth tapestry). But Javier Portús points out that in large paintings or tapestries depicting images of war, it is typical to relegate scenes of suffering to the corners in order to minimize their presence (2006, 12–13), a reading accepted by Avilés (2008, 98, note 16). Whether the scenes mean much or nothing is difficult to say. Most likely they remind the viewer of the consequences of war, vignettes as footnotes to scenes from the battlefield and sanitized so as not to obscure the official message of the tapestries.

13 Several accounts tell of Garcilaso's wounds, among them a letter, dated 22 June 1535, by Enrique Enríquez de Guzmán to his father, the count of Alba. Paolo Giovio writes about how Garcilaso, surrounded by several Moors, was saved by the Neapolitan Federico Carrafa (Keniston 1922, 133–5). Sepúlveda in his *De bello Africo* offers details of the rescue of Juan Suárez, a distinguished member of Charles's court, by a group of Spaniards, among them Alfonso de la Cueva, who lost his horse and sustained many wounds, and Garcilaso, who was wounded in the face and arm (2005, 46–7). For more on *De bello Africo*, see below. In Garcilaso's Sonnet 35, to his friend Mario Galeota, the wounds are an occasion to berate "ungrateful" Cupid, who has sided with the enemy to injure the poet "en la parte que la diestra mano/gobierna y en aquella que declara/los concetos del alma" [in the part that governs my right hand and in that which declares the concepts of my soul], to punish Garcilaso for speaking ill of the god of love.

14 What we find in this process of image-making is a dynamic that Bolzoni identifies in the workings of emblematic images and allegory in the sixteenth century but which applies here as well: a "circular relationship between memory and invention and in a mirroring relationship between words and images ... There is thus a tendency to construct a unified heritage, a great gallery of images capable of condensing, and thus expressing, various meanings, and capable, moreover, of reactivating them in different forms, in memory and in the text" (2001, 181).

15 Avilés comments that epic and lyric are united in the quatrains through metaphors that coincide in both love and war, a leitmotif in Garcilaso's erotic poems (2008, 96–8). In my interpretation, Dido appears implicitly in the quatrains and thus determines their lyric dimension. The scene in the second tercet, the lyric voice's appropriation of Dido's immolation to represent himself, engages the quatrain scenes and emanates from them.

16 Garcilaso's allegiance to empire has elicited differing interpretations. Helgerson suggests that Garcilaso's poetry is one of "contradictions," and as part of the new poetry of sixteenth-century Europe, "deeply at odds with itself": Garcilaso "is at once the celebrant of imperial revival, *and* the new poet, *and* the advocate of place, *and* the abandoned woman ..." (2007, 55; emphasis in the original). For Rodríguez García, a "deteleologizing process" in Garcilaso's shift of positions and reversals in the Goleta sonnet leads him to conclude that "no political program and no literary topos emerges unmodified": Garcilaso brings together a confession of his "lyric vocation" and "an exploration of the arbitrariness of any form of translation, whether imperial or figural" (1998, 16). Graf, in a well-documented study of Garcilaso's elegies, holds to the poet's critique of Charles's imperial ideology (2001, 1321), but finds an ambiguity in Garcilaso's position towards empire (1319). Javier Lorenzo argues that in the Goleta sonnet the purpose of the reference to Scipio and his destruction of Carthage is not to celebrate Charles's imperial conquest but to question its legitimacy. He also shows how Garcilaso's critique of empire is codified in the sonnet and in the First Elegy and the Second Elegy through Petrarchan themes and images (2004).

17 For thoughts on the discourse of friendship and the private self in the Second Elegy, see Middlebrook (2009, 96–100).

18 *De bello Africo* was later incorporated into a larger work, *De rebus gestis Caroli V* (Trascasas Casares 2005, xvii). Sepúlvedas's chronicling of the Tunis campaign profited from Luis de Ávila y Zúñiga's *Comentario de las guerras de Túnez*, an account that Garcilaso had furnished him (Keniston 1922, 139–40). I cite *De bello Africo* from Trascasas Casares's bilingual edition (2005), which contains a useful bibliography.

19 "Intrepido animo" is a variant that appears in several manuscripts in place of "tanto animo" of manuscript *Granatensis*, which is the basis of Trascasas Casares's edition (2005, 1.29, 35).

20 For a discussion of the turn from praise for Charles to sympathy for the Moorish victims within a discussion of arms and letters, see Cruz (2002, 197–9).

3. Objects of Dubious Persuasion

1 On the *Ode* as an oration structured according to Aristotelian rhetoric to show the failure of Orphic song, with its magic and rhetoric, see Barnard (1996). Here I reframe parts of that essay.

2 On the magic of Orpheus, see Segal (1989).

3 In addition to echoes of the principal models for the power of Orphic song over nature (Virgil 1999, *Georgics* 4.481–4, 510 and Ovid 1984, *Metamorphoses* 10.40–7, 86–105,143–4; 11.1–2), there are textual reminiscences of a Parthenion or maiden song by Pindar, "that siren-song which silences the Zephyr's swift winds" (1964, 26; cited in Segal 1989, 12), and the enchanting song of the lyre in Horace (*Odes* 3.11.13–24), within an act of persuasion of the reluctant Lyde, with its mythological *exemplum* of Danaus's daughters. Garcilaso's rhetor's act of persuasion includes its own mythological *exemplum*, Ovid's Anaxarete, as we see below. On Garcilaso's use of Horace's *Odes* 3.11, Propertius Elegy 1.2, and Ovid's *Metamorphoses* 14.623–771, see Lázaro Carreter (1986) and Cortés Tovar (2008), who goes beyond Propertius Elegy 1 to offer other allusions to Roman elegy in Garcilaso's *Ode*, including the topic of the *exclusus amator*.

4 For an analysis of Trajan's Column, see chapter 4.

5 On Charles's triumphal entries in Italy, see Mitchell (1986, 133–79), Strong (1984, 75–97), Gorse (1990, 193–9), and Checa Cremades (1979).

6 Daniel Heiple gives numerous examples of the Armed Venus and their relation to the *Ode* (1994, 369–78). Even though the coincidence in vocabulary and her fierceness links Violante to the traditional *Venus armata*, she does not fully conform to this designation, as I argue in what follows. Heiple finds Neoplatonic elements in the *Ode* by linking it to a fresco by Francesco del Cossa – a work first brought to our attention by Peter Dunn – and other pictorial works (382–92). I discuss Cossa and others but draw different conclusions.

7 Luis Avilés comments on the meshing of the military theme and Violante's harshness: "La transición que promete el poeta de pasar de los temas guerreros y violentos al hacer notar la beldad y la aspereza de la dama no implica una desaparición de las referencias militares. Todo lo contrario, se sigue insistiendo en articular dichas referencias" [The transition that the poet promises on leaving behind martial and violent themes as he makes note of the lady's beauty and harshness does not do away with the military references. On the contrary, he keeps insisting in articulating such references] (2005, 32).

8 Antecedents of the connection of *viola* to a lover weakened by passion, dating back to el Brocense's commentary, include Horace's *Ode* 3.10 and Sannazaro's *Arcadia*, Prose 10 (Gallego Morell 1972, 274). Francisco Rico mentions Petrarch's Sonnet 224 ("un pallor di viola et d'amor tinto") and comments on the motif of the transformation of the lover into the beloved in Petrarch's *Canzone* 23 and its relation to the *Ode* (1978, 337).

9 Morros, who favours "en tu figura" [in your figure] on line 30, notes that in this reading "figura" is not simply emblematic but bears the meaning of form or person; thus Mario is transformed into Violante herself just as the lyric I is transformed into Laura in Petrarch's *Canzone* 23 (1995, 86). But even el Brocense's variant "en su figura" [in its figure] carries by implication, given the word play with Violante's name, the traditional Petrarchan motif of transformation.

10 It is possible that Garcilaso visited Ferrara during his many travels in the Italian peninsula. Ferrara had a vibrant court life animated by well-known poets and artists, and was close to Bologna, which Garcilaso had visited as a member of the imperial entourage at Charles's coronation 24 February 1530.

11 Despite the bondage motif, Edgar Wind finds no Neoplatonic meaning in the paintings by Botticelli and Piero di Cosimo, since Mars is depicted as "a sleeping loving swain, surrounded by amoretti playing at war" (1968, 90). According to Wind, "The planet Mars always retains, even when dominated by the planet Venus, a certain degree of boldness and bellicose fervour" (90).

12 Boats propelled by paddle wheels and oars were popular among inventors and artists in the fifteenth and sixteenth centuries. Drawings by Giuliano da Sangallo (c. 1490) show ancient galleys propelled by paddle wheels and oars floating on what seems to be the Tiber near the Castel Sant Angelo and the Villa Farnesina (Meiss 1974, 324).

13 On the *exclusus amator* in ancient writers, see Copley (1956).

14 On anatomy theatres, see also French (1999), Klestinec (2011), and Siraisi (1990) and (2001). Garcilaso may have had the opportunity to visit such centres in other Italian cities, like Pavia and Rome, during his period of exile. It is doubtful that Garcilaso visited one in Spain, which was then slowly building a practice of human dissection. Anatomy theatres did not flourish there until the end of the sixteenth century. On the theatre and the teaching of anatomy in early modern Spain, see Martínez-Vidal and Pardo-Tomás (2005).

15 On anatomical treatises, see in particular Cunningham (1997), Carlino (1999), Park (1994), and O'Malley (1965).

16 Carlino points out that "the qualms over [the practice of dissection] are astonishing. The manner of their expression and the adoption of certain rituals in Renaissance anatomy suggest that they were generated by a common fear of contamination by proximity to the impure and malodorous bodies of the deceased in funerary practice ... This attitude also affected society as a whole, which continued to hold the opening up of the body as a dishonorable and sacrilegious event" (1999, 7).

17 Neoplatonism circulates widely this material view of language. In the *Philebus Commentary*, Ficino writes of the intimate relation between word and thing: "A name, as Plato says in the *Cratylus*, is a certain power of the thing itself first conceived in the mind, then expressed by the voice, finally signified by letters" (138-40; cited in Tomlinson 1993, 116).

18 In Horace's *Odes* 1.8 Lydia is "ruining Sybaris" with too much love-making. Violante is ruining Mario by doing just the opposite. Navarrete points out that the poem represents "an inversion not only of Horace but of the entire courtly and Petrarchan code" (1994, 109).

4. The Mirror and the Urn

An earlier version of "At the Fountain of Narcissus" appeared as "The Mirror of Narcissus: Imaging the Self in Garcilaso de la Vega's Second Eclogue." In *Ovid in the Age of Cervantes*, edited by Frederick A. de Armas, 137–57. Toronto: University of Toronto Press, 2010.

1 On mirrors, see, especially, Bialostocki (1977), Goldberg (1985), Grabes (1982), and Melchior-Bonnet (2002). The convex mirror was more popular in northern European painting of this period than in Italy. One notable exception was Parmigianino's self-portrait, which I examine below.

2 Leonardo writes on this notion in his *Treatise on Painting* (1436) under a heading that reads "How the Mirror Is the Master and Guide of Painters." For Leonardo's treatise, see Kemp (1989).

3 The following studies from the abundant scholarship on Narcissus have been particularly useful: Bartsch (2006, 84–96), Bettini (1999, 94–108, 228–36), Brenkman (1976), Hardie (1988), Knoespel (1985), and Vinge (1967).

4 On this practice in Petrarch, see Barkan (1980, 1986, 206–15), Vickers (1982), and Enterline (2000).

5 Garcilaso's Albanio serves as a model for Góngora's unstable Polyphemus, who as a Narcissus figure at his mirror confronts these very dichotomies (Barnard 2002, 77–9). Isabel Torres deals with these issues in her interpretation of Garcilaso's Albanio (2009, 879–81). In her study, Torres opens up a new way of explaining the relation between the two parts of the eclogue

by positing a "water/mirror poetics" as a structural link. For other useful studies of the eclogue, see in particular Azar (1981), Boase (1988), Checa [Cremades] (2003), Fernández-Morera (1982, 54–72), Komanecky (1971), Morros (2003), and Waley (1977).

6 For a study that uses Freud to examine melancholia in early modern texts, see Enterline (1995). For *topoi* in Garcilaso's treatment of melancholia, see Orobitg (1997).

7 On Bellini's painting, see also Goffen (1991), Hills (1999, 130–1), and Phillippy (2006, 165–6). Quintero (2004) examines paintings of women looking into mirrors, notably Titian's *Venus with Mirror* (c. 1555) and Velázquez's *The Rokeby Venus* (c. 1647–51), and Golden Age literary analogues, pointing to the "specular staging" in terms of male mastery. Quintero comments on the period's production of this type of painting for private male viewing, as in Philip II's *camerino* in the Escorial, with pertinent bibliography, in particular, Civil (1990) and Portús (1999).

8 On Titian's painting, see also Bialostocki (1977, 70) and Goffen (1997, 66–7, 70–1).

9 For a Neoplatonic reading of Camila, see Rivers (1973), and compare with Lumsden, who offers an interpretation along the lines of a moral taboo (1947b, 268–9).

10 On the relation between interiority and melancholia, see chapter 5.

11 Parts of Albanio's apostrophe to his body are a reworking of Narcissus's own. Albanio, however, weaves fragments from Narcissus's refined seduction into a *frottola*, a poetic form in *rimalmezzo*, often used by Italian poets "to portray highly emotional states of mind or the disconnected language of rustics" (Fernández-Morera 1982, 59). Albanio, like Narcissus, tells his body that the barrier separating them is not the sea, not even city walls or mountains, but a thin layer of water (Morros 1995, 958–62). Also like Narcissus, Albanio tells his image that its gaze – Narcissus's "friendly looks" become Albanio's eager "nunca te hartas de mirarme" [you never tire of looking at me] – its movements, and gestures show its desire for union (vv. 965–9).

12 Bartsch bases her interpretation on Hardie, who writes on Ovid's use of Lucretius's *De Rerum Natura*: "Narcissus is condemned to the insatiable gazing of the Lucretian lover (cf. Lucr. 4.1102), who can never get past the surface, lured on by the *simulacra* that stream from the superficies of the body" (1988, 84).

13 The main models for the Orpheus myth are Virgil's *Georgics* 4 and Ovid's *Metamorphoses* 10–11. For an appropriation of Garcilaso's Orpheus for the representation of the poetic voice featured in the first tapestry of the Third Eclogue, see Barnard (1987a). On Orpheus in the Third Eclogue, see also Nelson (2010, 203–11) and Gallagher (1980).

14 On Echo, see Hollander (1981), Loewenstein (1984), and Spivak (1993).

15 On melancholia, in addition to Schiesari, see, especially, the now classic study by Klibansky, Panofsky, and Saxl (1964), as well as Enterline (1995) and Wittkower and Wittkower (1963). Albanio also displays clinical symptoms of melancholia familiar from contemporary medical treatises: a sad, suicidal figure, fearful and paralyzed with grief, he goes for days without sleep or food. On a catalogue of Albanio's clinical symptoms, see Soufas (1990, 69–70).

16 The phrase cited is from Bal (2001, 240), for whom the Narcissus story is "about the denial of the true, natural body" (2001, 241).

17 The anthropomorphized river reclining on its urn – a familiar iconographic motif in early modern art and literature – may have been inspired by the river Sebeto reclining on his urn in Sannazaro's *Arcadia* (2009, 12.37) or by the bas relief on the frontispiece of the temple of Castor and Pollux in Rome, which was still standing in Garcilaso's time (Summonte, *Historia*, 86–7; cited in Morros 1995, 501). Garcilaso uses a variation of the river/urn image in Elegy I, a eulogy dedicated to Fernando on the death of his younger brother Bernaldino de Toledo in Sicily after the Tunis campaign (1535): "El viejo Tormes …/seca el río …/y humedece la tierra con su lloro,/no recostado en urna al dulce frío/de su caverna umbrosa, mas tendido/por el arena en el ardiente estío" [The old Tormes … dries up the river … and soaks the earth with his tears, not reclined on his urn in the sweet cool of his dark cavern but lying on the sand in the burning summer] (vv. 142–7). The lament for the duke's brother is made more poignant by the fact that the weeping Tormes has abandoned his urn.

18 According to Derrida, the *archons* not only "ensured the physical security" of the archival site and its documents but were given the "hermeneutic right and competence" to interpret them. "Entrusted to such *archons*," continues Derrida, "these documents in effect speak the law: they recall the law and call on or impose the law" (1996, 2).

19 Castiglione in *Il Cortegiano* deems lineage critical to the making of the courtier.

20 Fernández-Morera calls attention to the unruliness of Fernando, who is "presented much like a boar which, having been let loose, literally wants to lie with the female" (1982, 70).

21 Witness a sixteen-year-old Fernando leaving home without his grandfather's consent to join the Constable of Castile, Iñigo de Velasco, in Fuenterrabía to fight the French and Navarrese rebels, where as it turned out he would meet Garcilaso (Maltby 1983, 13).

22 What follows is taken from Maltby (1983, 24–5).

23 When the boat reaches Cologne, an allusion to a painting of Saint Ursula
(vv. 1480–90), martyred by the Huns – similar to a painting in the Victoria
and Albert Museum (Rivers 1974, 394) – presages the battle of Christian
against heathen in Vienna and Fernando's role as Christian warrior.

24 The connection between a Habsburg and a Roman imperial narrative was
part of the genealogical myth-making in which Charles is identified with
Roman emperors. Fernández Oviedo y Valdés in his *Catálogo real de
Castilla* merged mythological and historical figures to establish a fictive
Roman ancestry for Charles (Tanner 1993, 113). In his *Relox de principes*
(1529) – a mirror for princes based on the example of Marcus Aurelius –
Antonio de Guevara, court preacher and Charles's historiographer, identi-
fies the emperor with the ancient ruler, who embodied the virtues of
imperial Rome (1994). Titian's portrait of Charles on horseback after his
victory over the Protestants at the Battle of Mühlberg (1548) is the most
striking pictorial representation in this tradition, as it recalls the
Equestrian Statue of Marcus Aurelius in the Capitoline Hill. Charles "is
Romanized as the stoic emperor," writes Frances Yates of this painting,
"the World Ruler on whose domains the sun never set. Yet he is also the
northern ruler, the Christian and chivalrous emperor, wearing the collar of
the Order of the Golden Fleece" (1975, 22). The confrontation with
Suleyman in the eclogue's urn accords with that portrayal of Charles as
defender of Christendom, now battling against the infidel in the role of the
new Trajan. Garcilaso uses this false genealogy to connect Charles with the
Scipios in Sonnet 33, "Boscán desde La Goleta," and with Caesar in the
"Ode to Ginés de Sepúlveda," which I examine in chapter 2.

25 On Trajan's Column, see Packer (2001), Lepper and Frere (1988), and
Florescu (1969).

5. Eros at Material Sites

1 The phrase appears in Ficino's response to an accusatory letter from his
friend Giovanni Cavalcanti: "if it should be necessary that [the melancholy
temperament] does issue from Saturn, I shall, in agreement with Aristotle,
say that this nature is a unique and divine gift" (1985, 2:34). Ficino typical-
ly regarded Saturn as a dark and malevolent planet, but also the "iuvans
pater" of men of intellect.

2 The calling to nymphs based on the Virgilian passage was widely imitated
by Italian poets, who may have contributed to Garcilaso's version. In
Sannazaro's *Arcadia*, Prose 8, the rejected, grieving Carino seeks pity and
sympathy from anonymous, silent nymphs. His invocation to the spring

and forest nymphs contains verbal echoes of Garcilaso's sonnet's invocation: "O Napaeans lift up your golden heads from the crystal waves and receive my last complaints before I die ... O Dryads, loveliest maidens of the forest depths ... with long, yellow hair falling down over your white shoulders, see to it, I pray you ... that my death among these shades should not be kept in silence" (1966). Bernardo Tasso's Sonnet 137 to the nymphs in his *Primo libro* (1531) occupies a place much like Sannazaro's and Garcilaso's in the mythological tradition and the tradition of melancholia. It possesses that urgent, unqualified intensity of the melancholy poet/lover who pleads with the nymphs to hide his tears in the fertile deeps of their river, so as to please his lady:

> Ninfe, che'n questi chiari alti cristalli
> Vaghe scherzando al camin vostro andate,
> Et amiche d'Amore e di pietate
> Guidate ognor dolci amorosi balli ...
> Aprite al pianto mio l'umido seno,
> E queste amare lagrime chiudete
> Nel più secreto vostro erboso fondo,
> Che veder non le possa il cieco mondo,
> Poi le sprezza colei, de le cui liete
> Vaghezze è 'l Cielo, et di sue grazie adorno (1995, 1:113).

> [Nymphs, who in these clear, deep crystal waters gracefully playing, you make your way, and friends of Love and mercy, continue your gentle loving dances ... Open your watery bosom to my weeping, and shelter these bitter tears in the most secret part of your grassy deep, so the blind world will not see them. For she disdains them, she who adorns Heaven with her happy loveliness and her grace.

On Tasso, see Heiple (1994, 125–6, 211–12).

3 For Ficino and Petrarch, I draw on Coffin (1979, 9, 12–13).

4 Lacan's "mirror stage" guarantees such an image, that of a coherent, stable entity. But since this imaginary wholeness is a fantasy, alienation from himself and from the world is the subject's unavoidable condition (1977, 4).

5 In Sonnet 12, a melancholy subject finds himself in a similar linguistic indecision. He shuttles in utter confusion between extremes of daring and fearing as he contemplates paintings that mirror his psychological condition, Icarus and Phaeton tumbling to their deaths. In this poem "either-or" (o-o) is privileged to reveal instability and inner rupture, imposing a parenthetical prison for the subject, who appears hopelessly caught in a linguistic entrapment. Paralyzed by psychological confusion between

linguistic signs, he is unable to move beyond, to find liberation from his melancholia.

6 H. Diane Russell writes that Dürer's woman "is an object on a table, just as are the lute and a vase that are shown in two other perspective wood-cuts in the treatise" (1990, 21). This is in effect what occurs in Garcilaso's poem, where Daphne's body is the object of the speaker's gaze. For a study of gender roles using Dürer's engraving in Calderón's *El pintor de su deshonra*, see Bass (2008, 70–1).

7 Rafael Lapesa, echoing Fernando de Herrera, suggests that Garcilaso may have been inspired by a painting (1985, 158). On works of art portraying Daphne's metamorphosis available to Garcilaso, including Agostino Veneziano's mannerist Daphne (its distortions bearing close resemblance to the sonnet's renditions), see Barnard (1987b, 122–5).

8 On the tradition of the blazon in the early modern period, see in particular Vickers (1997) and Kritzman (1991).

9 For additional details on the differences between Ovid's rendition of Daphne's transformation and Garcilaso's rewriting in the sonnet, as well as Apollo's reaction dealt with below, see Barnard (1987b, 110–16). Here I go beyond these details to give a new reading to Garcilaso's version.

10 Mary Ann Doane explains the power of the Other in terms of the Lacanian gaze, the destabilizing presence for the subject, which is at work in Garcilaso's sonnet: "What is specific to Lacan's gaze is not the mainte-nance of the subject but its dispersal, its loss of stable boundaries. The gaze situated outside, the subject necessarily becomes a part of the picture, assimilated by its own surroundings. Differentiation is lost and, with it, subjectivity as a category" (1991, 84).

11 On the notion of dream in the cinema, see also Metz, "Film and Dream: The Knowledge of the Subject" (1982, 101–8).

12 On Galenic theory, see in particular, Schoenfeldt (1999), Siraisi (1990), and Temkin (1973).

13 Joseph Koerner explains what for him constitutes the purpose of the draw-ing: "Dürer made this small sketch as a means of describing the symptoms of his illness to a doctor. Yet the care with which the artist has drawn and modeled his likeness with delicate touches of watercolor suggests a wider function for the work. In his penetrating gaze, the sick Dürer addresses us as viewers, inviting us to witness not merely the symptoms of an illness, but the whole afflicted person" (1996, 177).

14 In Sonnet 8, Garcilaso offers a detailed version of the woman's eyes wounding through their rays, causing internal turmoil as in the *Canción*. On this sonnet, see Rivers (1960–1). The theory of spirits appears, among

others, in Castiglione's *Il Cortegiano* 4, which undoubtedly served as a model, given Garcilaso's close acquaintance with this text. For an intertextual analysis of the Canción, using Ficino, Castiglione, Benet Garret (il Cariteo), and other models , see Morros (2000).

15 On these and other transformations as emblems of the lyric subject's internal condition, see Barkan (1986, 206–15), Enterline (2000, 91–124), and Durling, (1976, 26–33).

16 On autobiography and the construction of the self in Petrarch, see in particular Enterline (2000, 93–6) and Mazzotta (1993, 108–12).

17 On the tradition of fantasy and the phantasm, see also Couliano (1987) and Serés (1994). For details on this tradition in Garcilaso, especially in Sonnet 8, see Gargano (1988). For an analysis of melancholia, imagination, and artistic representation as applied to Calderón's *El pintor de su deshonra*, see Bass (2008, 72–6).

18 In psychoanalytic theory, particularly in Freud, a dissatisfaction "on moral grounds" is a characteristic feature of melancholia (1978, 14:247–8).

19 The line offers two other possible meanings: "a fear that has made me forget her" and "a fear that she has forgotten me." Of course, the subject's psychological instability allows for all three meanings simultaneously.

20 On linguistic fragments that define the woman in Garcilaso's poetry, see Azar (1989).

21 On Augustine's notions of autobiography, see in particular Bruner and Weisser (1991) and Spengemann (1980).

22 Bergmann links the constancy of the subject's love in this sonnet to the *Philebus*'s account of perception and memory connected to writing and painting (1979, 238), bringing into her discussion Petrarch and Michelangelo, among others. Agamben places the *Philebus* within the phantasmatic tradition: "the artist who, in Plato's text, draws the images (*eikonas*) of things in the soul is the phantasy; these pictures are in fact shortly thereafter defined as 'phantasms' (*phantasmata*)" (1993, 74). Morros offers a long commentary on the sources of the sonnet, including Plato, Ficino, and Aristotle, and abundant examples from other poets and prose writers (1995, 368–75). See also Lapesa (1985, 61–4).

23 Daniel Defert notes that sixteenth-century French dictionaries do not define *habitus monasticus* simply as garment (concurring with *Autoridades*). "The *habitus monasticus* designates the code, the way of life, from which the garment cannot be separated: '*habit-habitus* makes the monk' ... The garment is a code of conduct and a reminder of the code for the wearer as well as for others" (1984, 28).

24 If the subject of Sonnet 5 celebrates the habit made from his beloved as cloth, the subject of Sonnet 27, by contrast, rejects the enslavement of his habit (again costume and custom) cut from Love's cloth (¿quién podrá deste hábito librarse ...? [who can liberate himself from this habit ...?]. Placed side by side, the two poems reveal the typical paradoxical pleasure and pain of Petrarchan love. On Sonnet 27, see Heiple, who focuses on its religious dimensions (1994, 155–6).

25 For other examples, see Morros (1995, 369–71), including *cancionero* poets, such as Garci Sánchez de Badajoz and Diego Sánchez de Haro.

6. Staging Objects in Pastoral

1 In this regard, Richardson mentions "the bracelet of bright hair about the bone" from John Donne's "The Relic," by which the poet "imagines he and his beloved will meet again on the day of resurrection" (2011, 3). Among the objects the eclogue's shepherds use for "performing emotions," Elisa's hair as relic is the closest to Donne's image, a token that, as we see below, unites the lovers and is a space for thinking through the intensity of Nemoroso's own love for his beloved

2 On the *scripta puella*, see Wyke (1987) and (2002), and Sharrock (1991). The mistress of Ovid's *Amores* 1.12 is an appropriate example; her textuality reflected in the very material fiction where she is inscribed, the "writing tablets" on which she sends the poet-lover her messages (Brown 2010, 667).

3 Cruz finds a similar inversion in the myth of Anaxarete, a type of Violante, in the *Ode* (1988, 68).

4 Idyll 6 is especially relevant. Damoetas, playing the role of Polyphemus in a singing contest with Daphnis, has the Cyclops celebrate himself at the waters as mirror: "I'm not as ugly, you know, as men say I am;/Just now I looked at myself in the calm sea, and –/As I judged it – saw two handsome cheeks and this/One handsome eye. The water reflected the gleam/ Of my teeth, which were whiter than Parian marble" (2002, vv. 34–8).

5 Virgil's passage reads, "hic gelidi fonts, hic mollia prata, Lycoris, hic nemus" [here are cold springs, here soft meadows, Lycoris, here woodland] (vv. 42–3). Garcilaso's text adds "ves" [see] to the sequence in order to focus on the specular play. For Virgilian allusions in the eclogue, see Bayo (1970), Cravens and George (1981), and Fernández-Morera (1982).

6 Morros (1995, 467–8) notes pastoral sources for mementoes venerated by a lover (hair, ribbon, clothing) in Theocritus, Virgil, and Sannazaro, as well as in a passage from Chrétien de Troyes's *Le chevalier de la charrette* [*The Knight of the Cart*]. Lancelot adores Guinevere's hair, found in her comb:

"[T]ouching it a hundred thousand times to his eye, his mouth, his forehead and his cheeks ... He placed the hair on his breast near his heart, between his shirt and his skin" (1991, 225) , a gesture similar to Nemoroso's, although Lancelot's beloved is alive, and left the comb behind as a marker, a trace he can follow in order to find her.

7 Nemoroso's ritual performance with dead Elisa's hair as relic may be cogently explained through modern trauma theories, fitting Cathy Caruth's notion that trauma is a form of possession. A traumatic crisis, writes Caruth, "is not assimilated or experienced fully at the time, but only belatedly, in its repeated possession of the one who experiences it. To be traumatized is precisely to be possessed by an image or event" (1995, 4). The trauma of possession is in turn lessened through performance. Diana Taylor writes about this act of amelioration: "Trauma becomes transmittable, understandable, through performance – through the reexperienced shutter, the retelling, the repeat" (2001, 230).

8 Morros (1995, 133), following Mele (1930, 221) and Lapesa (1985, 133), identifies as models Petrarchan allusions to the "roof of gold" and "crystalline column" to celebrate Laura's body (1976, *Canzone* 325, vv. 16, 27–8).

9 It has long been recognized that Elisa's celestial sphere is something other than a Christian heaven. Responding to Otis H. Green's Christian interpretation (1953), Elias Rivers comments that "Garcilaso avoided being explicitly Christian or pagan: he exemplifies Renaissance syncretism in the best sense" (1980, 72, note 22). Lapesa writes "este anhelo ascensional se une a la representación pagana de los Campos Eliseos, tal como aparece en la égloga V de la Arcadia" [this longing to ascend is linked to the pagan representation of the Elysian Fields, as it appears in Eclogue V of the Arcadia] (1985, 139). Taking as point of departure Petrarch's Sonnets 302 and 287, Anne Cruz notes an ambiguity in Garcilaso's passage: the Neoplatonic ascent of the beloved may be both to a Christian heaven and to an essentially artistic place (1988, 105). On Neoplatonic dimensions of the eclogue, see Parker (1948) and (1985, 49–51). For a cogent response to Parker, see Torres (2008), who gives an alternate reading of the eclogue based on notions of time, intertextuality, and memory.

10 Robert ter Horst suggests that the suspension of time is one of the clear, though futile, objectives of the poem (1968). For other useful studies of the eclogue, see Cascardi (1980), Ghertman (1975), Zimic (1988), Komanecky (1971), ter Horst (1987), and Smith (1995), who studies the constraints of "homosocial desire" displayed in Salicio's song (vv. 175–82).

11 For line 412, I accept Rivers's reading "bordadas de oro" (1974) – instead of "orladas de oro" of manuscript Mg proposed by Alberto Blecua (1970,

133–5) and accepted by Morros (1995) – for its artistic touch, so evident throughout the eclogue, as well as its suggestive relation to the image of Elisa as a "tela delicada" [delicate cloth].

Epilogue

1 Richard Helgerson has made the case for Garcilaso meriting a fuller European reputation for his radical remaking of Spanish poetry before Joachim du Bellay and Pierre de Ronsard remade French poetry along similar lines, and in anticipating Philip Sydney and Edmund Spenser in England (2007, xiii).

2 Boscán's "Carta a la Duquesa de Soma" [The Letter to the Duchess of Soma] advocates a courtly subject defined by self-moderation, restraint, and "mental prowess" within an Italianate poetics. On Boscán and the courtier, see Middlebrook (2009, 41–4) and Lorenzo (2005, 249–61). Writing about Castiglione's notions of courtiership, José Antonio Maravall reminds us that the courtier possesses a type of discipline in which habit and reason unite: "su enseñanza, siempre dirigida a su proyección final en la conducta, le aparta de la ciega subordinación al pasado ... le salva de la rutina y se aplicará con la más acertada medida a los tiempos nuevos" [his learning always directed towards its final goal in conduct, distances him from a blind subordination to the past ... saves him from everyday routine and makes him devote himself in measured correctness to the new times] (1986, 30). Courtly values and practices extend to matters of government and even war.

3 Garcilaso was the forerunner of early modern writers who engaged material culture and made objects "perform" in theatre, poetry, and prose, as recent studies demonstrate. Juárez Almendros analyses clothing and ornaments in fictional and historical autobiographical writings for the construction of identity (2006). De Armas studies how Cervantes was inspired by frescoes, sculptures, and paintings of Renaissance Italy; he explores questions of ekphrasis, the politics of imitation, and religious ideology (2006). Bass offers a full-scale study of the role of portraits in Spanish drama in the sixteenth and seventeenth centuries, when portraiture entered the stage as a performative cultural object (2008). And Laguna explores Cervantes' works in relation to the visual culture of Spain, Italy, and Flanders, offering new insights on aesthetic and political issues (2009). See also the probing studies in collections edited by García Santo-Tomás (2009) and Barnard and de Armas (2013).

Works Cited

Agamben, Giorgio. 1993. *Stanzas: Word and Phantasm in Western Culture.* Translated by Ronald L. Martinez. Minneapolis: University of Minnesota Press.

Alberti, Leon Battista. 1972. *On Painting and On Sculpture.* Edited and translated by Cecil Grayson. London: Phaidon.

Appelbaum, Stanley, ed. and trans. 1964. *The Triumph of Maximilian I: 137 Woodcuts by Hans Burgkmair and Others.* New York: Dover.

Ariosto, Ludovico. 2008. *Orlando Furioso.* Translated by Guido Waldman. Oxford: Oxford University Press.

Atil, Esin. 1987. *The Age of Sultan Süleyman the Magnificent.* Washington: National Gallery of Art.

Avilés, Luis F. 2005. "Las asperezas de Garcilaso." *Calíope* 11:21–47.

Avilés, Luis F. 2008. "Ética del espectador: Vermeyen y Garcilaso ante la conquista de Túnez." In *Cánones críticos en la poesía de los Siglos de Oro,* edited by Pedro Ruiz Pérez, 87–110. Vigo: Academia del Hispanismo.

Azar, Inés. 1981. *Discurso retórico y mundo pastoral en la "Égloga segunda" de Garcilaso.* Amsterdam and Philadelphia: John Benjamins.

Azar, Inés. 1989. "Tradition, Voice and Self in the Love Poetry of Garcilaso." In *Studies in Honor of Elias L. Rivers,* edited by Bruno Damiani and Ruth El Saffar, 24–35. Potomac, MD: Scripta Humanistica.

Bal, Mieke. 2001. *Looking In: The Art of Viewing.* London and New York: Routledge.

Balis, Arnout, et al. 1993. *Les Chasses de Maximilien.* Paris: Réunion des Musées Nationaux.

Barkan, Leonard. 1980. "Diana and Actaeon: The Myth as Synthesis." *English Literary Renaissance* 10.3:317–59. http://dx.doi.org/10.1111/j.1475-6757.1980.tb00720.x.

Barkan, Leonard. 1986. *The Gods Made Flesh: Metamorphosis and the Pursuit of Paganism*. New Haven: Yale University Press.

Barkan, Leonard. 1999. *Unearthing the Past: Archaeology and Aesthetics in the Making of Renaissance Culture*. New Haven: Yale University Press.

Barnard, Mary E. 1987a. "Garcilaso's Poetics of Subversion and the Orpheus Tapestry." *PMLA* 102.3:316–25. http://dx.doi.org/10.2307/462479.

Barnard, Mary E. 1987b. *The Myth of Apollo and Daphne from Ovid to Quevedo: Love, Agon, and the Grotesque*. Durham: Duke University Press.

Barnard, Mary E. 1992. "Correcting the Classics: Absence and Presence in Garcilaso's Third Eclogue." *Revista de Estudios Hispánicos* 26:3–20.

Barnard, Mary E. 1996. "Myth, Rhetoric and the Failure of Language in Garcilaso's 'Ode ad florem Gnidi.'" In *Brave New Words: Studies in Spanish Golden Age Literature*, edited by Edward H. Friedman and Catherine Larson, 51–65. New Orleans: University Press of the South.

Barnard, Mary E. 2002. "The Gaze and the Mirror: Vision, Desire, and Identity in Góngora's *Fábula de Polifemo y Galatea*." *Calíope: Journal of the Society for Renaissance and Baroque Hispanic Poetry* 8:69–85.

Barnard, Mary E., and Frederick A. de Armas, eds. 2013. *Objects of Culture in the Literature of Imperial Spain*. Toronto: University of Toronto Press.

Barolski, Paul. 1995. "A Very Brief History of Art from Narcissus to Picasso." *Classical Journal* 90:255–9.

Barthes, Roland. 1979. "From Work to Text." In *Textual Strategies: Perspectives in Post-Structuralist Criticism*, edited by Josué V. Harari, 73–81. Ithaca: Cornell University Press.

Bartolomě Arraiza, Alberto, ed. 1999. *Artes decorativas II*. In *Summa Artis: Historia general del arte* 45. Madrid: Espasa Calpe.

Bartsch, Shadi. 2006. *The Mirror of the Self: Sexuality, Self-Knowledge, and the Gaze in the Early Roman Empire*. Chicago and London: University of Chicago Press.

Bass, Laura R. 2008. *The Drama of the Portrait: Theater and Visual Culture in Early Modern Spain*. University Park: Pennsylvania State University.

Baudry, Jean-Louis. 1986a. "Ideological Effects of the Basic Cinematographic Apparatus." Translated by Alan Williams. In *Narrative, Apparatus, Ideology*, edited by Philip Rosen, 286–98. New York: Columbia University Press.

Baudry, Jean-Louis. 1986b. "The Apparatus: Metapsychological Approaches to the Impression of Reality and the Cinema." Translated by Jean Andrews and Bertrand Augst. In *Narrative, Apparatus, Ideology*, edited by Philip Rosen, 299–318. New York: Columbia University Press.

Bayo, M.J. 1970. *Virgilio y la pastoral española del Renacimiento*. Madrid: Gredos.

Bergmann, Emilie L. 1979. *Art Inscribed: Essays on Ekphrasis in Spanish Golden Age Poetry*. Harvard Studies in Romance Languages 35. Cambridge, MA: Harvard University Press.

Bergmann, Emilie L. 2004. "Optics and Vocabularies of the Visual in Luis de Góngora and Sor Juana Inés de la Cruz." In *Writing for the Eyes in the Spanish Golden Age*, edited by Frederick A. de Armas, 151–65. Lewisburg, PA: Bucknell University Press.

Bergmann, Emilie L. 2013. "Embodying the Visual, Visualizing Sound in Sor Juana Inés de la Cruz's *Primero sueño*." In *Objects of Culture in the Literature of Imperial Spain*, edited by Mary E. Barnard and Frederick A. de Armas, 141–58. Toronto: University of Toronto Press.

Bettini, Maurizio. 1999. *The Portrait of the Lover*. Translated by Laura Gibbs. Berkeley: University of California Press.

Bialostocki, Jan. 1977. "Man and Mirror in Painting: Reality and Transience." In *Studies in Late Medieval and Renaissance Painting in Honor of Millard Meiss*, edited by Irving Lavin and John Plummer, 1:61–72. New York: New York University Press.

Blecua, Alberto. 1970. *En el texto de Garcilaso*. Madrid: Insula.

Blockmans, Wim [Willem Pieter]. 2002. *Emperor Charles V: 1500–1558*. Translated by Isola van den Hoven-Bardon. London: Arnold.

Boase, Roger. 1988. "The Meaning of the Crow-Hunting Episode in Garcilaso's *Egloga Segunda* (ll. 260–95)." *Journal of Hispanic Philology* 13 (1):41–8.

Bober, Phyllis Pray, and Ruth Rubinstein. 1986. *Renaissance Artists and Antique Sculpture: A Handbook of Sources*. Oxford: Harvey Miller and Oxford University Press.

Bolzoni, Lina. 2001. *The Gallery of Memory: Literary and Iconographic Models in the Age of the Printing Press*. Translated by Jeremy Parzen. Toronto: University of Toronto Press.

Boscán, Juan. 1994. *El cortesano*. Edited by Mario Pozzi. Madrid: Cátedra.

Bouza, Fernando. 2004. *Communication, Knowledge, and Memory in Early Modern Spain*. Translated by Sonia López and Michael Agnew. Philadelphia: University of Pennsylvania Press.

Bouza, Fernando. 2007. "Letters and Portraits: Economy of Time and Chivalrous Service in Courtly Culture." In *Correspondence and Cultural Exchange in Europe, 1400–1700*, edited by Francisco Bethencourt and Florike Egmond, 145–62. Vol. 3 of *Cultural Exchange in Early Modern Europe*. Edited by Robert Muchembled and William Monter. Cambridge: Cambridge University Press.

Brenkman, John. 1976. "Narcissus in the Text." *Georgia Review* 30:293–327.

Brown, Jonathan. 1986. *Velázquez: Painter and Courtier*. New Haven: Yale University Press.

Brown, Jonathan. 1998. *Painting in Spain 1500–1700*. New Haven and London: Yale University Press.

Brown, Sarah Annes. 2010. "Ovid." In *The Classical Tradition*, edited by Anthony Grafton, Glenn W. Most, and Salvatore Settis, 667–73. Cambridge, MA, and London: The Belknap Press of Harvard University Press.

Bruner, Jerome, and Susan Weisser. 1991. "The Invention of Self: Autobiography and Its Forms." In *Literacy and Orality*, edited by David R. Olson and N. Torrance, 129–48. Cambridge: Cambridge University Press.

Bunes Ibarra, Miguel Angel. 2006. "Vermeyen y los tapices de la *Conquista de Túnez*: Historia y representación." In *La imagen de la guerra en el arte de los antiguos Países Bajos*, edited by Bernardo J. García García, 95–134. Madrid: Editorial Complutense y Fundación Carlos de Amberes.

Cacho Casal, Rodrigo. 2009. "The Memory of Ruins: Quevedo's Silva to 'Roma antigua y moderna.'" *Renaissance Quarterly* 62. 4:1167–203. http://dx.doi.org/10.1086/650026.

Cain, Thomas. 1971. "Spenser and the Renaissance Orpheus." *University of Toronto Quarterly* 41.1:24–47. http://dx.doi.org/10.3138/utq.41.1.24.

Cammarata, Joan. 1983. *Mythological Themes in the Works of Garcilaso de la Vega*. Madrid: Porrúa.

Campbell, Stephen. 2004. *The Cabinet of Eros: Renaissance Mythological Painting and the Studiolo of Isabella d'Este*. New Haven: Yale University Press.

Campbell, Thomas P. 2002. *Tapestry in the Renaissance: Art and Magnificence*. New York: Metropolitan Museum of Art and New Haven: Yale University Press.

Campbell, Thomas P. 2007. *Henry VIII and the Art of Majesty: Tapestries at the Tudor Court*. New Haven: Published for the Paul Mellon Centre for Studies in British Art by Yale University Press.

Carabell, Paula. 1998. "Painting, Paradox, and the Dialectics of Narcissism in Alberti's *De pictura* and in the Renaissance Theory of Art." *Medievalia et Humanistica* 25:53–73.

Carlino, Andrea. 1999. *Books of the Body: Anatomical Ritual and Renaissance Learning*. Translated by John Tedeschi and Anne C. Tedeschi. Chicago: University of Chicago Press.

Caruth, Cathy. 1995. *Trauma: Explorations in Memory*. Baltimore: Johns Hopkins University Press.

Carruthers, Mary J. 1998. *The Craft of Thought: Meditation, Rhetoric, and the Making of Images, 400–1200*. Cambridge Studies in Medieval Literature 34. Cambridge: Cambridge University Press.

Carruthers, Mary J. [1991]. 2008. *The Book of Memory: A Study of Memory in Medieval Culture*. Cambridge Studies in Medieval Literature 10. Cambridge: Cambridge University Press.

Carruthers, Mary J. 2009. "*Ars oblivionalis, ars inveniendi*: The Cherub Figure and the Arts of Memory." *Gesta* 48.2:99–117. http://dx.doi.org/10.2307/29764902.

Cascardi, Anthony J. 1980. "The Exit from Arcadia: Reevaluation of the Pastoral in Virgil, Garcilaso, and Góngora." *Journal of Hispanic Philology* 4:119–41.

Castiglione, Baldassare. 1959. *The Book of the Courtier*. Translated by Charles S. Singleton. Garden City, NY: Doubleday.

Catullus. 1988. "The Poems of Gaius Valerius Catullus." In *Catullus, Tibullus, and Pervigilium Veneris*, translated by F.W. Cornish. 2nd edition, revised by G.P. Goold, 3–183. Cambridge, MA: Harvard University Press.

Cave, Terence. 1976. "*Enargeia*: Erasmus and the Rhetoric of Presence in the Sixteenth Century." *L'Esprit Créateur* 16:5–19.

Chartier, Roger. 2007. *Inscription and Erasure: Literature and Written Culture from the Eleventh to the Eighteenth Century*. Translated by Arthur Goldhammer. Philadelphia: University of Pennsylvania Press.

Checa Cremades, Fernando. 1979. "La entrada de Carlos V en Milán el año 1541." *Goya* 151:24–31.

Checa Cremades, Fernando. 1988. *Pintura y escultura del renacimiento en España, 1450–1600*. Madrid: Cátedra.

Checa Cremades, Fernando. 2003. "Algunas ideas sobre la significación de lo visual en Garcilaso." In *Garcilaso y su época: del amor y la guerra*, edited by José María Díez Borque and Luis Ribot García, 143–55. Madrid: Sociedad Estatal de Conmemoraciones Culturales.

Checa Cremades, Fernando. 2010, ed. *Los inventarios de Carlos V y la familia imperial/The Inventories of Charles V and the Imperial Family*. 3 vols. Madrid: Fernando Villaverde.

Cheles, Luciano. 1986. *The Studiolo of Urbino: An Iconographic Investigation*. University Park: Pennsylvania State University Press.

Chrétien de Troyes. 1991. *Arthurian Romances*. Translated by William W. Kibler. London: Penguin.

Christian, Kathleen Wren. 2010. *Empire without End: Antiquities Collections in Renaissance Rome, c. 1350–1527*. New Haven: Yale University Press.

Civil, Pierre. 1990. "Erotismo y pintura mitológica en la España del Siglo de Oro." *Edad de Oro* 9:39–49.

Coffin, David R. 1979. *The Villa in the Life of Renaissance Rome*. Princeton: Princeton University Press.

Cook, Harold J. 2006. "Medicine." In *The Cambridge History of Science*. Vol 3, *Early Modern Science*, edited by Katharine Park and Lorraine Daston, 407–34. Cambridge: Cambridge University Press. http://dx.doi.org/10.1017/CHOL9780521572446.019.

Copley, Frank. 1956. *Exclusus amator: A Study in Latin Love Poetry*. Madison, WI: American Philological Association.

Cortés Tovar, Rosario. 2008. "Los intertextos latinos en la *Ode ad Florem Gnidi*: su dimensión metapoética." *Studia Aurea* 5: no pagination. http://www.studiaaurea.com/articulo.php?id=93

Couliano, Ioan P. 1987. *Eros and Magic in the Renaissance*. Chicago: University of Chicago Press.

Cravens, Sydney P., and Edward V. George. 1981. "Garcilaso's Salicio and Vergil's Eighth Eclogue." *Hispania* 64.2:209–14. http://dx.doi.org/10.2307/341855.

Cruz, Anne J. 1988. *Imitación y transformación: El petrarquismo en la poesía de Boscán y Garcilaso de la Vega*. Amsterdam and Philadelphia: John Benjamins.

Cruz, Anne J. 2002. "Arms versus Letters: The Poetics of War and the Career of the Poet in Early Modern Spain." In *European Literary Careers: The Author from Antiquity to the Renaissance*, edited by Patrick Cheney and Frederick A. de Armas, 186–205. Toronto: University of Toronto Press.

Cruz, Anne J. 2011. "Reading over Men's Shoulders: Noblewomen's Libraries and Reading Practices." In *Women's Literacy in Early Modern Spain and the New World*, edited by Anne J. Cruz and Rosilie Hernández, 41–58. Burlington, VT: Ashgate.

Culler, Jonathan. 1981. "Apostrophe." In *The Pursuit of Signs: Semiotics, Literature, Deconstruction*, 135–54. Ithaca: Cornell University Press.

Cunningham, Andrew. 1997. *The Anatomical Renaissance: The Resurrection of the Anatomical Projects of the Ancients*. Aldershot: Scolar Press.

Dandelet, Thomas James. 2001. *Spanish Rome 1500–1700*. New Haven and London: Yale University Press.

Davis, Natalie Zemon. 2000. *The Gift in Sixteenth-Century France*. Madison: University of Wisconsin Press.

De Armas, Frederick A. 1998. *Cervantes, Raphael and the Classics*. Cambridge: Cambridge University Press.

De Armas, Frederick A. 2005. "Cervantes and Della Porta: The Art of Memory in *La Numancia, El retablo de las maravillas, El Licenciado Vidriera* and *Don Quijote*." *Bulletin of Hispanic Studies* 82.5:633–47. http://dx.doi.org/10.3828/bhs.82.5.6.

De Armas, Frederick A. 2006. *Quixotic Frescoes: Cervantes and Italian Renaissance Art*. Toronto: University of Toronto Press.

De Grazia, Margreta, Maureen Quilligan, and Peter Stallybrass. 1996. *Subject and Object in Renaissance Culture*. Cambridge: Cambridge University Press.

Defert, Daniel. 1984. "Un genre ethnographique profane au XVIe siècle: Les livres d'habits." In *Histoires de l'anthropologie (XVIe–XIXe siècles)*, edited by Britta Rupp-Eisenreich, 25–41. Paris: Klincksieck.

Delmarcel, Guy. 1999. *Flemish Tapestries*. New York: Harry Abrams.

Delmarcel, Guy. 2000. *Los Honores: Flemish Tapestries for the Emperor Charles V*. Translated by Alastair Weir. [Antwerp]: SDZ/Pandora.

Dent-Young, John. 2009. *Selected Poems of Garcilaso de la Vega: A Bilingual Edition*. Chicago: University of Chicago Press.

Derrida, Jacques. 1996. *Archive Fever: A Freudian Impression*. Chicago: University of Chicago Press.

Diccionario de Autoridades. 1984. Edición Facsímil. Madrid: Gredos.

Doane, Mary Ann. 1991. *Femmes Fatales: Feminism, Film Theory, Psychoanalysis*. New York and London: Routledge.

Dunn, Peter. 1965. "Garcilaso's Ode *A la flor de Gnido*: A Commentary on Some Renaissance Themes and Ideas." *Zeitschrift für Romanische Philologie* 81:288–309.

Durling, Robert M., ed. and trans. 1976. *Petrarch's Lyric Poems: The* Rime sparse *and Other Lyrics*. Cambridge, MA: Harvard University Press.

Egido, Aurora. 1990. "La memoria y el arte narrativo del *Persiles*." *Nueva Revista de Filología Hispánica* 38.2:621–41. Reprinted in *Cervantes y las puertas del sueño: Estudios sobre La Galatea, El Quijote, y El Persiles*, 285–306. Barcelona: PPU 1994.

Egido, Aurora. 1991. "La memoria y el *Quijote*." *Cervantes* 11.1:3–44. Reprinted in *Cervantes y las puertas del sueño: Estudios sobre La Galatea, El Quijote, y El Persiles*, 93–135. Barcelona: PPU, 1994.

Egido, Aurora. 2003. "El tejido del texto en la *Égloga III* de Garcilaso." In *Garcilaso y su época: del amor y la guerra*, edited by José María Díez Borque and Luis Ribot García, 179–200. Madrid: Sociedad Estatal de Conmemoraciones Culturales.

Ehrlich, Tracy L. 2002. *Landscape and Identity in Early Modern Rome: Villa Culture at Frascati in the Borghese Era*. Cambridge: Cambridge University Press. http://dx.doi.org/10.2307/3046099.

Eichberger, Dagmar. 1996. "Margaret of Austria's Portrait Collection: Female Patronage in the Light of Dynastic Ambitions and Artistic Quality." *Renaissance Studies* 10.2:259–79. http://dx.doi.org/10.1111/j.1477-4658.1996.tb00359.x.

Eichberger, Dagmar. 2010. "Margaret of Austria and the Documentation of Her Collection in Mechelen." In *Los inventarios de Carlos V y la familia imperial/The*

Inventories of Charles V and the Imperial Family, edited by Fernando Checa Cremades, 3:2351–63, 2365–542. Madrid: Fernando Villaverde.

Eichberger, Dagmar, and Lisa Beaven. 1995. "Family Members and Political Allies: The Portrait Collection of Margaret of Austria." *The Art Bulletin* 77: 225–48.

Ekserdjian, David. 2006. *Parmigianino*. New Haven and London: Yale University Press.

Enterline, Lynn. 1995. *The Tears of Narcissus: Melancholia and Masculinity in Early Modern Writing*. Stanford: Stanford University Press.

Enterline, Lynn. 2000. *The Rhetoric of the Body from Ovid to Shakespeare*. Cambridge Studies in Renaissance Literature and Culture 35. Cambridge: Cambridge University Press. http://dx.doi.org/10.1017/CBO9780511483561.

Erasmus. 1978. *De duplici copia verborum ac rerum*. In *Collected Works of Erasmus*, edited by Craig R. Thompson and translated by Betty I. Knott, 24: 295–659. Toronto: University of Toronto Press.

Fernández de Navarrete, E. 1850. *Vida del célebre poeta Garcilaso de la Vega*. Madrid: Imprenta de la Viuda de Calero.

Fernández-Morera, Darío. 1982. *The Lyre and the Oaten Flute: Garcilaso and the Pastoral*. London: Tamesis.

Ferrari, Giovanna. 1987. "Public Anatomy Lessons and the Carnival: The Anatomy Theatre of Bologna." *Past & Present* 117.1:50–106. http://dx.doi.org/10.1093/past/117.1.50.

Ficino, Marsilio. 1985. *Commentary on Plato's Symposium on Love*. Translated by Sears Jayne. 2nd rev. ed. Dallas, TX: Spring Publications.

Ficino, Marsilio. 1987. *El libro dell'Amore*. Edited by Sandra Niccoli. Florence: Olschki.

Findlen, Paula. 1998. "Possessing the Past: The Material World of the Italian Renaissance." *American Historical Review* 103.1:83–114.

Florescu, Florea Bobu. 1969. *Die Trajanssäule: Grundfragen und Tafeln*. Bucharest: Akademie- Verlag.

Foister, Susan. 2008. "Albrecht Dürer." In *Renaissance Faces: Van Eyck to Titian*, edited by Lorne Campbell, Miguel Falomir, Jennifer Fletcher, and Luke Syson, 254. London: National Gallery.

Foucault, Michel. 1973. *The Order of Things: An Archaeology of the Human Sciences*. New York: Vintage.

Freccero, John. 1972. "Medusa: The Letter and the Spirit." *Yearbook of Italian Studies* 2:1–18.

French, Roger. 1999. *Dissection and Vivisection in the European Renaissance*. Aldershot: Ashgate.

Freud, Sigmund. 1978. "Mourning and Melancholia." In *The Standard Edition of the Complete Psychological Works of Sigmund Freud*, translated by James Strachey, 14:243–58. London: Hogarth.

Gallagher, Patrick.1980. "Locus amoenus: The Aesthetic Centre of Garcilaso's Third Eclogue." In *Hispanic Studies in Honour of Frank Pierce*, edited by John England, 59–75. Sheffield: Department of Hispanic Studies, University of Sheffield.

Gallego Morell, Antonio. 1972. *Garcilaso de la Vega y sus comentaristas*. Madrid: Gredos.

Gallego Morell, Antonio. 1976. *Garcilaso: documentos completos*. Barcelona: Planeta.

García Pérez, Noelia. 2004. *Arte, poder y género en el Renacimiento español: El patronazgo artístico de Mencía de Mendoza*. Murcia: Nausícaä.

García Pérez, Noelia. 2006. "Emoción y memoria en la biblioteca de Mencía de Mendoza." *Goya* 313–14:227–36.

García Pérez, Noelia. 2009. "Mencía de Mendoza, Marquesa de Zenete: An Art Collector in Sixteenth-Century Spain." *Women's History Review* 18.4:639–58. http://dx.doi.org/10.1080/09612020903112331.

García Santo-Tomás, Enrique, ed. 2009. *Materia crítica: formas de ocio y de consumo en la cultura áurea*. Madrid and Frankfurt: Iberoamericana/ Vervuert.

Garcilaso de la Vega. 1995. *Garcilaso de la Vega: Obra poética y textos en prosa*. Edited by Bienvenido Morros. Barcelona: Crítica.

Gargano, Antonio. 1988. *Fonti, miti, topoi: cinque saggi su Garcilaso*. Naples: Liguori.

Ghertman, Sharon. 1975. *Petrarch and Garcilaso: A Linguistic Approach to Style*. London: Tamesis.

Goffen, Rona. 1989. *Giovanni Bellini*. New Haven: Yale University Press.

Goffen, Rona. 1991. "Bellini's Nude with Mirror." *Venezia Cinquecento* 2:185–99.

Goffen, Rona. 1997. *Titian's Women*. New Haven: Yale University Press.

Goldberg, Benjamin. 1985. *The Mirror and Man*. Charlottesville: University Press of Virginia.

González Mena, María Angeles. 1999. "Bordado y encajes eruditos," In *Artes decorativas II. Summa Artis: Historia general del arte 45*, edited by Alberto Bartolomé Arraiza, 83–130. Madrid: Espasa Calpe.

Gorse, George L. 1990. "Between Empire and Republic: Triumphal Entries into Genoa during the Sixteenth Century." In *'All the world's a stage …': Art and Pageantry in the Renaissance and Baroque*. 2 vols. Edited by Barbara Wisch and Susan Scott Munshower. Vol. 1, *Triumphal Celebrations and the Rituals*

of Statecraft, 188–256. University Park: Department of Art History, Pennsylvania State University Press.

Grabes, Herbert. 1982. *The Mutable Glass: Mirror-Imagery in Titles and Texts of the Middle Ages and English Renaissance*. Translated by Gordon Collier. Cambridge and New York: Cambridge University Press.

Graf, E.C. 2001. "From Scipio to Nero to the Self: The Exemplary Politics of Stoicism in Garcilaso de la Vega's Elegies." *PMLA* 116:1316–33.

Green, Otis H. 1953. "The Abode of the Blest in Garcilaso's 'Egloga Primera.'" *Romance Philology* 6:272–8.

Greene, Thomas. 1982. *The Light in Troy: Imitation and Discovery in Renaissance Poetry*. New Haven: Yale University Press.

Gubar, Susan. 1985. "'The Blank Page' and the Issues of Female Creativity." In *The New Feminist Criticism: Essays on Women, Literature and Theory*, edited by Elaine Showalter, 292–314. New York: Pantheon Books.

Guevara, Antonio de. 1994. *Relox de príncipes*. Edited by Emilio Blanco. In *Obras completas de Fray Antonio de Guevara*, 2:1–943. Madrid: Biblioteca Castro.

Guiffrey, Jules. 1878. *Tapisseries françaises*. Vol. 1, Pt.1 in *Histoire générale de la tapisserie: 1878–85*, edited by Jules Guiffrey, Eugène Müntz, and Alexander Pinchart. 3 vols. Paris: Société Anonyme de Publications Périodiques.

Guillou-Varga, Suzanne. 1986. *Mythes, mythographies et poésie lyrique au Siècle d'Or espagnol*. Lille: Université de Lille.

Harcourt, Glenn. 1987. "Andreas Vesalius and the Anatomy of Antique Sculpture." *Representations* (Berkeley, CA) 17.1:28–61. http://dx.doi.org/10.1525/rep.1987.17.1.99p0422b.

Hardie, Philip. 1988. "Lucretius and the Delusions of Narcissus." *Materiali e discussion per l'analisi dei testi classici* 20–1:71–89.

Harvey, Karen, ed. 2009. *History and Material Culture*. London and New York: Routledge.

Heath, Stephen. 1974. "Lessons from Brecht." *Screen* 15.2:103–28.

Heath, Stephen. 1981. *Questions of Cinema*. Bloomington: Indiana University Press.

Heiple, Daniel. 1994. *Garcilaso de la Vega and the Italian Renaissance*. University Park: Pennsylvania State University Press.

Helgerson, Richard. 2007. *A Sonnet from Carthage: Garcilaso de la Vega and the New Poetry of Sixteenth-Century Europe*. Philadelphia: University of Pennsylvania Press.

Hermida Ruiz, Aurora. 1999. "Historiografía literaria y nacionalismo español: Garcilaso de la Vega o el linaje del hombre invisible." PhD Diss., University of Virginia.

Hernando Sánchez, Carlos José. 1993. "La vida material y el gusto artístico en la Corte de Nápoles durante el renacimiento. El inventario de bienes del Virrey Pedro de Toledo." *Archivo español de arte* 66.261:35–55.

Herrero Carretero, Concha. 1999. "Tapicería." In *Artes decorativas II. Summa Artis: Historia general del arte* 45, edited by Alberto Bartolomé Arraiza, 133–201. Madrid: Espasa Calpe.

Hillman, David. 1997. "Visceral Knowledge." In *The Body in Parts: Fantasies of Corporeality in Early Modern Europe*, edited by David Hillman and Carla Mazzio, 81–105. New York and London: Routledge.

Hills, Paul. 1999. *Venetian Colour: Marble, Mosaic, Painting and Glass 1250–1550.* New Haven: Yale University Press.

Hollander, John. 1981. *The Figure of Echo: A Mode of Allusion in Milton and After.* Berkeley: University of California Press.

Homer. 1992. *The Odyssey.* Translated by Robert Fitzgerald. New York: Knopf.

Homer. 1999. *Iliad.* Edited by G.P. Goold, translated by A.T. Murray, and revised by William F. Wyatt. 2 vols. Cambridge, MA: Harvard University Press.

Horn, Hendrick J. 1989. *Jan Cornelisz Vermeyen: Painter of Charles V and His Conquest of Tunis.* 2 vols. Doornspuk, The Netherlands: Davaco.

Jardine, Lisa. 1996. *Worldly Goods: A New History of the Renaissance.* New York and London: Norton.

Jones, Ann Rosalind. 1987. "Nets and Bridles: Early Modern Conduct Books and Sixteenth-Century Women's Lyrics." In *The Ideology of Conduct: Essays on Literature and the History of Sexuality*, edited by Nancy Armstrong, 39–72. New York: Methuen.

Jones, Ann Rosalind. 1991. "New Songs for the Swallow: Ovid's Philomela in Tullia d'Aragona and Gaspara Stampa." In *Refiguring Woman: Perspectives on Gender and the Italian Renaissance*, edited by Marilyn Migiel and Juliana Schiesari. 263–77. Ithaca and London: Cornell University Press.

Jones, Ann Rosalind. 1996. "Dematerializations: Textile and Textual Properties in Ovid, Sandys, and Spenser." In *Subject and Object in Renaissance Culture.* Cambridge Studies in Renaissance Literature and Culture 8, edited by Margreta de Grazia, Maureen Quilligan, and Peter Stallybrass, 189–209. Cambridge: Cambridge University Press.

Jones, Ann Rosalind, and Peter Stallybrass. 2000. *Renaissance Clothing and the Materials of Memory.* Cambridge: Cambridge University Press.

Joplin, Patricia Klindienst. 1984. "The Voice of the Shuttle is Ours." *Stanford Literature Review* 1.1:25–53.

Juárez Almendros, Encarnación. 2006. *El cuerpo vestido y la construcción de la identidad en las narrativas autobiográficas del Siglo de Oro.* London: Tamesis.

Junquera, Juan José. 1985. "Le goût espagnol pour la tapisserie." In *Tapisserie de Tournai en Espagne: La tapisserie bruxelloise en Espagne au XVIᵉ siècle*, 16–52. Tournai, Brussels, and Rijkhoven: Europalia.

Junquera de Vega, Paulina. 1968. "Las batallas navales en los tapices." *Reales sitios* 17:40–55.

Junquera de Vega, Paulina. 1970. "Tapices de los reyes católicos y de su época." *Reales Sitios* 26:16–26.

Junquera de Vega, Paulina, and Concha Herrero Carretero. 1986. *Catálogo de tapices del Patrimonio Nacional.* Vol. 1, siglo XVI. Madrid: Editorial Patrimonio Nacional.

Kagan, Richard L. 2009. *Clio and the Crown: The Politics of History in Medieval and Early Modern Spain.* Baltimore: Johns Hopkins University Press.

Kamen, Henry. 2004. *The Duke of Alba.* New Haven: Yale University Press.

Kemp, Martin, ed. 1989. *Leonardo on Painting.* New Haven and London: Yale University Press.

Keniston, Hayward. 1922. *Garcilaso de la Vega: A Critical Study of His Life and Works.* New York: Hispanic Society of America.

Kettering, Sharon. 1988. "Gift-Giving and Patronage in Early Modern France." *French History* 2.2:131–51. http://dx.doi.org/10.1093/fh/2.2.131.

Kirkbride, Robert. 2008. *Architecture and Memory: The Renaissance Studioli of Federico da Montefeltro.* New York: Columbia University Press.

Klein, Lisa M. 1997. "Your Humble Handmaid: Elizabethan Gifts of Needlework." *Renaissance Quarterly* 50.2:459–93. http://dx.doi.org/10.2307/3039187.

Klestinec, Cynthia. 2011. *Theaters of Anatomy: Students, Teachers, and Traditions of Dissection in Renaissance Venice.* Baltimore: Johns Hopkins University Press.

Klibansky, Raymond, Erwin Panofsky, and Fritz Saxl. 1964. *Saturn and Melancholy: Studies in the History of Natural Philosophy, Religion and Art.* New York: Basic Books.

Knoespel, Kenneth J. 1985. *Narcissus and the Invention of Personal History.* New York: Garland.

Koerner, Joseph Leo. 1996. *The Moment of Self-Portraiture in German Renaissance Art.* Chicago: University of Chicago Press.

Komanecky, Peter M. 1971. "Epic and Pastoral in Garcilaso's Eclogues." *MLN* 86.2:154–66. http://dx.doi.org/10.2307/2907612.

Krieger, Murray. 1992. *Ekphrasis: The Illusion of the Natural Sign.* Baltimore and London: Johns Hopkins University Press.

Krier, Theresa M. 1990. *Gazing on Secret Sights: Spenser, Classical Imitation, and the Decorums of Vision.* Ithaca: Cornell University Press.

Kritzman, Lawrence D. 1991. *The Rhetoric of Sexuality and the Literature of the French Renaissance.* Cambridge: Cambridge University Press. http://dx.doi.org/10.1017/CBO9780511627651.

Lacan, Jacques. 1977. *Écrits*. Translated by Alan Sheridan. New York: Norton.

Laguna, Ana María G. 2009. *Cervantes and the Pictorial Imagination: A Study on the Power of Images and Images of Power in Works by Cervantes*. Lewisburg: Bucknell University Press.

Lapesa, Rafael. [1948, 1968] 1985. *La trayectoria poética de Garcilaso*. 3rd ed. rev. In *Garcilaso: Estudios completos*, 11–176. Madrid: Istmo.

Lázaro Carreter, Fernando.1986. "La 'Ode ad florem Gnidi' de Garcilaso de la Vega." In *Garcilaso*, edited by Victor García de la Concha, 109–26. Salamanca: Universidad de Salamanca.

Lazure, Guy. 2007. "Possessing the Sacred: Monarchy and Identity in Philip II's Relic Collection at the Escorial." *Renaissance Quarterly* 60.1:58–93. http://dx.doi.org/10.1353/ren.2007.0076.

Lepper, Frank, and Sheppard Frere. 1988. *Trajan's Column: A New Edition of the Cichorius Plates*. Gloucester: Alan Sutton.

Lida, María Rosa. 1975. "El ruiseñor de las *Geórgicas* y su influencia en la lírica española de la edad de oro." In *La tradición clásica en España*, 100–17. Barcelona: Ariel.

Loewenstein, Joseph. 1984. *Responsive Readings: Versions of Echo in Pastoral, Epic, and the Jonsonian Masque*. Yale Studies in English 192. New Haven, London: Yale University Press.

López Grigera, Luisa. 1988. "Notas sobre las amistades italianas de Garcilaso: un nuevo manuscrito de Pietro Bembo." In *Homenaje a Eugenio Asensio*, 219–310. Madrid: Gredos.

Lorenzo, Javier. 2004. "After Tunis: Petrarchism and Empire in the Poetry of Garcilaso de la Vega." *Hispánofila* 141:17–30.

Lorenzo, Javier. 2005. "Traducción y cortesanía: la construcción de la identidad cortesana en los prólogos al libro de *El cortesano* de Juan Boscán." *Modern Language Notes* 120.2:249–61.

Lumsden, Audrey. 1947a. "Garcilaso de la Vega as a Latin Poet." *Modern Language Review* 42.3:337–41. http://dx.doi.org/10.2307/3717299.

Lumsden, Audrey. 1947b. "Problems Connected with the Second Eclogue of Garcilaso de la Vega." *Hispanic Review* 15.2:251–71. http://dx.doi.org/10.2307/470358.

Lumsden, Audrey. 1952. "Garcilaso and the Chatelainship of Reggio." *Modern Language Review* 47.4:559–60. http://dx.doi.org/10.2307/3719711.

Maltby, William S. 1983. *Alba: A Biography of Fernando Alvarez de Toledo, Third Duke of Alba 1507–1582*. Berkeley: University of California Press.

Maravall, José Antonio. 1986. "Garcilaso entre la sociedad caballeresca y la utopía renacentista." In *Garcilaso*, edited by Victor García de la Concha, 7–47. Salamanca: Ediciones Universidad de Salamanca.

Marder, Elissa. 1992. "Disarticulated Voices: Feminism and Philomela." *Hypatia: A Journal of Feminist Philosophy* 7.2:148–66.

Martín I Ros, Rosa M. 1999. "Tejidos." In *Artes decorativas II. Summa Artis: Historia general del arte* 45, edited by Alberto Bartolomé Arraiza, 9–80. Madrid: Espasa Calpe.

Martín Rodríguez, Antonio María. 2008. *El mito de Filomela en la literatura española*. Leon: Universidad de León.

Martínez-Vidal, Álvar, and José Pardo-Tomás. 2005. "Anatomical Theaters and the Teaching of Anatomy in Early Modern Spain." *Medical History* 49.3:251–80. http://dx.doi.org/10.1017/S0025727300008875.

Martínez-López, Enrique. 1972. "Sobre 'aquella bestialidad' de Garcilaso (égl. III.230)." *PMLA* 87:12–25.

Mauss, Marcel. 1990. *The Gift: The Form and Reason for Exchange in Archaic Societies*. Translated by W.D. Halls. New York: Norton.

Mazzotta, Giuseppe. 1993. *The Worlds of Petrarch*. Durham: Duke University Press.

McLean, Paul D. 2007. *The Art of the Network: Strategic Interaction and Patronage in Renaissance Florence*. Durham and London: Duke University Press.

McVay, Ted E. 1993. "The Goddess Diana and the 'ninfa degollada' in Garcilaso's Eclogue III." *Hispanófila* 109: 19–31.

Meiss, Millard. 1974. "Raphael's Mechanized Seashell: Notes on a Myth, Technology, and Iconographic Tradition." In *Gatherings in Honor of Dorothy E. Miner*, edited by Ursula E. McCracken, Lilian M.C. Randall, and Richard H. Randall, Jr, 317–32. Baltimore: Walters Art Gallery.

Melchior-Bonnet, Sabine. 2002. *The Mirror: A History*. Translated by Katharine H. Jewett. New York: Routledge.

Mele, Eugenio. 1930. "In margine alle poesie di Garcilaso." *Bulletin Hispanique* 32.3:218–45. http://dx.doi.org/10.3406/hispa.1930.2377.

Metz, Christian. 1982. *The Imaginary Signifier: Psychoanalysis and the Cinema.* Translated by Celia Britton, et al. Bloomington: Indiana University Press.

Middlebrook, Leah. 2009. *Imperial Lyric: New Poetry and New Subjects in Early Modern Spain*. University Park: Pennsylvania State University.

Mignolo, Walter D. 1995. *The Darker Side of the Renaissance: Literacy, Territoriality, and Colonization*. Ann Arbor: University of Michigan Press.

Mitchell, Bonner. 1986. *The Majesty of the State: Triumphal Progresses of Foreign Sovereigns in Renaissance Italy (1494–1600)*. Florence: Olschki.

Morán, J. Miguel, and Fernando Checa. 1985. *El coleccionismo en España: De la cámara de maravillas a la galería de pinturas*. Madrid: Cátedra.

Morros, Bienvenido, ed. 1995. *Garcilaso de la Vega: Obra poética y textos en prosa*. Barcelona: Crítica.

Morros, Bienvenido. 2000. "La canción IV de Garcilaso como un infierno de amor: de Garci Sánchez de Badajoz y el Cariteo a Bernardo Tasso." *Criticón* 80:19–47.

Morros, Bienvenido. 2003. "El tema de la guerra y de la caza en Garcilaso." In *Garcilaso y su época: del amor y la guerra*, edited by José María Díez Borque and Luis Ribot García, 227–40. Madrid: Sociedad Estatal de Conmemoraciones Culturales.

Navarrete, Ignacio. 1994. *Orphans of Petrarch: Poetry and Theory in the Spanish Renaissance*. Berkeley: University of California Press.

Nebrija, Antonio de. 1992. *Gramática de la lengua castellana*. Edited by Antonio Quilis. Madrid: Ediciones de Cultura Hispánica.

Necipoglu, Gülru. 1989. "Süleyman the Magnificent and the Representation of Power in the Context of Ottoman-Hapsburg-Papal Rivalry." *Art Bulletin* 71.3:401–27. http://dx.doi.org/10.2307/3051136.

Nelson, Benjamin J. 2010. "Ovidian Fame: Garcilaso de la Vega and Jorge de Montemayor as Orphic Voices in Early Modern Spain and the *Contamino* of the Orpheus and Eurydice Myth." In *Ovid in the Age of Cervantes*, edited by Frederick A. de Armas, 203–27. Toronto: University of Toronto Press.

Nora, Pierre. 1995. "Between Memory and History: *Les Lieux de mémoire*." Translated by Marc Roudebush. In *Histories: French Constructions of the Past*, edited by Jacques Revel and Lynn Hunt, 631–43. New York: The New Press.

O'Malley, Charles. 1965. *Andreas Vesalius of Brussels: 1514–1564*. Berkeley: University of California Press.

Ong, Walter. 2002. *Orality and Literacy*. New York: Routledge.

Orobitg, Christine. 1997. *Garcilaso et la mélancolie*. Toulouse: Presses Universitaires du Mirail.

Ovid. 1984. *Metamorphoses*. 2 vols. Edited and translated by Frank Justus Miller. 2nd ed. Revised by G.P. Goold. Cambridge, MA: Harvard University Press.

Ovid. 1996. *Tristia; Ex Ponto*. Translated by Arthur Leslie Wheeler. 2nd ed. Revised by G.P. Goold. Cambridge, MA: Harvard University Press.

Packer, James E. 2001. *The Forum of Trajan in Rome: A Study of the Monuments*. Vol. 1. Berkeley: University of California Press.

Padrón, Ricardo. 2004. *The Spacious Word: Cartography, Literature, and Empire in Early Modern Spain*. Chicago and London: University of Chicago Press.

Panofsky, Erwin. 1951. "'Nebulae in Pariete': Notes on Erasmus' Eulogy on Dürer." *Journal of the Warburg and Courtauld Institutes* 14.1/2:34–41. http://dx.doi.org/10.2307/750351.

Panofsky, Erwin. 1955. *Meaning in the Visual Arts*. Chicago: University of Chicago Press.

Park, Katharine. 1994. "The Criminal and the Saintly Body: Autopsy and Dissection in Renaissance Italy." *Renaissance Quarterly* 47.1:1–33. http://dx.doi.org/10.2307/2863109.

Parker, Alexander A. 1948. "Theme and Imagery in Garcilaso's First Eclogue." *Bulletin of Spanish Studies* 25.100:222–7. http://dx.doi.org/10.1080/14753825012331358643.

Parker, Alexander A. 1985. *The Philosophy of Love in Spanish Literature: 1480–1680.* Edited by Terence O'Reilly. Edinburgh: Edinburgh University Press.

Paterson, Alan K.G. 1977. "Ecphrasis in Garcilaso's 'Egloga Tercera.'" *Modern Language Review* 72.1:73–92. http://dx.doi.org/10.2307/3726297.

Petrarch. 1976. *Petrarch's Lyric Poems: The* Rime sparse *and Other Lyrics.* Edited and translated by Robert M. Durling. Cambridge, MA: Harvard University Press.

Petrucci, Armando. 1993. *Public Lettering: Script, Power, and Culture.* Translated by Linda Lappin. Chicago: University of Chicago Press.

Phillippy, Patricia. 2006. *Painting Women: Cosmetics, Canvasses, and Early Modern Culture.* Baltimore: Johns Hopkins University Press.

Plato. 1972. *Phaedrus.* Translated by R. Hackforth. Cambridge: Cambridge University Press.

Plato. 1990. *The Theaetetus of Plato.* Translated by M.J. Levett, revised by Myles Burnyeat. Indianapolis and Cambridge: Hacket.

Plato. *Philebus.* 1993. Translated by Dorothea Frede. Indianapolis and Cambridge: Hacket.

Porqueras-Mayo, Alberto. 1970. "La ninfa degollada de Garcilaso (égloga III, versos 225–32)." In *Actas del Tercer Congreso Internacional de Hispanistas,* edited by Carlos H. Magis, 715–24. Mexico: Colegio de México.

Portús, Javier. 1999. "Los cuadros secretos del Prado." *Descubrir el Arte* 1:73–80.

Portús, Javier. 2005. "Las Hilanderas como fábula artística." *Boletín del Museo del Prado* 23.41:70–83.

Portús, Javier. 2006. "Miserias de la guerra: de Brueguel a Velázquez." In *La imagen de la guerra en el arte de los antiguos Países Bajos,* edited by Bernardo J. García García, 3–27. Madrid: Editorial Complutense y Fundación Carlos de Amberes.

Quint, David. 1983. *Origin and Originality in Renaissance Literature: Versions of the Source.* New York: Yale University Press.

Quintero, María Cristina. 2004. "Mirroring Desire in Early Modern Spanish Poetry: Some Lessons from Painting." In *Writing for the Eyes in the Spanish Golden Age,* edited by Frederick A. de Armas, 87–108. Lewisburg: Bucknell University Press.

Quintilian. 1961. *Institutio Oratoria*. 4 vols. Translated by H.E. Butler. Cambridge, MA.: Harvard University Press.

Raggio, Olga. 1999. *The Gubbio Studiolo and Its Conservation*. Vol. 1. New York: Metropolitan Museum of Art.

Redondo Cantera, María José. 2010. "The Inventories of Empress Isabella of Portugal." In *Los inventarios de Carlos V y la familia imperial/The Inventories of Charles V and the Imperial Family*, edited by Fernando Checa Cremades, 2:1245–78, 1279–2322. Madrid: Fernando Villaverde.

Richardson, Catherine. 2011. *Shakespeare and Material Culture*. Oxford: Oxford University Press.

Rico, Francisco. 1978. "De Garcilaso y otros petrarquismos." *Revue de Littérature Comparée* 52:325–38.

Rivers, Elias L. 1960–1. "The Sources of Garcilaso's Sonnet VIII." *Romance Notes* 2:96–100.

Rivers, Elias L. 1962. "The Pastoral Paradox of Natural Art." *Modern Language Notes* 77.2:130–44. http://dx.doi.org/10.2307/3042857.

Rivers, Elias L. 1973. "Albanio as Narcissus in Garcilaso's Second Eclogue." *Hispanic Review* 41:297–304. http://dx.doi.org/10.2307/471961.

Rivers, Elias L, ed. 1974. *Garcilaso de la Vega: Obras completas con comentario*. Madrid: Castalia.

Rivers, Elias L. 1980. "Nature, Infidelity and Death: Eclogue I." In *Garcilaso de la Vega: A Critical Guide*, 64–74. London: Grant & Cutler.

Rodríguez de la Flor, Fernando. 1996. *Teatro de la memoria: siete ensayos sobre mnemotecnia española de los siglos XVII y XVIII*. Salamanca: Junta de Castilla y León, Consejería de Cultura y Turismo.

Rodríguez García, José María. 1998. "*Epos delendum est*: The Subject of Carthage in Garcilaso's 'A Boscán desde La Goleta.'" *Hispanic Review* 66.2:151–70. http://dx.doi.org/10.2307/474525.

Romilly, Jacqueline de. 1973. *Magic and Rhetoric in Ancient Greece*. Cambridge, MA: Harvard University Press.

Rosenthal, Earl E. 1971. "Plus Ultra, Non Plus Ultra, and the Columnar Device of Emperor Charles V." *Journal of the Warburg and Courtauld Institutes* 34:204–28. http://dx.doi.org/10.2307/751021.

Rosenthal, Earl E. 1973. "The Invention of the Columnar Device of Emperor Charles V at the Court of Burgundy in Flanders in 1516." *Journal of the Warburg and Courtauld Institutes* 36:198–230. http://dx.doi.org/10.2307/751163.

Rossi, Paolo. 2000. *Logic and the Art of Memory: The Quest for a Universal Language*. Translated by Stephen Clucas. Chicago: University of Chicago Press.

Russell, H. Diane. 1990. *Eva/Ave: Woman in Renaissance and Baroque Prints*. Washington: National Gallery of Art.

Sánchez Cantón, Francisco Javier. 1950. *Libros, tapices y cuadros que coleccionó Isabel la Católica*. Madrid: Consejo Superior de Investigaciones Científicas.

Sannazaro, Jacopo. 1961. *Arcadia*. Edited by Alfredo Mauro. Bari: Laterza.

Sannazaro, Jacopo. 1966. *Arcadia and Piscatorial Eclogues*. Translated by Ralph Nash. Detroit: Wayne State University Press.

Sannazaro, Jacopo. 2009. *Latin Poetry*. Translated by Michael C.J. Putnam. Cambridge, MA: Harvard University Press.

Sawday, Jonathan. 1995. *The Body Emblazoned: Dissection and the Human Body in Renaissance Culture*. London and New York: Routledge.

Schied, John, and Jesper Svenbro. 1996. *The Craft of Zeus: Myths of Weaving and Fabric*. Translated by Carol Volk. Cambridge, MA: Harvard University Press.

Schiesari, Juliana. 1992. *The Gendering of Melancholia: Feminism, Psychoanalysis, and the Symbolics of Loss in Renaissance Literature*. Ithaca: Cornell University Press.

Schoenfeldt, Michael C. 1999. *Bodies and Selves in Early Modern England: Physiology and Inwardness in Spenser, Shakespeare, Herbert, and Milton*. Cambridge Studies in Renaissance Literature and Culture 34. Cambridge: Cambridge University Press.

Schwarz, Heinrich. 1952. "The Mirror in Art." *The Art Quarterly* 15:97–118.

Segal, Charles. 1989. *Orpheus: The Myth of the Poet*. Baltimore and London: Johns Hopkins University Press.

Sepúlveda, Juan Ginés de. 2005. *Io. Genesii Sepulvedae De bello Africo*. Edited and translated by Mercedes Trascasas Casares. Madrid: Universidad Nacional de Educación a Distancia.

Serés, Guillermo. 1994. "El concepto de fantasía, desde la estética clásica a la deciochesca." *Anales de Literatura Española* 10:207–36.

Sharrock, Alison. 1991. "Womanufacture." *Journal of Roman Studies* 81:36–49. http://dx.doi.org/10.2307/300487.

Shephard, Tim. 2010. "Constructing Identities in a Music Manuscript: The Medici Codex as a Gift." *Renaissance Quarterly* 63.1:84–127. http://dx.doi.org/10.1086/652534.

Silver, Larry. 2008. *Marketing Maximilian: The Visual Ideology of a Holy Roman Emperor*. Princeton: Princeton University Press.

Siraisi, Nancy G. 1990. *Medieval and Early Renaissance Medicine: An Introduction to Knowledge and Practice*. Chicago: University of Chicago Press. http://dx.doi.org/10.7208/chicago/9780226761312.001.0001.

Siraisi, Nancy G. 2001. "Signs and Evidence: Autopsy and Sanctity in Late Sixteenth-Century Italy." In *Medicine and the Italian Universities 1250–1600*, 356–380. Leiden: Brill.

Smith, Paul Julian. 1988. *Writing in the Margin: Spanish Literature of the Golden Age*. Oxford and New York: Oxford University Press.

Smith, Paul Julian. 1995. "Homographesis in Salicio's Song." In *Cultural Authority in Golden Age Spain*, edited by Marina S. Brownlee and Hans Ulrich Gumbrecht, 131–42. Baltimore: Johns Hopkins University Press.

Soufas, Teresa Scott. 1990. *Melancholy and the Secular Mind in Spanish Golden Age Literature*. Columbia and London: University of Missouri Press.

Spengemann, William C. 1980. *The Forms of Autobiography: Episodes in the History of a Literary Genre*. New Haven and London: Yale University Press.

Spitzer, Leo. 1952. "Garcilaso, Third Eclogue, Lines 265–271." *Hispanic Review* 20.3:243–8. http://dx.doi.org/10.2307/470708.

Spivak, Gayatri Chakravorty. 1993. "Echo." *New Literary History* 24.1:17–43. http://dx.doi.org/10.2307/469267.

Stock, Brian. 1996. *Augustine the Reader: Meditation, Self-Knowledge and the Ethics of Interpretation*. Cambridge, MA: Harvard University Press.

Strong, Roy. 1984. *Art and Power: Renaissance Festivals 1450–1650*. Berkeley: University of California Press.

Tanner, Marie. 1993. *The Last Descendant of Aeneas: The Hapsburgs and the Mythic Image of the Emperor*. New Haven: Yale University Press.

Tasso, Bernardo. 1995. *Rime*. Edited by Domenico Chiodo. 2 vols. Turin: Edizioni Res.

Taylor, Diana. 2001. 2003. "Staging Social Memory: Yuyachkani." In *Psychoanalysis and Performance*, edited by Patrick Campbell and Adrian Kear, 218–35. London: Routledge. Revised as "Staging Traumatic Memory: Yuyachkani." In *The Archive and the Repertoire: Performing Cultural Memory in the Americas*, 190–211. Durham: Duke University Press.

Temkin, Owsei. 1973. *Galenism: Rise and Decline of a Medical Philosophy*. Ithaca: Cornell University Press.

Ter Horst, Robert. 1968. "Time and Tactics of Suspense in Garcilaso's Egloga Primera." *Modern Language Notes* 83.2:145–63. http://dx.doi.org/10.2307/2908193.

Ter Horst, Robert. 1987. "Poetry and Power in Garcilaso's *Egloga Primera*." *Revista de Estudios Hispánicos* 21:1–10.

Theocritus. 2002. *Idylls*. Translated by Anthony Verity. Oxford: Oxford University Press.

Thomson, W.G. 1973. *A History of Tapestry from the Earliest Times until the Present Day*. 3rd ed. Revised by F.P. and E.S. Thomson. East Ardsley, Eng.: EP Publishing.

Tomlinson, Gary. 1993. *Music in Renaissance Magic: Toward a Historiography of Others*. Chicago: University of Chicago Press.

Torres, Isabel. 2008. "Neo-Parkerism: An Approach to Reading Garcilaso de la Vega, Eclogue 1." *Bulletin of Spanish Studies* 85.6:93–105. http://dx.doi.org/10.1080/14753820802542325.

Torres, Isabel. 2009. "Sites of Speculation: Water/Mirror Poetics in Garcilaso de la Vega, Eclogue II." *Bulletin of Hispanic Studies* 86.6:877–92. http://dx.doi.org/10.1353/bhs.0.0101.

Tracy, James D. 2002. *Emperor Charles V, Impresario of War: Campaign Strategy, International Finance, and Domestic Politics.* Cambridge: Cambridge University Press.

Trascasas Casares, Mercedes, ed. and trans. 2005. *Io. Genesii Sepulvedae De bello Africo.* Madrid: Universidad Nacional de Educación a Distancia.

Tuve, Rosemond. 1972. *Elizabethan and Metaphysical Imagery.* Chicago: University of Chicago Press.

Vance, Eugene. 1986. *Mervelous Signals: Poetics and Sign Theory in the Middle Ages.* Lincoln: University of Nebraska Press.

Vaquero Serrano, María. 2002. *Garcilaso: Poeta del amor, caballero de la guerra.* Madrid: Espasa-Calpe.

Vasari, Giorgio. 1996. *Lives of the Painters, Sculptors, and Architects.* Translated by Gaston du C. de Vere. 2 vols. New York: Knopf.

Vickers, Nancy J. 1981. 1982. "Diana Described: Scattered Woman and Scattered Rhyme." *Critical Inquiry* 8:265–79. Reprinted in *Writing and Sexual Difference*, edited by Elizabeth Abel, 95–110. Chicago: University of Chicago Press.

Vickers, Nancy J. 1997. "Members Only: Marot's Anatomical Blazons." In *The Body in Parts: Fantasies of Corporeality in Early Modern Europe*, edited by David Hillman and Carla Mazzio, 3–21. New York and London: Routledge.

Vinge, Louise. 1967. *The Narcissus Theme in Western European Literature up to the Early 19th Century.* Lund: Gleerups.

Virgil. 1965. *Eclogues. Georgics. Aeneid. The Minor Poems.* Edited and translated by H. Rushton Fairclough. Vol. 1. Cambridge, MA: Harvard University Press.

Virgil. 1999, 2000. *Eclogues. Georgics. Aeneid. The Minor Poems.* Edited and translated by H. Rushton Fairclough. Revised by G.P. Goold. 2 vols. Cambridge, MA: Harvard University Press.

Vitruvius. 1999. *Ten Books on Architecture.* Translated by Ingrid D. Rowland. Cambridge: Cambridge University Press.

Waley, Pamela. 1977. "Garcilaso's Second Eclogue is a Play." *Modern Language Review* 72.3:585–96. http://dx.doi.org/10.2307/3725399.

Warwick, Genevieve. 1997. "Gift Exchange and Art Collecting: Padre Sebastiano Resta's Drawing Albums." *Art Bulletin* 79. 4:630–46. http://dx.doi.org/10.2307/3046279.

Weiss, Roberto. 1958. *Un umanista veneziano: Papa Paolo II.* Venice and Rome: Istituto per la Collaborazione Culturale.

Welles, Marcia L. 1986. *Arachne's Tapestry: The Transformations of Myth in Seventeeth-Century Spain.* San Antonio, TX: Trinity University Press.

Whitby, William M. 1986. "Transformed into What? Garcilaso's 'Ode ad florem Gnidi.'" *Revista Canadiense de Estudios Hispánicos* 11:131–43.

Wind, Edgar. 1968. *Pagan Mysteries in the Renaissance.* New York: Norton.

Wittkower, Rudolf, and Margot Wittkower. 1963. *Born under Saturn: The Character and Conduct of Artists: A Documented History from Antiquity to the French Revolution.* London: Weidenfeld and Nicolson.

Woods, M.J. 1969. "Rhetoric in Garcilaso's First Eclogue." *Modern Language Notes* 84.2:143–56. http://dx.doi.org/10.2307/2908012.

Woods-Marsden, Joanna. 1998. *Renaissance Self-Portraiture: The Visual Construction of Identity and the Social Status of the Artist.* New Haven and London: Yale University Press.

Wyke, Maria. 1987. "Written Women: Propertius's *Scripta Puella.*" *Journal of Roman Studies* 77:47–61. http://dx.doi.org/10.2307/300574.

Wyke, Maria. 2002. *The Roman Mistress: Ancient and Modern Representations.* Oxford: Oxford University Press.

Yates, Frances A. 1966. *The Art of Memory.* Chicago: University of Chicago Press.

Yates, Frances A. 1975. *Astraea: The Imperial Theme in the Sixteenth Century.* London and Boston: Routledge & Kegan Paul.

Zimic, Stanislav. 1988. "Las églogas de Garcilaso de la Vega: Ensayos de interpretación." *Boletín de la Biblioteca Menéndez Pelayo* 64:5–107.

Index

TORONTO IBERIC